# MICHELANGELO
# The Sistine Chapel Ceiling

*Illustrations · Introductory Essay ·
Backgrounds and Sources · Critical Essays*

NORTON CRITICAL STUDIES IN ART HISTORY

CHARTRES CATHEDRAL *edited by* Robert Branner

GIOTTO: THE ARENA CHAPEL FRESCOES *edited by* James H. Stubblebine

MICHELANGELO: THE SISTINE CHAPEL CEILING *edited by* Charles Seymour, Jr.

THE PARTHENON *edited by* Vincent J. Bruno

RUBENS: THE ANTWERP ALTARPIECES: The Raising of the Cross and the Descent from the Cross *edited by* John Rupert Martin

# MICHELANGELO
## The Sistine Chapel Ceiling

*Illustrations · Introductory Essay ·*
*Backgrounds and Sources · Critical Essays*

EDITED BY

CHARLES SEYMOUR, JR.

W · W · NORTON & COMPANY

New York · London

W. W. Norton & Company, Inc., 500 Fifth Avenue, New York, N.Y. 10110
W. W. Norton & Company Ltd., 25 New Street Square, London EC4A 3NT

Published simultaneously in Canada by George J. McLeod Limited, Toronto
Printed in the United States of America

Library of Congress Cataloging in Publication Data
Seymour, Charles, Jr., 1912–     comp.
    Michelangelo, the Sistine Chapel ceiling.
    (A Norton critical study in art history)
    Includes bibliographical references.
    1. Buonarroti, Michel Angelo, 1475–1564.
2. Vatican.  Cappella Sistina.  I. Title.
ND623.B92S42        759.5           74–90982
ISBN 0-393-04319-3
ISBN 0-393-09889-3 {pbk.}

# CONTENTS

# LIST OF ILLUSTRATIONS

TEXT ILLUSTRATIONS

# PREFACE

FROM THE MOMENT Michelangelo entered its history, the ceiling of the Sistine Chapel staged a double drama—a human one as well as an esthetic one. To the painter, the ceiling must have provided a virtually unimaginable challenge. Ever since its unveiling in 1512, the ceiling has also proved to generations of awed observers a visual puzzle of no small dimension. How was it ever meant actually to be seen? Could its countless details ever be grasped by mortal eyes? *All at one time?* If not, how and where should one begin to look? And then, how should one proceed? Finally, short of finding an inevitably uncomfortable spot on which to recline on the marble-incrusted pavement of the Chapel, where may one discover the best available point of viewing?

These questions plague us today just as they had earlier obsessed no less an historian of art than Heinrich Wölfflin. Let us begin by admitting quite frankly that a total view of the ceiling from one place and at one moment in time is a physical impossibility. We must scan this immense painting rather slowly, part by part, and from below, at a distance of some 60-odd feet; more, indeed, if we adjust the visual angle by standing, as one probably should, at various points along the sides, as well as walking directly below on the central axis of the Chapel. In this way what one can see is a series of larger or smaller fragments, beautiful and moving in themselves, to be sure, but which can mean relatively little without an understanding of the total context, the very visual context that escapes a single view.

Here, clearly, is a dilemma. We must have recourse to means other than immediate and direct vision. Modern photography in conjunction with the much more venerable method of presentation of ideas by words offer a way out of the dilemma. With their help we can grasp the whole intellectually; in theory, we can also rapidly and coherently perceive its parts.

The purpose of this volume is to make this admittedly second-hand process of perception as clear and plain as may be feasible within a handy and not-too-expensive format. As complete a photographic record as possible is presented along with selections from the available historical evidence and wealth of published critical insights in order to help a modern viewer and reader to reassemble, as it were, the fragments that direct experience of the ceiling yields to the average visitor's eye. And only then, it must be added, when there is a break in the furious onrush of tourists who have taken the place of the thousands of pilgrims visiting the Rome of Michelangelo and of his patron, Pope Julius II.

Here, then, within the covers of a small book, is offered an opportunity to look and to ponder in relative quiet. As one might expect from so complex and overpowering a work of art as the ceiling, the number of interpretations cannot easily be counted or classified. Unanimity is far from the rule. There are many mansions in this house; there are many approaches of method; there are almost as many sets of conclusions. No student should expect much of a concensus here except on the level of fundamental premises. As one reads one's way into the subject, opinions start to vary. When faced with the Sistine Chapel ceiling, the alerted reader should expect a challenge to think. It will be necessary to sift opinions as well as to focus upon images.

The selection of critical and art-historical texts and excerpts in this volume respects the differences of approach and conclusions in the vast literature on the ceiling; but it does not stress the gaps between them, nor does it attempt to cover the entire span of writings about the ceiling. The first section of texts is confined to documentation, normally thought of as a drab pursuit of fact but here by no means lacking in fascinating angles. The dispersal and destruction of some of the Renaissance papal archives in the Sack of Rome in 1527 has meant that the detailed history of the painting of the ceiling can never be told, even though the ingenuity of antiquarians and scholars over the centuries has done much to make up for regrettable losses. There are numerous gaps in the story; and, at points, there are still legitimate grounds for disagreement as to what exactly happened—or when it happened, or why.

A first duty, then, is to draw up an inclusive chronological outline, indicating the source of information for each dated event, whether it be a primary document or a later expert surmise based on probability. In the outline of events drawn up here (see pp. xix–xxi), the sources are indicated in parentheses; they range from contempo-

rary documents, letters, and diary entries, to much later estimates of probability by the art historians Wölfflin and Tolnay. Where there is still disagreement among experts, such disagreement is indicated with brief summaries of the positions taken.

Out of the available published contemporary documents on the ceiling—ranging in date between May 10, 1506, and October, 31, 1512—twenty items have been selected for translation into English from the original Italian or, in a few cases, from the original Church Latin. These translations and the accompanying annotations were done especially for this volume in a seminar mentioned below. Then there follows, in English translation also, Michelangelo's famous, ironic "Sonnet to Giovanni da Pistoia" on his difficulties in painting the ceiling, and his letter of December, 1523, to Giovanni Francesco Fatucci, in which the painter details his own later version of the events connected with his work on the ceiling. We next pass to the biographical material that deals with the ceiling in the "authorized" *Life* of the artist by Ascanio Condivi, published in 1553, soon after Vasari's first edition of *Lives of the Artists*, including the famous *Life* of Michelangelo, which had appeared in 1550. Condivi's material, given here in a new translation by Alice Sedgwick Wohl, is fuller on the ceiling than the account in Vasari's first version, and in 1568, when Vasari published his revised and enlarged edition of the *Lives of the Artists*, he included most of Condivi's additions.

In addition to the documents cited above, four items of varying lengths are given in the "Backgrounds and Sources" section. Here, conveniently reprinted in one place, are collateral materials that really must be consulted in order to study the ceiling effectively. First, the stories of Genesis that make up the sequence of nine frescoes of the vault proper are given in the Douay Version of the Bible, translated directly from the Latin Vulgate; the Douay Version has been selected simply because both artist and patron would have used the Vulgate as their main Biblical source. Next, the first chapter of Matthew is given, in the Reims-Douay Version; this provides the primary textual basis for the imagery of the frescoes in the lunettes over the windows. Then, in order to give some idea of the philosophical background, particularly of Florentine Neoplatonism, which has frequently been invoked as a major influence on the imagery of the ceiling, a portion of Giovanni Pico della Mirandola's classic *Oration on the Dignity of Man* is reprinted in translation. Finally, material dealing with the process of fresco painting in the sixteenth century —beginning with the first quick "idea-sketch" and leading through various stages of preparatory work to the actual act of painting—is presented from a number of highly informative passages included by

Vasari in the Introduction to his *Lives of the Artists* mentioned earlier.

It would be possible to provide a very nearly complete outline of Western art-criticism by using the available critical writings on the ceiling alone. The choice of selections for the next section entitled "Criticism and Esthetics" has accordingly been extremely difficult and may seem to some readers arbitrary. Certain principles have, however, been followed. It was decided that the selections should be sufficiently long to represent fairly the substance and the style of each writer. In order to make as much room as possible for the reprinted selections only the strictest minimum of the authors' explanatory or reference notes were to be retained. It was felt that if a student really needed such notes, particularly those of the more scholarly selections, they could be studied in consultation with the original version of the text. The editor also felt that since this anthology is to be used mainly by English-speaking students, emphasis could reasonably be placed on selections originally in English. In the writings on criticism and esthetics, emphasis is placed on the English tradition, beginning with Sir Joshua Reynolds and leading through Ruskin and Pater to Bernard Berenson. This choice eliminates for lack of space the Romantically inclined writings on the ceiling of such giants as Stendhal, Michelet, Goethe, and Burckhardt. However, two excerpts, in English translation, from the writings of a pair of influential critics of the early twentieth century were chosen from French and German writers: Romain Rolland and Julius Meier-Graefe.

Difficulties of choice had been similarly encountered in the selection of art-historical writing under the heading of "History of Art and Ideas." The first, by Heinrich Wölfflin, represents what might be called the classic visual analysis of the ceiling, section by section and part by part. Following in Jacob Burckhardt's steps, Wölfflin produced the first firm basis for a visual approach to the ceiling. A modern analysis based on just as sensitive a visual approach is presented in Sydney Freedberg's writings on the ceiling from his *Painting of the High Renaissance in Florence and Rome*. As an example of contrasting approach that stresses organization of the whole rather than the treatment of its parts, and above all emphasizes the architectonic aspects of spatial composition and illusion, there has been chosen the work of a modern Swedish art-historian, Sven Sandström. Lastly, since this volume is directed toward possible use in general humanities courses as well as in courses in art history, there have been included excerpts from Don Cameron Allen's lively book-length study of the literary and artistic theme of Noah—a subject that occupies, incidentally, no less than one third of the Genesis scenes of the Sistine vault.

Because of technical difficulties concerned with copyright and possible interference with previously issued editions as well as one case of simply too much length, selections from the writings on the ceiling by Frederick Hartt and the late Edgar Wind have been regretfully omitted, and what we had hoped to include from Dr. Tolnay greatly curtailed. However, the Bibliography will provide references to the works of these scholars, which the modern student cannot afford to miss.

The appended Bibliography is highly selective; it is arranged according to topics of study rather than by a single inclusive alphabetical listing of authors.

No one can study the Sistine ceiling today without feeling indebted to Ernst Steinmann's monumental monograph on the Sistine Chapel (1901–1905), and more recently to Charles de Tolnay, whose volume on the ceiling (1945) has now been reissued. The editor adds here his respect and gratitude of many years standing. Debts to other authorities, some of them friends and acquaintances, can be indicated only, by suggestion, in the Bibliography; they are nonetheless very real. I would like particularly to thank Professor Kermit Champa for his excellent suggestion of including the Meier-Graefe passage in the anthology of criticism.

While compiling this volume, the editor had the good luck of being able to meet each week with two small groups of students at Yale University, one on the graduate level, the other on the undergraduate level. During most of the academic year 1968–1969, problems concerning the history and interpretation of the ceiling were worked on and discussed by each group. A number of possible critical and interpretative essays or excerpts from books were tried out. Much was necessarily eliminated, but the choices that have resulted here are due in large part to frank evaluations from the students themselves of the interest and potential usefulness of material that might qualify for reprinting. The editor can only faintly indicate his appreciation to these seminar members at Yale who were able, with remarkable speed, to master the necessary knowledge of detail and who generously gave of their time and enthusiasm well beyond the normal call of academic duty. They are: Gloria Kury Keach, Helen Manner, Adele Richardson, Susan Smith, Jonathan Elkus, Perkins Foss, John Friedman, Harold Mancusi-Ungaro, and Edward Nygren.

For the texts of the *tituli* over the wall frescoes I am indebted to Dr. Rufus Fears and to Professor James Tobin. For the preparation of the manuscript for publication, I would like to thank Mrs. Philip

Baxter and Mrs. Robert Schotta for their faithful typing; and for their care in editing, Miss Carol Flechner, Mr. Robert Farlow, and Mr. H. Stafford Bryant, Jr., all of W. W. Norton & Company, Inc., and Professor Robert Branner. My final word of appreciation goes to those authors and publishers represented in the anthology and sources section who generously gave permission to reprint their work in the form it has assumed here at times abbreviated to save precious space, at times emended to be more representative of their current thinking. I am especially grateful for a prepublication permission from Professor and Mrs. Hellmut Wohl for Mrs. Wohl's translation with her husband's notes of the Condivi selection.

CHARLES SEYMOUR, JR.
*Yale University*

# THE SISTINE CEILING:
# CHRONOLOGICAL OUTLINE

MAY 10, 1506: Michelangelo in Florence. First extant mention of the Pope's interest in Michelangelo's painting the ceiling (Letter).

DECEMBER 19, 1506: Michelangelo in Bologna at work on a bronze statue of Julius II (Letter).

FEBRUARY 13, 1508: Statue finished. Michelangelo ready to leave Bologna (Letter).

MIDDLE OF MARCH, 1508: Michelangelo in Florence (Tolnay).

END OF MARCH or beginning of April, 1508: Michelangelo called to Rome (Tolnay).

MAY 10, 1508: Michelangelo in Rome. Contract for the ceiling signed (*Ricordo*). This contract was probably based on the first plan. Wölfflin placed beginning of work on the ceiling from this date; but, according to Tolnay, the actual painting was not begun until January, 1509, the interim having been spent on preparatory work.

MAY 13, 1508: Michelangelo in Rome; orders pigments from Florence (Letter).

JUNE 10, 1508: Scaffolding being worked on (*Diary* of Paris de Grassis).

JULY 27, 1508: Scaffolding probably in place. Preparation of the ceiling for painting begun (*Ricordo*).

JULY OR AUGUST, 1508: Hiring of five assistants (*garzoni*) for the painting of the ceiling planned (*Ricordo*).

SEPTEMBER 2, 1508: Pigments sent from Florence (Letter).

OCTOBER 7, 1508: *Garzoni* in Rome; one of them, Jacopo di Sandro, dismissed on this date (Letter).

OCTOBER–NOVEMBER, 1508: Michelangelo might have begun painting

about this time, although according to one usual theory, work
started in January, 1509. Painting began at the entrance wall
(Condivi). Confirmed by stylistic evidence.

JANUARY 27, 1509: Work going badly (Letter). Vasari reports that
during the winter, spots of mould appeared on the completed
first third of the ceiling, and Condivi mentions Michelangelo's
having consulted Giuliano da San Gallo about this problem.

JUNE 3, 1509: Sometime prior to this date Albertini, author of a
famous Roman guide-book, saw part of the ceiling.

JUNE, 1509: Michelangelo ill (Letter).

SEPTEMBER 15, 1509: Michelangelo receives payment from the Pope
(Letter). Tolnay interprets this as an indication that the first
part—*i.e.*, the first three histories and accompanying figures
(Prophets, Sibyls, Ignudi, and spandrels)—was done. Wölfflin
feels that the first half was completed by this date. Condivi's
remarks on the unveiling of the first half while the Pope was
in Rome could apply to 1510 as well as to 1509.

JUNE 24, 1510: Michelangelo may have been in Florence for the feast
of St. John (Letter).

AUGUST 17, 1510: Pope leaves Rome after the unveiling of half the
vault (Condivi).

SEPTEMBER 7, 1510: Michelangelo in Rome, ready to start the second
half of the ceiling; complains about the Pope's leaving Rome
without giving him money or instructions (Letter). Wölfflin
interprets this as meaning that the entire vault (histories and
accompanying figures) was completed early in Autumn of
1510; however, Tolnay maintains that only the first half of
the vault, up to and including *The Creation of Eve*, was
done at this point. Michelangelo's letter to Fatucci (Decem-
ber, 1523) does not support Wölfflin's position, nor does Con-
divi's report, that it took twenty months to finish the whole
work. However, if work were started in October, 1508, then
August, 1510, would represent the end of a twenty-two-
month span.

SEPTEMBER 22, 1510: Pope in Bologna.

SEPTEMBER 26, 1510: Michelangelo in Florence (Letter).

LATE IN SEPTEMBER, 1510: Michelangelo in Bologna (Letter).

OCTOBER 26, 1510: Michelangelo back in Rome (Letter).

DECEMBER, 1510, to early January, 1511: Michelangelo in Bologna and
Florence (Letter).

JANUARY 2, 1511: The Pope leaves Bologna on military campaign.

JANUARY 11, 1511: Michelangelo once again in Rome (Letter). Work
begun (?) on the cartoons for the lunettes (Letter to Fatucci,

December, 1523). Wölfflin felt that designs for spandrels, lunettes, and altar pendentives all date from this period; for Tolnay, the spandrels and altar pendentives done at the same time as the histories, and only designs for first eight lunettes date from this period.

FEBRUARY 23, 1511: Work reported temporarily stopped because of delay in payment (Letter).

JUNE 27, 1511: Pope once again in Rome.

AUGUST 14–15, 1511: First unveiling of completed vault (*Diary* of Paris de Grassis). For Tolnay, this means everything except the lunettes, while Wölfflin would also place altar pendentives and spandrels in the last work period.

OCTOBER 4, 1511: Start of the painting of the remainder of the ceiling implied (Letter).

JULY 4–19, 1512: Alfonso d'Este goes up scaffolding to view work in progress (Letter).

JULY 24, 1512: Michelangelo very hard at work on ceiling (Letter).

OCTOBER, 1512: Ceiling finished (Letter).

OCTOBER 31, 1512: Entire ceiling unveiled (*Diary* of Paris de Grassis).

# THE ILLUSTRATIONS

PHOTO CREDITS: Both the editor and publisher are grateful to all who have provided photographs, in particular to the Alinari and Anderson Collections of Florence, Italy; the Detroit Institute of Fine Arts; the British Museum; the Metropolitan Museum of Art; the Cleveland Museum of Art; the Uffizi; and particularly the Vatican Museum.

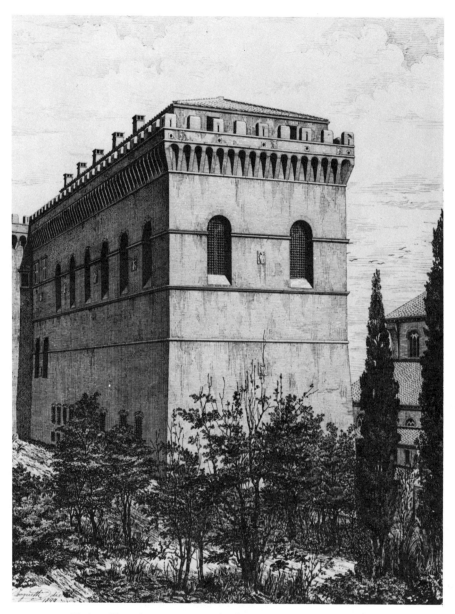

1. Sistine Chapel, reconstructed view, as built (after Steinmann)

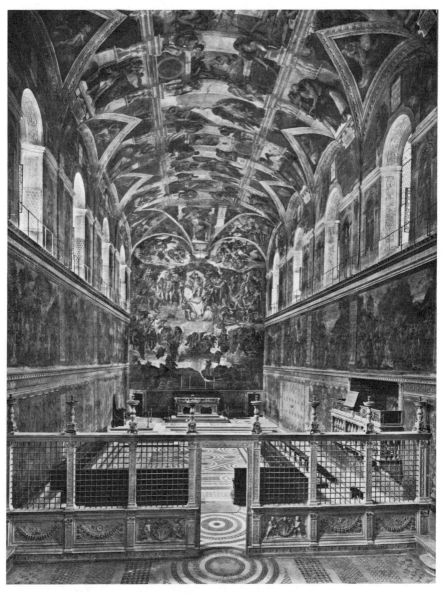

2. Sistine ceiling and interior, from east

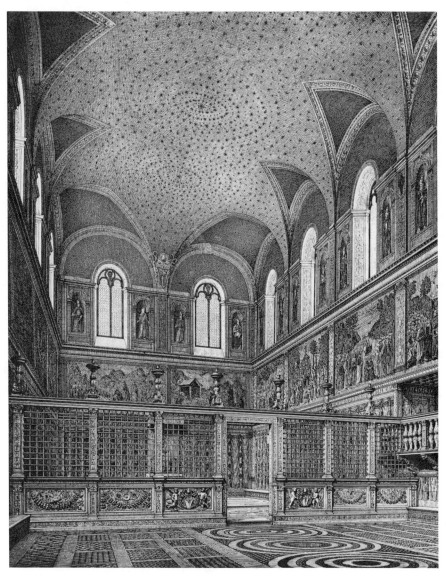

3. Reconstructed view, as of 1508, looking toward altar
(after Steinmann)

4-5. Overall view of ceiling, east to west

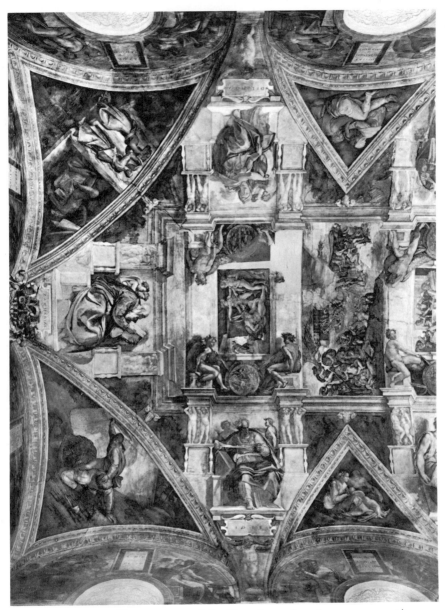

6. Sistine ceiling, eastern end (earliest phase of work, *ca.* 1509–1510)

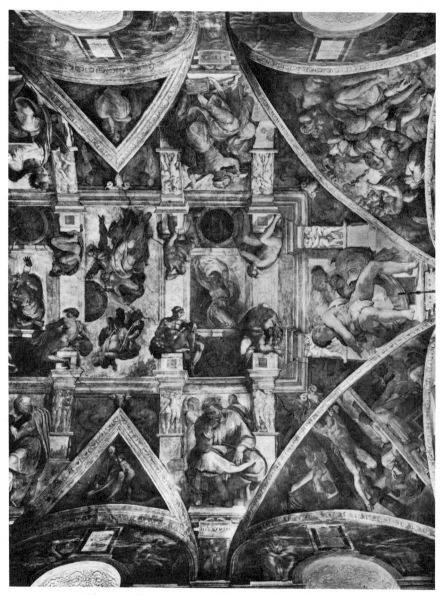

7. Sistine ceiling, western end (later phase, *ca.* 1510–1511)

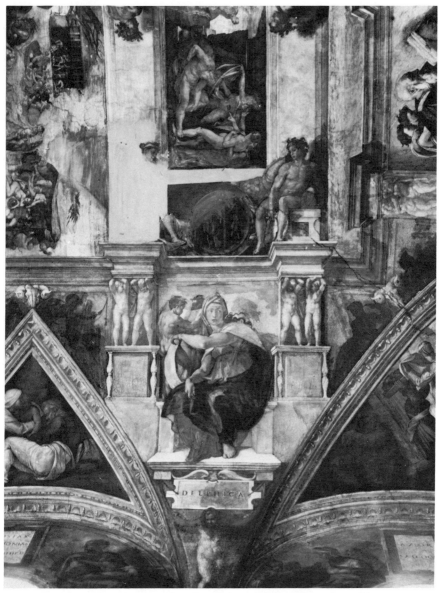

8. Organization of main motives (early phase of work)

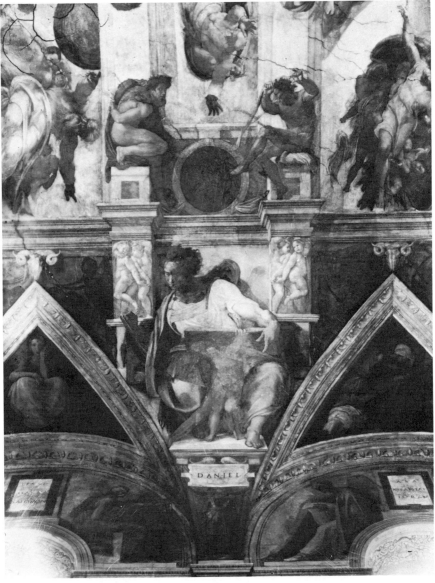

9. Organization of main motives (later phase)

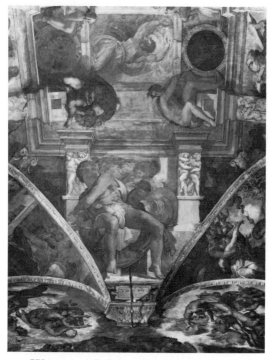

10. Western end (later phase) in greater detail
11. Eastern end (earlier phase) in greater detail

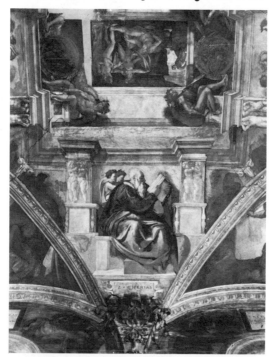

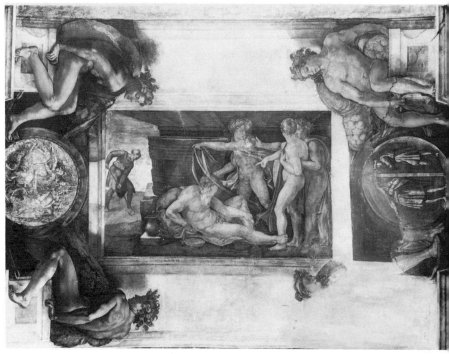

12. *The Drunkenness of Noah* (easternmost history) with Ignudi
13. *The Sacrifice of Noah* with Ignudi

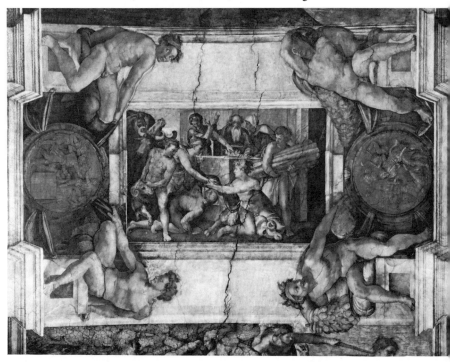

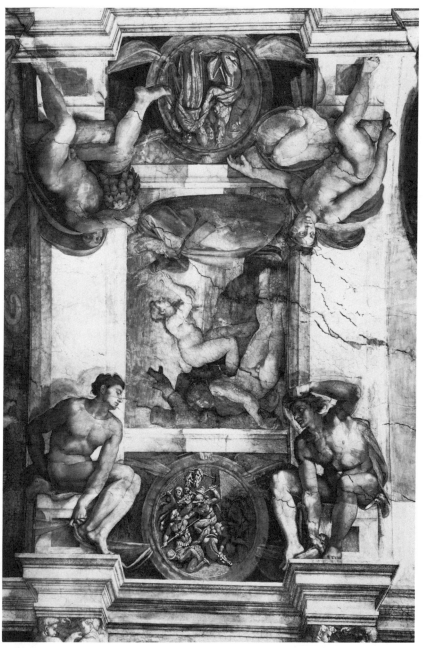

14. *The Creation of Eve* with Ignudi

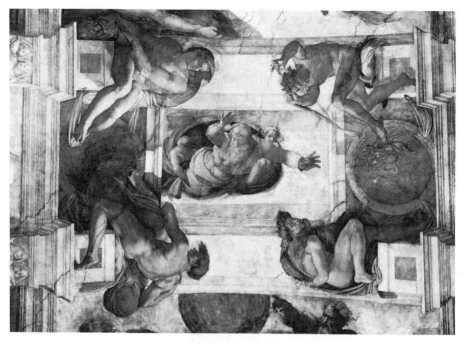

15. *The Congregation of the Waters* with Ignudi

16. *The Separation of Light and Darkness* with Ignudi

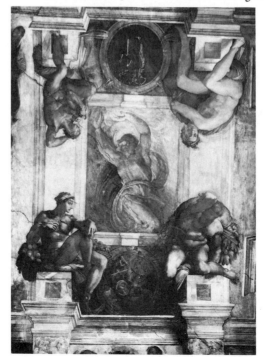

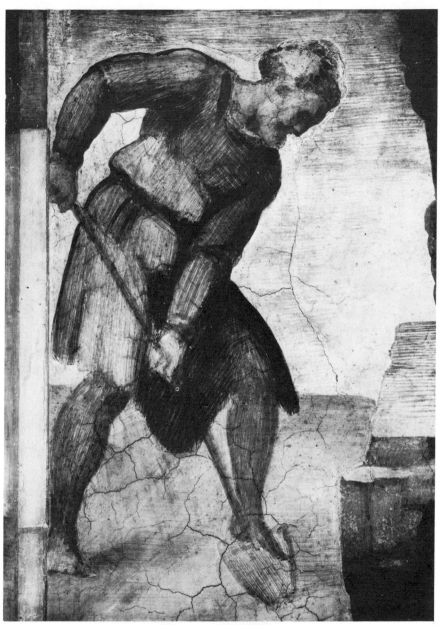

17. Detail of Noah digging from figs. 12 and 18

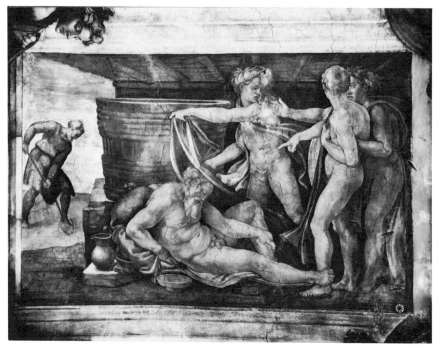

18. *The Drunkenness of Noah*
19. *The Flood*

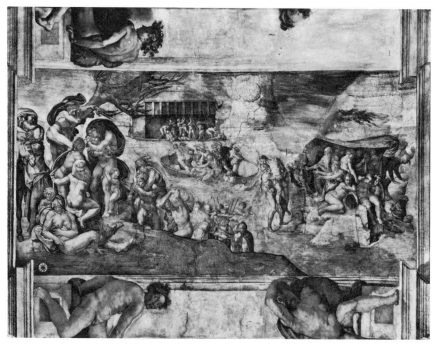

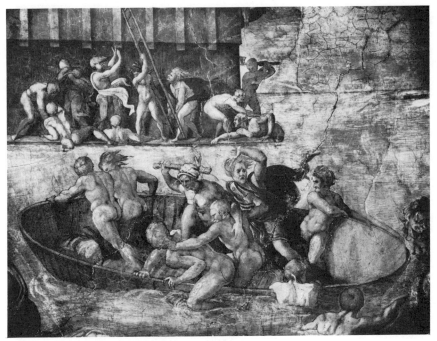

20. Detail of the boat and the ark from fig. 19
21. *The Sacrifice of Noah*

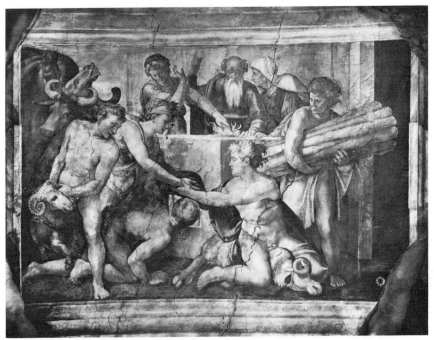

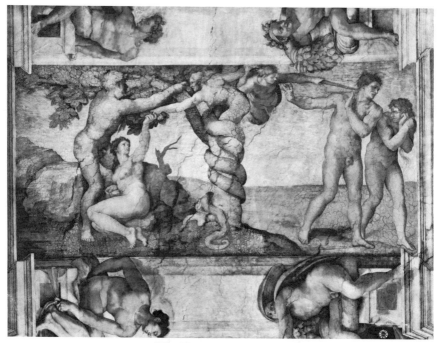

22. *The Temptation and Expulsion*
23. Detail of Adam and Eve from fig. 22

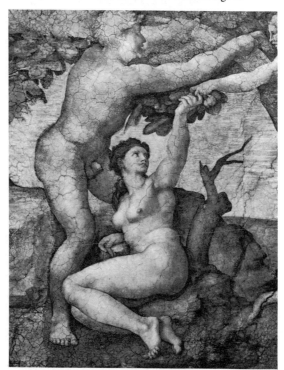

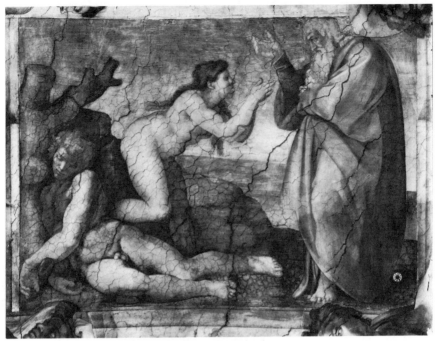

24. *The Creation of Eve*

25. Detail of the Creator from fig. 24

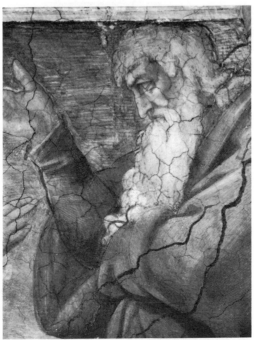

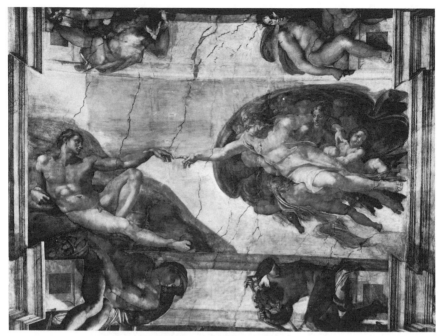

26. *The Creation of* Adam

27. Detail of the body of Adam from fig. 26

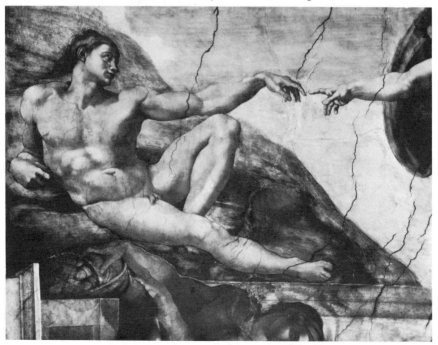

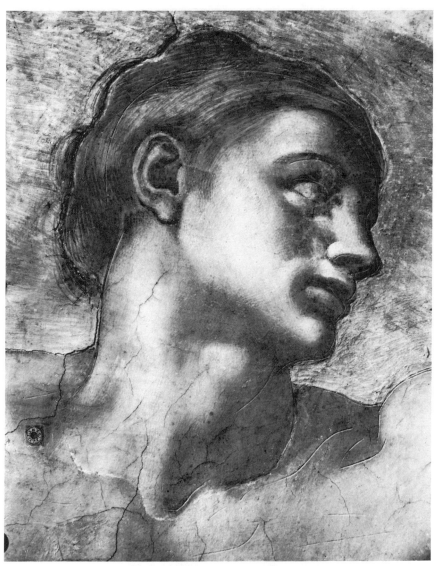

28. Detail of the head of Adam from fig. 26

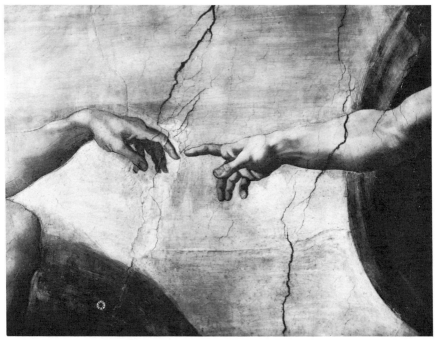

29. Detail of the hands of Adam and God from fig. 26

30. *The Congregation of the Waters*

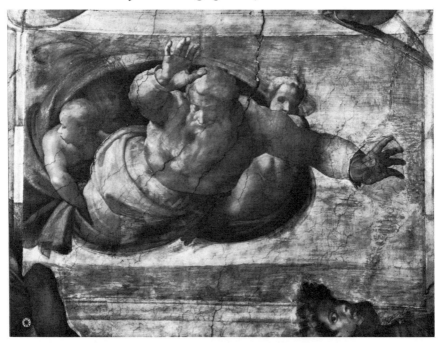

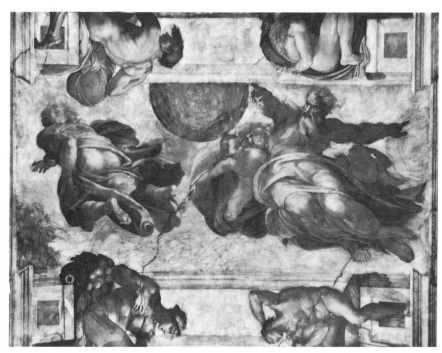

31. *The Creation of the Sun, Moon, and Plants*
32. *The Separation of Light and Darkness*

33. Ignudo (first group), damaged remains

34. Ignudo (first group)

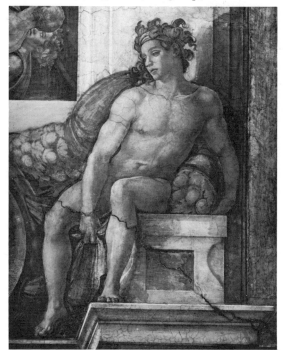

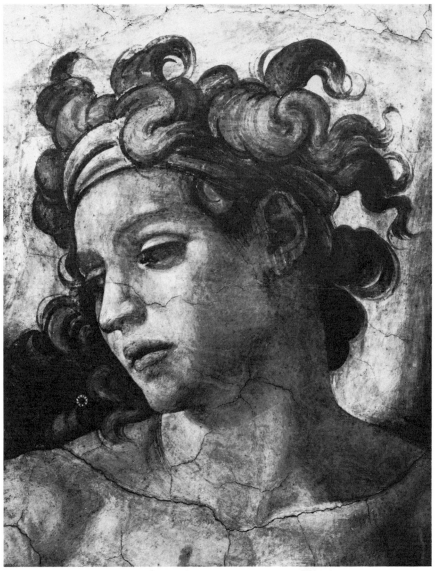

35. Detail of the head of Ignudo from fig. 34

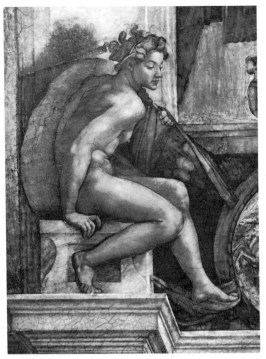

36. Ignudo (first group)
37. Ignudo (first group)

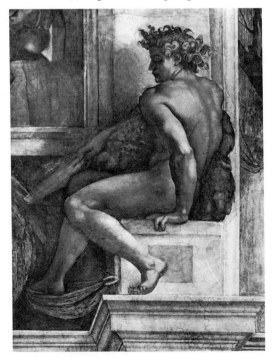

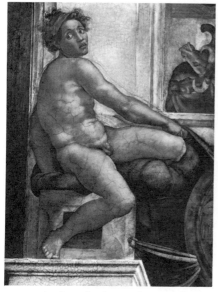

38. Ignudo (second group)

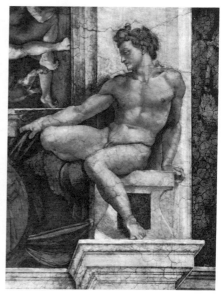

39. Ignudo (second group)

40. Ignudo (second group)

41. Ignudo (second group)

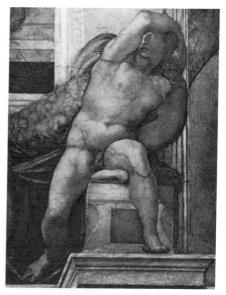

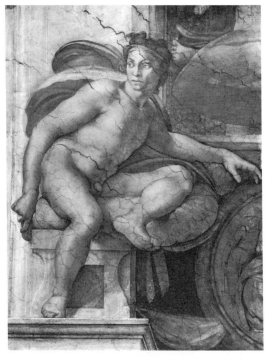

42. Ignudo (third group)
43. Ignudo (third group)

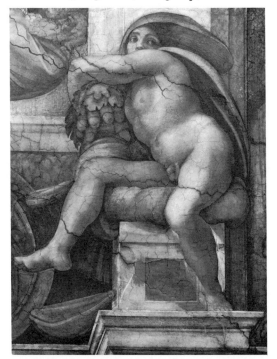

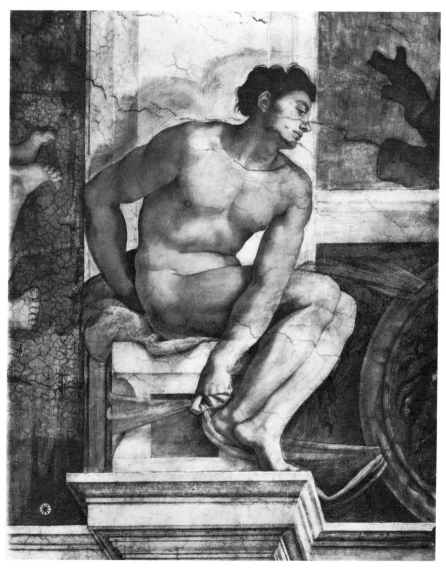

44. Ignudo (third group)

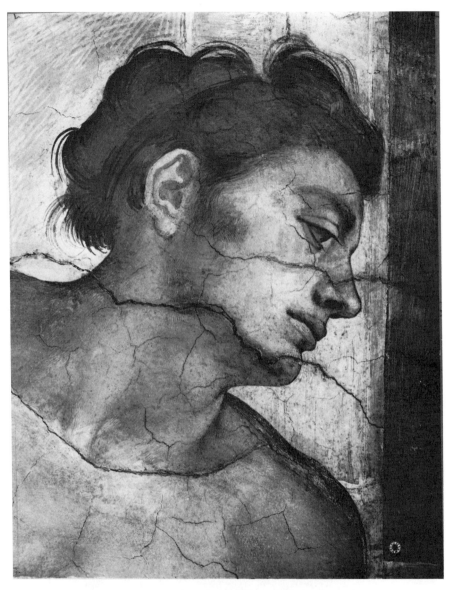

45. Detail of the head of Ignudo from fig. 44

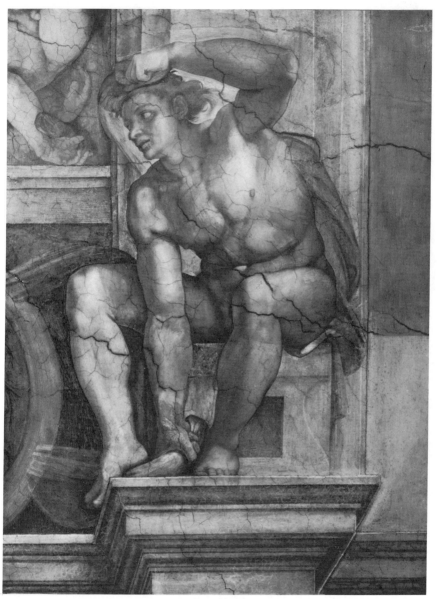

46. Ignudo (third group)

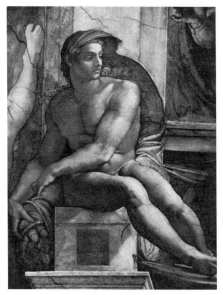

47. Ignudo (fourth group)

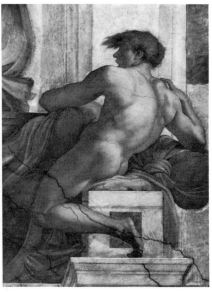

48. Ignudo (fourth group)

49. Ignudo (fourth group)

50. Ignudo (fourth group)

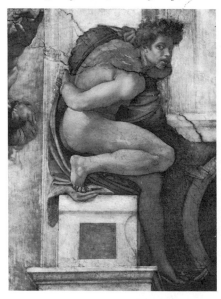

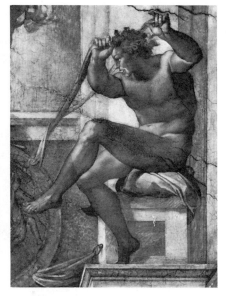

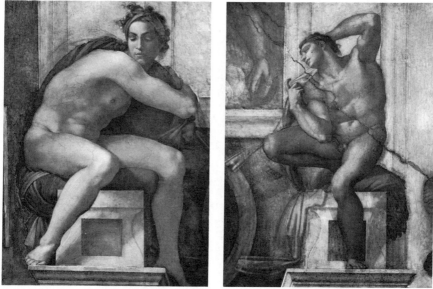

51. Ignudo (fifth group)

52. Ignudo (fifth group)

53. Detail of the head of Ignudo from fig. 52

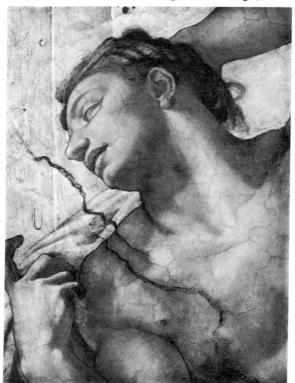

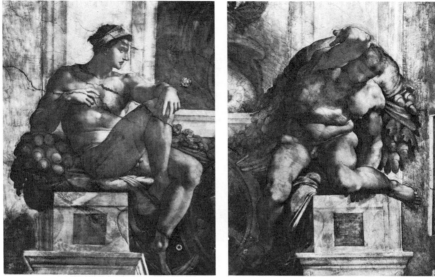

54. Ignudo (fifth group)

55. Ignudo (fifth group)

56. Medallion: *The Destruction of Baal's Image*

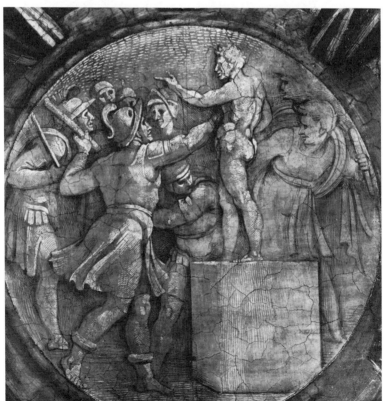

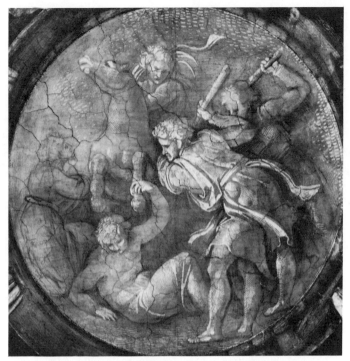

57. Medallion: *The Death of Uriah*

58. Medallion: *The Massacre of the Tribe of Ahab*

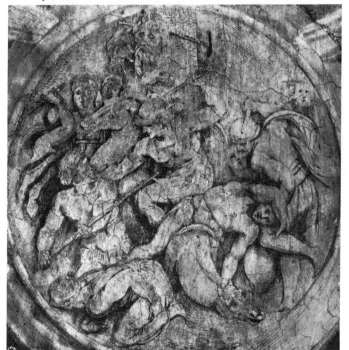

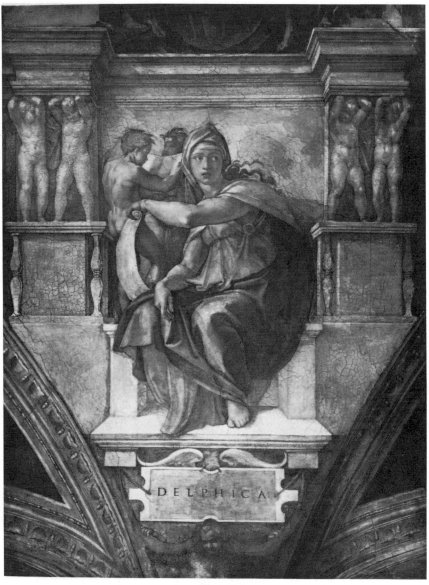

59. Delphica

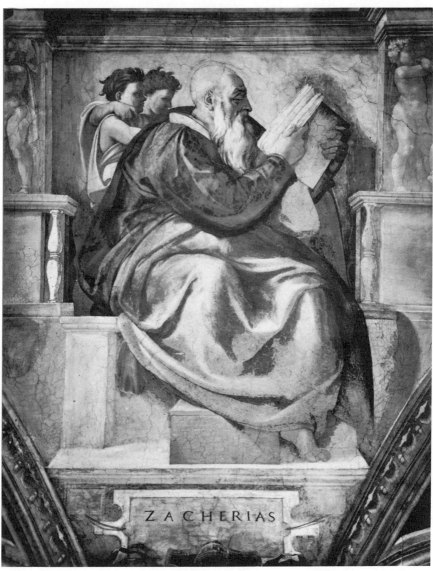

60. Zechariah

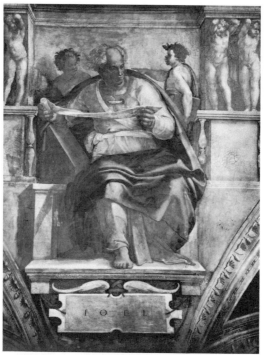

61. Joel
62. Erythraea

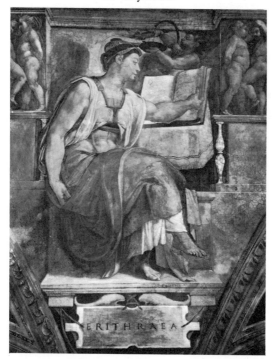

63. Detail showing the curvature of the painted surface of the vault in fig. 62

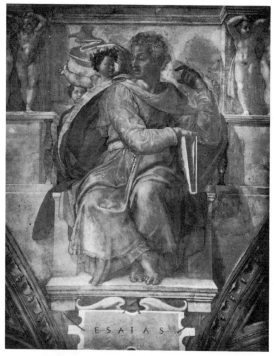

64. Isaiah

65. Detail of a putto, to left of Isaiah in fig. 64

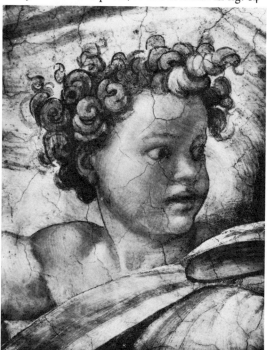

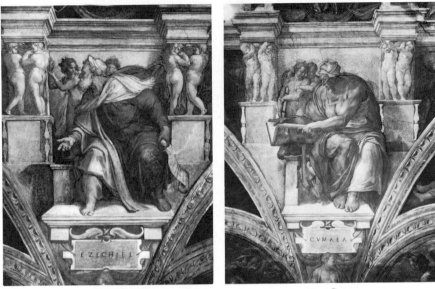

66. Ezekiel

68. Cumaea

67. Detail of the hand of Ezekiel from fig. 66

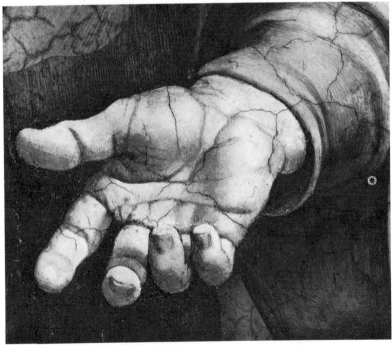

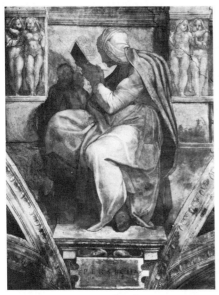

69. Persica

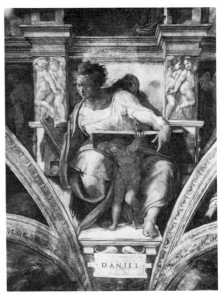

70. Daniel

71. Jeremiah

72. The head of Jeremiah from fig. 71

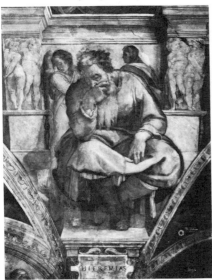

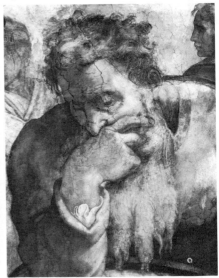

73. The head of Libyca from fig. 74

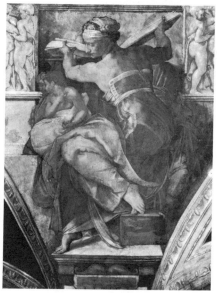

74. Libyca

75. Jonah

76. Putto under Delphica (early phase)

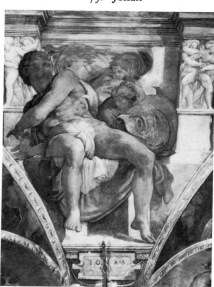

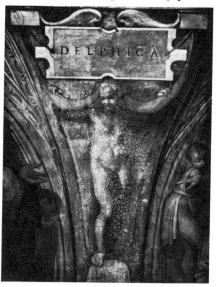

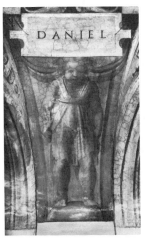

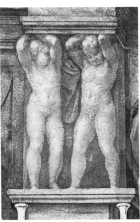

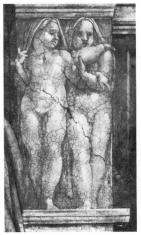

77. Putto under Daniel (later phase)

78. Putti beside Delphica (early phase)

79. Putti beside Persica

80. Putti and Bronze Nudes over *David and Goliath* (early phase)

81. Putti and Bronze Nudes over *The Brazen Serpent* (later phase)

82. Pendentive: *Judith and Holofernes*

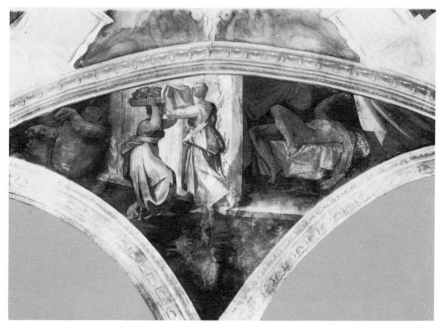

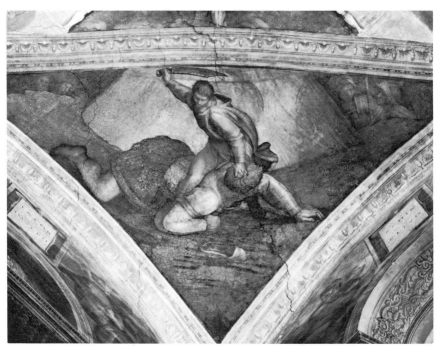

83. Pendentive: *David and Goliath*
84. Pendentive: *The Hanging of Haman*

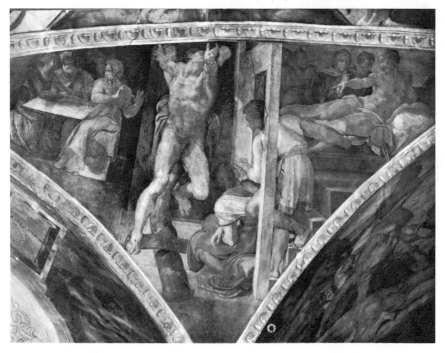

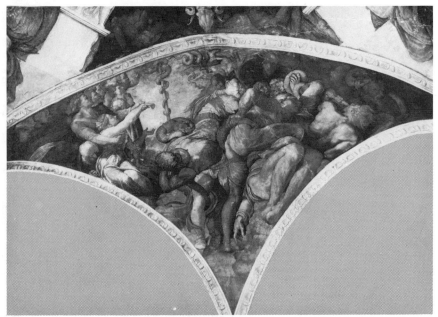

85. Pendentive: *The Brazen Serpent*

86. Spandrel: Zorobabel

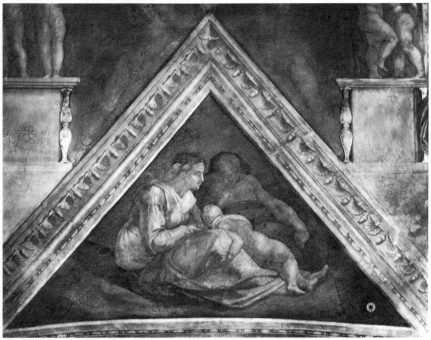

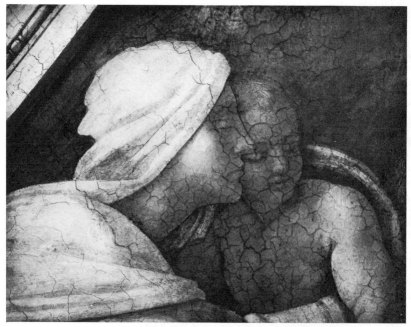

87. Spandrel: Detail of heads from Josiah

88. Spandrel: Ozias          89. Spandrel: Ezekias

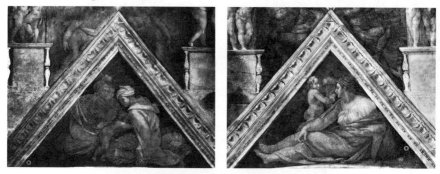

90. Spandrel: Roboam

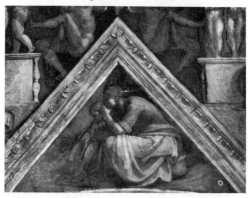

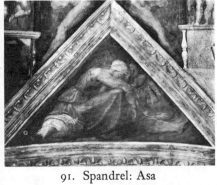
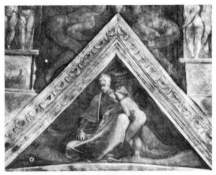

91. Spandrel: Asa

92. Spandrel: Solomon

93. Spandrel: Jesse

94. Detail of the framing and surround-
ings of Zorobabel in fig. 86 (early phase)

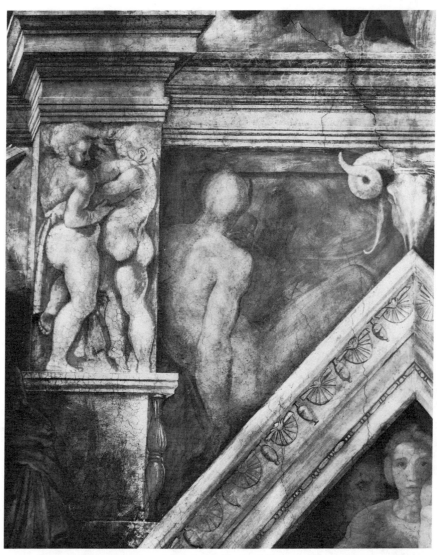

95. Detail of the framing and surroundings of Jesse in fig. 93 (later phase)

96. Lunette: Eleazar and Matthew
97. Lunette: Jacob and Joseph

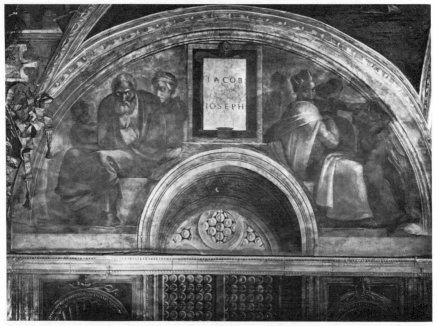

98. Lunette: Azor and Zadoch
99. Lunette: Abiud and Eliakim

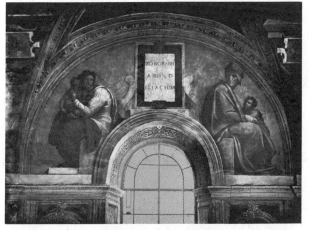

100. Lunette: Achim and Eliud

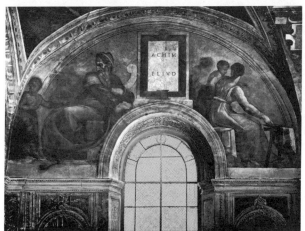

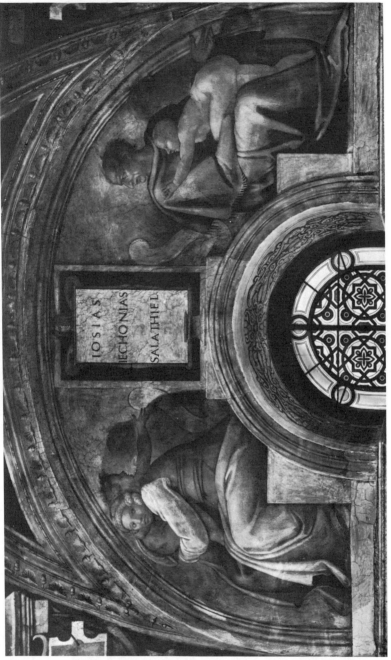

IOSIAS

IECHONIAS

SALATHIEL

101. Lunette: Jechomas and Salathiel

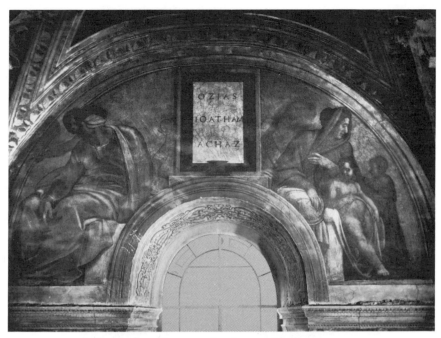

102. Lunette: Joatham and Achaz
103. Lunette: Manasses and Amon

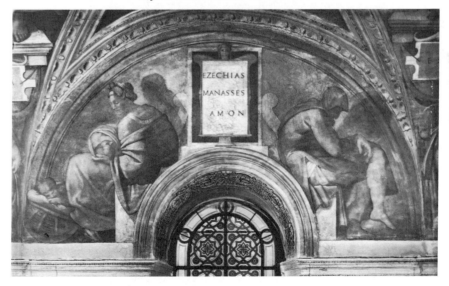

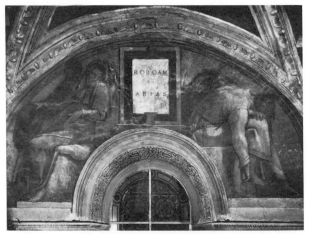

104. Lunette: Abiah
105. Lunette: Josaphat and Joram

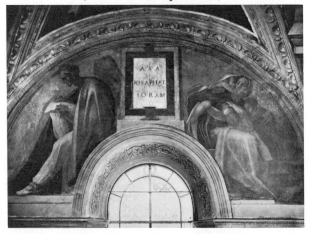

106. Lunette: Boaz and Obed

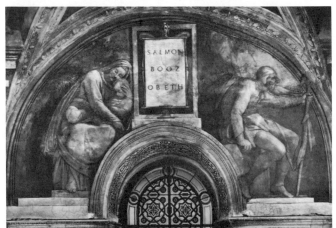

107. Lunette: David and Solomon

108. Lunette: Aminadab

109. Lunette: Detail of Matthew from fig. 96

110. Lunette: Detail of Abiah from fig. 104

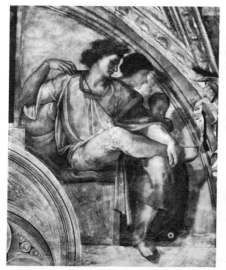

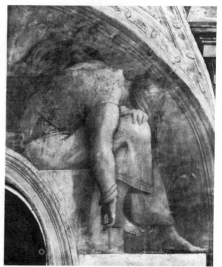

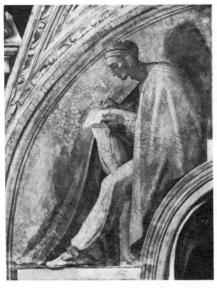

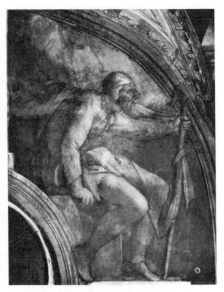

111. Lunette: Detail of Josaphat from
fig. 105

112. Lunette: Detail of Obed from
fig. 106

113. Lunette: Detail of Naason

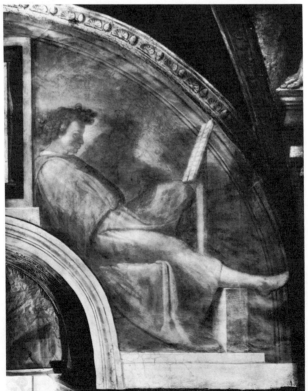

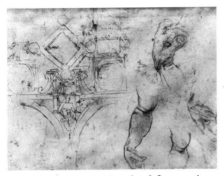

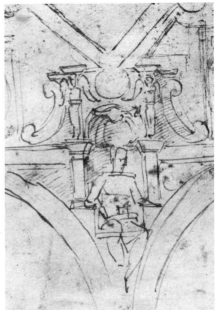

114. a) Drawing: Sketch of first project and studies for Adam, British Museum

b) Detail of sketch of first project

115. Detail of sketch for second project, Detroit Institute of Fine Arts

116. Drawing: For a nude, British Museum

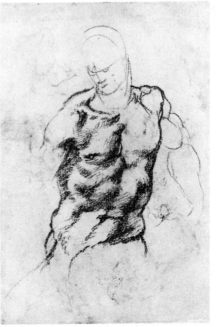

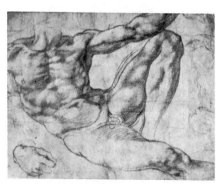

117. Drawing: For Adam, British
Museum

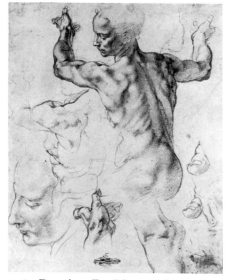

118. Drawing: For Libyca, Metropolitan
Museum of Art

119. Drawing: For Haman, British
Museum

120. Drawing: For Ignudo, Cleveland
Museum of Art

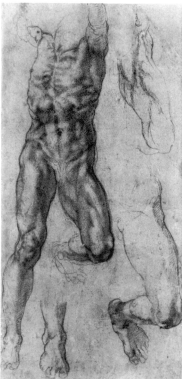

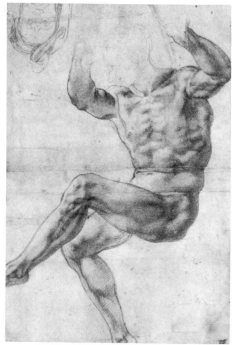

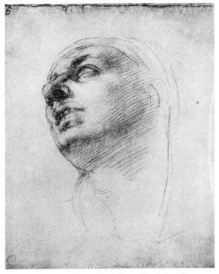

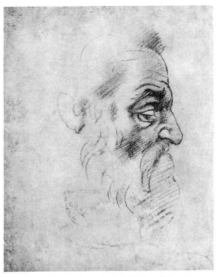

121. Drawing: For Jonah (?), Casa
Buonarroti

122. Drawing: For Zechariah (?),
Uffizi

123. Drawing (verso of preceding): For Eve
(see fig. 23) and reclining male figure (Adam?),
Uffizi

124. Drawing: For Ignudo, Uffizi

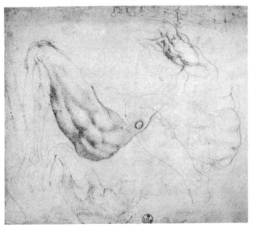

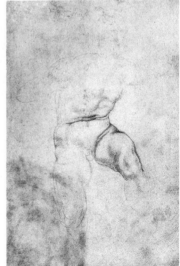

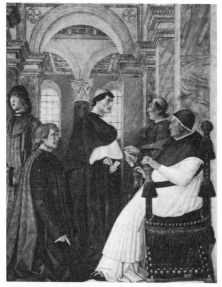

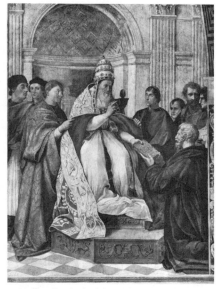

125. Melozzo da Forli: Detail of *Sixtus IV with Cardinal Giulio della Rovere*, Vatican

126. Raphael (with assistant): *Julius II as Lawgiver* (Gregory IX), Vatican

127. Raphael: *Michelangelo (ca. 1510) as Democritus*, Vatican

128. Piero di Cosimo: *Giuliano da San Gallo*, Mauritshuis, The Hague

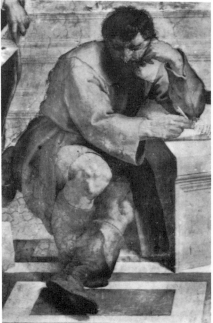

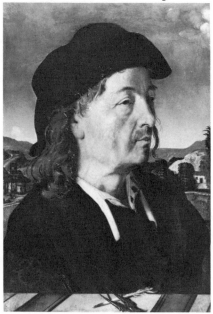

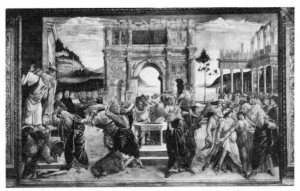

129. Botticelli: "Conturbatio Moisi" with *The Punishment of Korah* (1481–1483), Sistine Chapel (recently cleaned state)

130. Perugino: *The Stoning of Christ* with *Christ's Charge to Peter* (1481–1483), Sistine Chapel

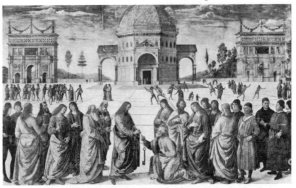

131. Michelangelo: *The Doni Madonna* (*ca.* 1504), Uffizi

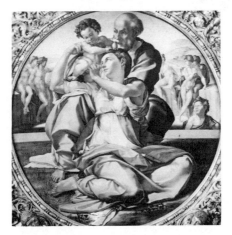

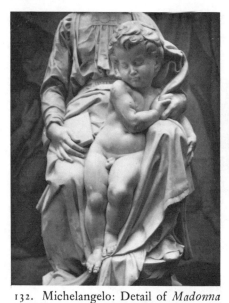

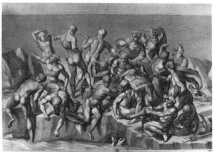

133. Michelangelo: Main elements of design in *The Battle of Cascina*, from an engraving after the lost cartoon

132. Michelangelo: Detail of *Madonna and Child* (*ca.* 1504), Notre-Dame, Bruges

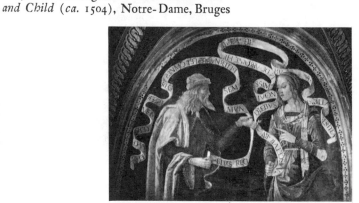

134. Pintoricchio (assistant): The Prophet Daniel and The Erythraean Sibyl (*ca.* 1495), Borgia apartments, Vatican

135. Pintoricchio: Detail of the Delphic Sibyl in the vault of the choir of S. Maria del Popolo (*ca.* 1508), Rome

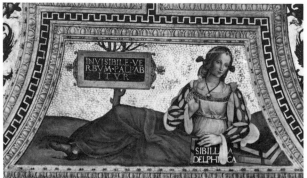

136. Pintoricchio: Vault of the choir of
Maria del Popolo, Rome

137. Arch of Constantine, Rome

138. The *Belvedere Hercules*, torso,
Vatican

139. Florentine, fine manner engraving:
Cumaean Sibyl (*ca.* 1480)

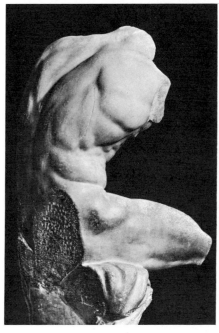

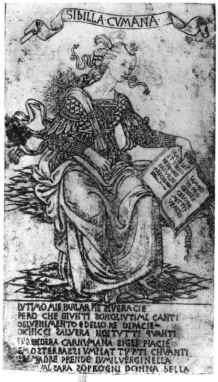

140. Michelangelo: Autograph of "Sonnet to Giovanni da Pistoia," with caricature of the artist at work on the Sistine (*ca.* 1510), Casa Buonarroti

# MICHELANGELO AND THE
# SISTINE CHAPEL CEILING

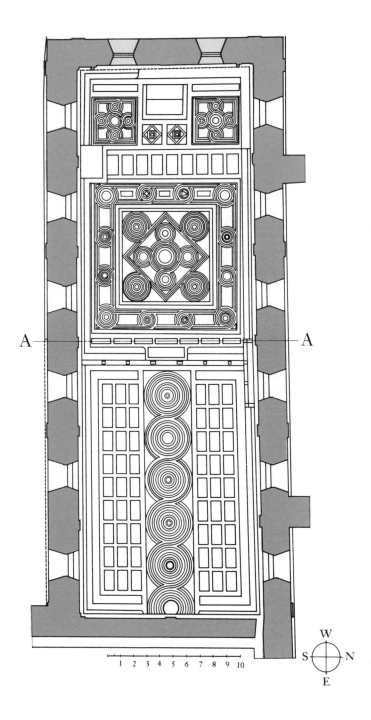

W
S ⊕ N
E

1 2 3 4 5 6 7 8 9 10

*D*URING the course of the fifteenth century the popes' main Roman residence shifted from the Lateran Palace, situated in an exposed location among the ruins of ancient Rome, to the Vatican. Here, protected by the huge mass of the Castello Sant' Angelo, which guarded the access to the Vatican Hill from across the Tiber, there had grown up a well-planned suburb, the Borgo Leonino named after Pope Leo the Great. This was an area sufficiently small to be defensible yet sufficiently large to include a vast pilgrimage-church (the Basilica of St. Peter's), a hospital, a prison, and finally, housing for all but the most affluent members of the Curia, who for the most part lived across the Tiber in palaces of their own choosing or building.

Under the scholarly Pope Sixtus IV, of the della Rovere family, the Vatican Library was strengthened as an instrument of humanistic as well as religious learning. Sixtus also built a new papal Chapel strong as a fortress (exterior, fig. 1; plan, text fig. 1), had its interior painted, and gave it the name it has borne in history: the Sistine. As has been often noted in the literature, a poem of 1477 calls Sixtus the "author" of the scheme—not only of the building but of the program of its decoration then in the stage of planning. When Sixtus' nephew, Giuliano della Rovere, became Pope in 1503 he took the name of Julius II, similar to his own given name but resonant with overtones of Roman history. He proceeded without delay to continue the "renovation," or "restoration" as it was then called, of the capital of Western Christendom. With the perspective of time it is possible for us to see that as an urbanist he was careful to continue the policy of his uncle. He concentrated on the Borgo and its connecting links of communication with the city and its pilgrimage centers. But he went much further in commissioning from his chief architect, Bramante, not only the new and splendid courtyard of the Belvedere adjacent to the Vatican Palace, but a whole new colossal St. Peter's to house his tomb. This last was commissioned as early as 1505 from the then-still-rising Flor-

*Text fig. 1. Plan of the Sistine Chapel, ca. 1506 (after Steinmann).*
*At A: the original site of the marble screen separating the*
*"nave" from the "presbytery" of the chapel.*

entine sculptor Michelangelo Buonarroti, who dropped an important fresco commitment in Florence and enthusiastically went to work not only on a grandiose design for the tomb but on the collecting, under his personal supervision, of marble blocks in the quarries near Carrara from which he would carve the statuary planned for it.

Somewhere along this chain of logically planned events there occurred a minor disturbance, a change which at first was apparently minimal but which was ultimately to have reverberating importance for the whole history of Western art. Someone—it is not known precisely who, or precisely when—appears to have suggested that Pope Julius finish off in a more elaborate way the ceiling of his uncle's papal Chapel, the walls of which had been decorated with frescoes of corresponding scenes from the Old and New Testaments by a group of painters under the general leadership of Pietro Perugino and including such well-known names as Domenico Ghirlandaio, Sandro Botticelli, and Luca Signorelli, as well as Bartolommeo della Gatta and Cosimo Rosselli (text fig. 2). The *quattrocento* ceiling rose on spandrels and pendentives over a series of painted standing figures on niches representing Christ with St. Peter and St. Paul and the first thirty sainted popes from Linus to Marcellus I. The original ceiling-scheme represented a star-studded heaven, quite appropriate as a fictive celestial environment just above the saintly papal figures (as in text fig. 3). The altar wall, its central feature being the altarpiece of *The Assumption of the Virgin* (to whom the papal Chapel was dedicated under Sixtus IV), which was between two overpainted frescoes of *The Nativity of Christ* and *The Finding of Moses*, would have presented a scheme similar to that which may be seen in the drawing reproduced in text figure 3. A preparatory design in color for the first ceiling is still in existence in the Uffizi. The effect of the blue color of that ceiling with its sprinkling of gilt stars might well have been pleasantly decorative; it might even have suggested the illusion of somewhat greater height than what we see today. But it could hardly have created in any sense a visual climax to the history frescoes on the walls below, or an overarching plastic scheme unifying the fictive architecture of pilaster strips and lintels surrounding the histories or of the nichelike elements setting forth the papal images above them.

The designer of this first or *quattrocento* ceiling was a former assistant of Fra Filippo Lippi named Permatteo d'Amelia. By 1505 he would have belonged to a generation of artists that had outlived their

*Text fig. 2. Location (by subject and artist) of the fifteenth-century frescoes.*

| | | |
|---|---|---|
| GHIRLANDAIO<br>*Resurrection*<br>*—Ascension* | Entrance Wall | SIGNORELLI<br>*The Fight for the Body of Moses*<br>(repainted) |
| ROSSELLI<br>*The Last Supper*<br>*—Agony in the Garden*<br>*—Betrayal*<br>*—Crucifixion* | | SIGNORELLI<br>*The Last Acts*<br>*The Death of Moses* |
| PERUGINO<br>*Christ's Charge to Peter*<br>*—Tribute Money*<br>*—The Stoning of Christ* | | BOTTICELLI<br>*The Punishment of Korah and*<br>*the Sons of Aaron*<br>*The Stoning of Moses* |
| ROSSELLI<br>*Sermon on the Mount*<br>*—The Healing of the Leper* | | ROSSELLI<br>*The Giving of the Law*<br>*Adoration of the Golden Calf* |
| GHIRLANDAIO<br>*The Calling of the First Apostles* | | ROSSELLI<br>*The Crossing of the Red Sea* |
| BOTTICELLI<br>*The Three Temptations*<br>*—Old Testament Sacrifice* | | BOTTICELLI<br>*Moses in Egypt and Midian* |
| PERUGINO<br>*The Baptism*<br>*—St. John Preaching*<br>*—St. John on His Way to*<br>*the Jordan*<br>*—Christ Preaching* | | PERUGINO-PINTORICCHIO<br>*The Circumcision of Moses' Son* |
| PERUGINO<br>*Nativity* | Altar Wall | PERUGINO<br>*The Finding of Moses* |

PERUGINO
*Assumption*

fame and, hence, their usefulness to the patron of the New Order in Rome. Moreover, figures were evidently wanted for the new ceiling—heroic figures placed in an architectural setting of sorts that would both visually enrich the broad expanse of the vault and pendentives and would also carry out the structure of the painted interior walls.

Thus there was to come into being perhaps the most complex and

*Text fig. 3. Altar wall in 1483 (after Wilde).*

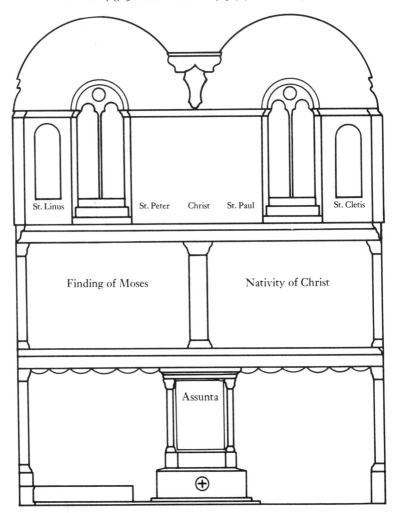

certainly the most grandiose program of painting that is to be found in the entire history of Western art. It was a program that was to delve deeply back into the Christian traditions of the Middle Ages and beyond them into the era of Greco-Roman and Hebraic antiquity. It was also, for its own age, strikingly modern in style, and in the future it was to provide up to our own present a standard of excellence never superseded.

Before we examine the stages of designing that led up to Michelangelo's ceiling as we know it today (figs. 4–5), it would be wise to try to account for the desirability of a new design to replace the one approved by the Pope's uncle, and for the choice of the artist to do this new work.

Reasons for the desirability of the new ceiling decoration have been put forward speculatively for some time; and there is, quite honestly, no reason today to feel any more historical certainty on this matter than before. But equally, if we go back in imagination to the years around 1500 and to the stylistic changes then coming into being in Italy (and particularly in Rome itself), the decision to scrap an older scheme and substitute for it a more "modern" one should not seem at all surprising. The idea of the starry-sky ceiling had had a very long history in Italy. It is to be found in Padua, in the Scrovegni Chapel (see *Giotto: The Arena Chapel Frescoes*, by James Stubblebine, one of the volumes that has already appeared in this series). In the vaults of his cathedral at Pienza, anachronistically Gothic in style, it was used by direction of Pope Pius II not long before it was ordered, or at least approved, by Pope Sixtus IV for his chapel in Rome. This type of ceiling decoration was, to be sure, more than merely time-honored. It had an aura of papal tradition. For Pope Julius, it was also extremely conservative; it belonged to the "Gothic" past, and Julius was involved with creating the future.

In the course of the last part of the fifteenth century and early sixteenth century new ceiling-types had come into prominence in Rome. For one, the Florentine architect-sculptor Giuliano da San Gallo had designed a daring wooden-coffered ceiling, with a marvelously plastic effect over a huge span, above the nave of the Roman basilica of S. Maria Maggiore. A painted vault with illusionistic architectural motives of similar power was evidently completed by Pintoricchio, the former painter of the Borgias. This was for the choir of S. Maria del Popolo, and it was completed at just about the time Michelangelo was to begin work on the Sistine ceiling (fig. 136). The date is far from certain, but the chances are that the planning for the work in S. Maria del Popolo went back somewhat earlier than the period of September, 1508–May, 1509, recently estimated for the S.

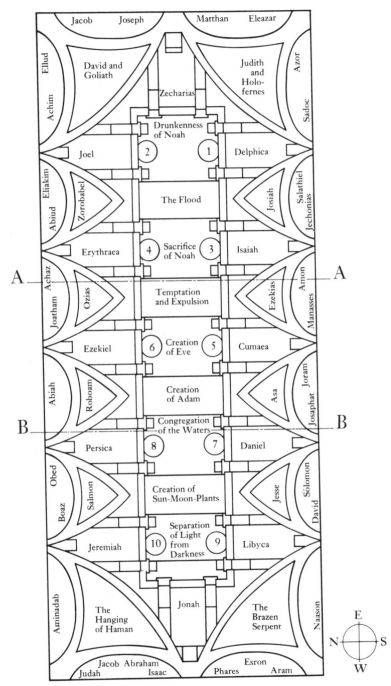

Maria del Popolo project (see p. 209). It is worth remembering that the family of Pope Julius, the della Rovere, were also patrons of S. Maria del Popolo. The lack of architectonic value in Permatteo d'Amelia's earlier treatment of the ceiling of the Sistine has already been mentioned. That earlier solution might be called "poor" or "mean" in a visual as well as an historical sense, and there is evidence in Michelangelo's letter to Fatucci, written years after the event, that Pope Julius wanted to avoid in the ceiling any effect that might, through lack of gilding or some other device, be considered "mean" (*povero*).

Why and when Pope Julius finally decided to entrust the new ceiling of the Sistine to Michelangelo are facts that remain painfully elusive. We simply don't have these facts, and we are never likely to have the evidence needed for a solid opinion. Thanks largely to Condivi and to Vasari, there is still current the wild idea that Bramante, eager to advance into papal favor his fellow townsman, Raphael of Urbino, pushed Michelangelo's name as a candidate for the extremely difficult job of painting the ceiling in the hope of his failure (and meanwhile deferring Michelangelo's almost certain success as sculptor of Pope Julius' tomb).

The evidence that Bramante had sunk to such miserably jealous behavior is to be found only in sources inspired by Michelangelo himself. The story is improbable and hardly fits into what is known otherwise of Bramante's character. Moreover, in 1505, Raphael was still at least three years away from his departure from Florence and journey to Rome and so could not yet have been much of a factor in Roman artistic politics. So we are left with the strongest possibility that over the years Michelangelo's own brooding mind built up from memories of numberless difficulties and disappointments in connection with both the ceiling and the tomb a kind of scapegoat for his frustrations—not in the person of Pope Julius as we might expect, but in that of Bramante. For Bramante had also left him almost insuperable problems as his predecessor in the building of St. Peter's.

In a letter of May 10, 1506, we see the first evidence that Michelangelo had been considered as the painter for the ceiling (see p. 102). It was written from Rome by a master mason who was evidently on

*Text fig. 4. Location of the principal subjects of*
*Michelangelo's ceiling and progress of work on the vault,*
*1508–1512. The first third of the vault (from the top to A)*
*was completed by September, 1509, and the remaining two thirds*
*(from A to B and from B to the bottom) by August, 1511.*

familiar professional terms with Bramante and on very friendly terms with Michelangelo, then in Florence, to whom the letter was addressed. The tone of the letter is familiar and gossipy. Bramante admittedly does not come off very well. But he is hardly revealed as the villain of the piece. Quite evidently at this date, Pope Julius had already decided on the repainting of the Sistine Chapel ceiling. He had also selected Michelangelo as his candidate for the job—regardless of the earlier commission for his tomb. Bramante is called in for consultation after the Pope's dinner and is shown as being uncomfortably squeezed by two strong pressures. On the one hand it is obvious that Pope Julius wants Michelangelo very much as the painter of the new ceiling. On the other hand, as Bramante evidently knows quite well, Michelangelo is fighting not only the ceiling commission but also the tomb. Bramante, according to this letter, actually counsels the Pope against continuing to try and persuade Michelangelo to take on the ceiling. He questions Michelangelo's lack of experience, not of fresco painting as such but of designing figures in foreshortening, which Bramante thought necessary for any ceiling decoration. He also raises the question as to whether Michelangelo would have "the courage" to take on so huge a task. Whether Bramante actually used these words or not in speaking to Pope Julius we cannot tell, but certainly something of the sort was transmitted to Michelangelo in Florence. Perhaps the slur was exactly what was needed to push him over once again into Pope Julius' camp. Perhaps this reported insult was the beginning of the feud with Bramante and his memory, which lasted certainly as late as 1550–1553, when Michelangelo gave his strongly anti-Bramante version of the commissioning of the ceiling's painting to Condivi.[1]

There is one more aspect of that all-important letter of May 10, 1506, that deserves attention. It is evident from the letter's opening that Pope Julius had hoped to enlist the aid of Giuliano da San Gallo in persuading Michelangelo to come back to Rome and to work on the ceiling. Giuliano (brother of Antonio da San Gallo the Elder, father of Francesco da San Gallo, and uncle of Antonio the Younger) should need no lengthy introduction here. He had worked in Rome, Ostia, and Loreto in the service of the Church as an architect of high distinction. He was also a sculptor—and a Florentine—as well as a close friend of Michelangelo's. It was he who evidently had been entrusted with the delicate responsibility of moving the colossal marble *David* in 1504 from the sculptors' yard near the Cathedral in Florence to the Piazza della Signoria where it was to stand. It was he who was

1. See the passage in Condivi's *Vita* and Professor Wohl's note on p. 114.

later to be called in early in 1509 to advise Michelangelo on the disheartening crisis of a mould which had appeared on the surface of the frescoes he had just begun on the ceiling.

If the relationship between Michelangelo and Giuliano da San Gallo is fairly clear to us, the same cannot be said of Bramante's relationship to either of the two artists. On the whole, as of May, 1506, Bramante appears not so much as a rancorous intriguer, as he was later to be made to seem. He is the tired and perplexed administrator in charge of a great number of complicated commissions, who is now in the process of losing patience with the temperamental indecision and all-too-easily-hurt feelings of Michelangelo. Far from trying to load on Michelangelo's shoulders the Herculean task of painting the ceiling, Bramante, in speaking to the Pope in 1506, is evidently trying to find a way to persuade him that Michelangelo would be a bad choice for the job—if indeed the job was to be done promptly and efficiently. One can hardly blame him for that.

The relationship between San Gallo and Bramante was probably even more ambivalent and also more critical. San Gallo was, up to 1506–1507, Pope Julius' trusted architectural favorite in Rome. He had designed Julius' cardinal's palace in Rome as well as the splendidly strong *Rocca*, or fortress, at Ostia—and it should not be forgotten that Julius II had been Bishop of Ostia. One has the feeling that Bramante was displacing a very unwilling former favorite, one who would have very much liked to have had Bramante's place in the creation of Pope Julius' New Rome. The jealousy, then, is more likely to have been in 1506 between Bramante and San Gallo than between Bramante and Michelangelo. Michelangelo does not appear at first as Bramante's enemy but rather as San Gallo's friend. Ultimately, one can easily imagine that these rather fluid relationships hardened into two rival camps: on the one hand Michelangelo, the painter, with San Gallo, the architect; and on the other, Bramante, the architect, with Raphael, the painter. It is this latter situation that has entered the history books; but it is patently not true for the critical moment in the ceiling's history that we are now discussing.

The myth revolving around the Bramante-Michelangelo rivalry has been nourished through the years by a misunderstanding of Michelangelo's role as a painter. True, he usually signed himself *"Michelangniolo schultore"*; but this did not mean much more than that sculpture was for him a primary professional interest among several. (Pisanello, today remembered mainly as a medalist, signed himself *"opus Pisani pictoris"*—in other words as a painter—on the very medallions which proclaimed his outstanding talent in quite another field.) Much also has been made of the final line of Michelangelo's "Sonnet

to Giovanni da Pistoia," written in satiric style as a mock-complaint during the period he was painting the ceiling in Rome:

> I'm not in a good place, and I'm no painter.[2]

Of course, he was actually in a very "good place" in the eyes of the world—working on the largest painting commission of the time under the greatest patron of the age. And in the eyes of the world he was not merely a painter, but a painter with no clear superior, at least at the moment. One should not lose track of the fact that at the time Michelangelo left Florence to work for the Pope in Rome, he was engaged on equal terms with no less a painter than Leonardo da Vinci to make a fresco, on a huge scale, in the Great Hall of the Council in the Florentine center of government. Michelangelo was a republican in politics, and the Florentine commission which he had given up—or at least postponed—in order to go to Rome might have seemed, at times, more worthy in a moral sense than the work that he was committed to finish for the Rovere pope. We have here, then, possibly another way of interpreting the words "not in a good place" written from Rome. But that the man who had been commissioned to paint *The Battle of Cascina* would call himself "no painter," except in a moment of ironic discouragement, can hardly be entertained seriously.

Recent scholarship has put emphasis on Michelangelo's first professional training in the *bottega* of the painter Domenico Ghirlandaio. His first recorded drawings are not after sculpture, but after Masaccio's and Giotto's great fresco-cycles in Florence. That he very early showed a genius for monumental painting can hardly be doubted. There are a number of figures in the choir fresco-cycle in S. Maria Novella in Florence by Ghirlandaio and his assistants that, within fairly recent times, have in all seriousness and with considerable plausibility been ascribed to the hand of the young Michelangelo before his fifteenth year. Evidence has cropped up in his newly published banker's correspondence (recently rediscovered by Harold Mancusi-Ungaro) that Michelangelo was engaged in painting what may have been a sizeable altarpiece for a Roman church shortly before his first departure from Rome for Florence in 1501.

Despite later reports and literary hyperbole[3] to the contrary, when he was called by Pope Julius to Rome in or around 1505, Michelangelo had, at the very least, as solid a reputation as a painter as he did as a sculptor. If, as is indicated by purely circumstantial

---

2. See the text of the entire poem in a recent translation by Professor Gilbert on p. 110.

3. See, for example, Michelet's famous passage to the effect that when he had begun the ceiling, Michelangelo had never before held a brush!

evidence, he was introduced to Pope Julius by his older friend Giuliano da San Gallo, his Florentine as well as his Roman reputation as a skilled painter would hardly have been passed over in silence. There is, in fact, buried in the Vasarian *Lives* the remainder of an oral tradition which maintains that it was none other than Giuliano da San Gallo who recommended Michelangelo as the best candidate for repainting the ceiling of the Sistine.[4]

This, then, is the case for Michelangelo the painter. It is worth rehearsing here; but it should not overshadow the fact that Michelangelo was originally called to Rome to carve the statuary for Pope Julius' tomb. Only when the work on the tomb had actually begun, or at least the preparatory designs started, does it seem likely that the question could have arisen of taking Michelangelo away from the tomb and putting him to work on the ceiling.

The letter of May 10, 1506, seems to have been written in the midst of some heated discussions over Michelangelo's possible role in the ceiling project. Then, even before it was finally decided that Michelangelo should paint the ceiling, a new event took place. The papal troops recaptured for the States of the Church the city of Bologna, and Pope Julius decreed that a colossal seated portrait of himself be cast in bronze and set up above the main portal of the huge municipal Church—not the Cathedral—of San Petronio in Bologna. Not only did Michelangelo have to model and cast the enormous statue, three times larger than life according to the usual Renaissance definition of a colossus, he may also have had to supervise the taking down, stone by stone, of the *quattrocento* portal by Jacopo della Quercia and its rebuilding, as it originally was, according to research by Professor James Beck, in which the façade was moved forward in order to provide the depth of the niche above that was to hold the Pope's statue.[5] During all this time-consuming and nerve-wracking work and with the specter of an unsuccessful casting of the huge bronze haunting his thoughts (which later turned out to be a reality), Michelangelo was most of the time absent both from Rome and from his home in Florence. The project for the tomb, already evidently deferred, and the plans for the ceiling necessarily remained in abeyance.

We pick up the story of the ceiling once again after the second, and successful, casting of the statue in Bologna. Michelangelo is finally free to take up his interrupted work in Rome. From Bologna Michelangelo evidently went to Florence, and at the end of March or the beginning of April, 1508 (according to Tolnay's estimate), he went

4. Vasari, *Vite*, ed. Milanesi, IV, p. 284.
5. J. H. Beck with A. Fanti, "Un Probabile Intervento di Michelangelo," *Arte Antica e Moderna*, XVII (1962), pp. 206-7.

on farther south to Rome. On May 10 the first contract for the ceiling was signed. Three days later we find Michelangelo ordering a quantity of blue pigment, probably ultramarine, from the Gesuati, the best suppliers in Florence. We next hear of work on the scaffolding while the cardinals fumed at the noise and dust at their service on the Vigil of Pentecost. By July 27 the scaffolding was presumably in place. We can imagine it as a sturdy wooden structure extending down half the length of the Chapel—perhaps based on the jutting cornice over the *quattrocento* histories; perhaps (as some feel) based on the Chapel floor, going as high as was needed for the painter to be able to reach conveniently the surface of the vault.

During the following summer months there were cash outlays to pay masons and plasterers, and a good deal of talk of hiring five young painter-assistants (*garzoni*) from Florence; one of them was dismissed peremptorily on October 7. Perhaps it was at the same time, or not long after, that the remaining *garzoni* arrived on that famous morning to find the Chapel locked against them. As reported by Vasari, they speedily took the hint and the road back to Florence.

In the meantime, on September 2, the blue pigment of best quality ordered earlier from Florence had arrived in Rome. Although some authorities maintain that actual painting did not begin until January, 1509, there is some reason to believe that Michelangelo had actually begun to paint in the advancing autumn of 1508. He began, according to Condivi, at the entrance wall, and the stylistic evidence confirms this. Many feel he worked alone, except for help used in preparing the surface for painting, probably in the transfer of the outlines of his cartoons to the soft plaster, and in the early stages of enlarging his drawings to cartoons. Such unassisted work was unprecedented in Michelangelo's day, but it seems fully in accord with his lonely, scornful, and impatient personality.

There was trouble almost at once. A letter of January 27, 1509, reports that the work was going badly. At a much later date, Vasari reported that toward the beginning of the work, spots of mould ominously appeared in the completed first third of the vault. Condivi had been in close touch with the artist in Rome during this period and, writing many years later, recalls that Michelangelo consulted Giuliano da San Gallo about this problem of mould after he had finished *The Flood*. And scholars now consider that, on the basis of style, *The Flood* was the first of the Genesis stories which Michelangelo treated. Particularly wet weather in the late fall and winter seems to have been the cause of the trouble which, momentarily to the artist, must have seemed like a major disaster. It is true that the area of *The Flood* could have been weakened almost from the start, for it was

from this particular area that sizeable portions of the painted *intonaco* fell in 1797 in consequence of reverberations caused by a powder explosion in the Castello Sant' Angelo. The destruction, affecting all but the entirety of the ignudo at the left of the Delphic Sibyl and a large part of the sky of *The Flood*, can still be seen today (figs. 12 and 19). These indications may be sufficient grounds to suppose that *The Flood* and perhaps even more of the first third of the vault area were completed by the winter of 1509.

Before going further into the problems of the dating of the various parts of the ceiling it would be advisable to stop and consider the nature of the task that Michelangelo had undertaken and how he had approached the immediate question of a fitting over-all design.

The scheme, perhaps the one agreed upon in the contract of May, 1508, was the first of three. A drawing, hardly more than a bare "idea-sketch," transmits to us what is generally agreed upon today as the initial plan of treating the ceiling (fig. 114a; text fig. 5, p. 211). Twelve Apostles were to be shown seated in thrones between the spandrels over the windows: five on each side of the Chapel and one at each end. The vault above them was to have been divided into framed elements: some diamond-shaped, others rectangular, and still others circular. How long this project was allowed to stand cannot be estimated closely. Probably not for very long. A second scheme, known through a sketch now in Detroit (fig. 115), increased the size of the main framed areas in the vault and changed them from lozenge-shaped to hexagonal (text fig. 6, p. 211). Meanwhile, flanking winged putti or angels were added to the tondos, which are now more ovoid and have been moved over between the spandrels. The sketch seems to indicate in a very vague way thrones for the Apostle-figures of the first scheme, but those figures do not explicitly appear in the new sketch. It is possible that there were other supplementary sketches with Apostles that have not survived.

What these two preliminary schemes make clear is that Michelangelo was playing with geometrically shaped framed elements that had a good deal to do with contemporary ceiling-design not only in Rome (the S. Maria del Popolo choir, for example) but also in Venice and in Florence (the vault of the sacristy of S. Spirito in which Giuliano da San Gallo had had a hand). The large figures of the Apostles on thrones constituted something new and special to the Chapel's program as a whole. The enthroned Apostles could be read iconographically as the forerunners of the thirty popes painted in niches below them in the decoration sponsored by Sixtus IV, even though in scale they would have quite outweighed those earlier fig-

ures. The second scheme takes giant strides toward organizing the vault in an architecturally clearer and more logical way; there is a suggestion now of transverse arch elements and a division of the vault proper into alternating larger and smaller areas which are presumably intended to contain scenes of some sort. Both early schemes can be said to contain in embryo the elements that were to appear in the third and last scheme which controlled what we see today as executed in the Sistine.

The Chapel, as an architectural creation per se, belonged to a most interesting phase of Renaissance building esthetics: the last quarter of the *quattrocento*. That period saw a striking growth in actual size and visual effects of scale in monumental building. It was the period of construction of the most impressive of the fortresses; we have mentioned one at Ostia and there were others at Volterra and Poggibonsi in Tuscany. The fortresslike exterior of the Sistine as it was designed is in good measure reflected in the interior with its huge arched openings for windows cut into thick splays. The architectural space of the interior is both ample and extremely precise mathematically and possibly symbolically. It has been noted that the length of this interior (text fig. 1) is twice its height and three times its width, which is 44 feet, a figure quite comparable to the width of a High Gothic cathedral nave.

These dimensions, then, are not only most impressive in themselves but may also carry symbolic significance since the ground plan of the Sistine appears to correspond to the comparable elements (as reconstructed by modern scholars) for Solomon's Temple in Jerusalem as described in the First Book of Kings. The point is of particular interest as a clue to choice of imagery in the paintings of the Chapel, as we will very shortly see. The historical relationship to the Temple was also emphasized by Pope Julius, who, in a bull of 1512, compared his new St. Peter's to the second (Herod's) Temple in Jerusalem.

The Sistine project was in marked contrast to the free field offered by the rebuilding of St. Peter's. In the Sistine Pope Julius and Michelangelo had to deal with an already-existing situation, which, for reasons of nepotic piety, the patron would have been very unwilling to alter. We have mentioned the row of the first sainted popes at the window level which provided a facet of imagery that suggested a very large subject indeed: the legitimacy of supreme papal authority. Here was a topic very dear both to Sixtus IV and his nephew Julius II. Directly below, the main part of the *quattrocento* decoration appeared. It consisted of two cycles of histories—that is, in the Albertian terminology of the Renaissance, subjects taken from past literature, myth, or history that had relevant moral value. The Sistine cycles

were taken from the stories of Moses and of Christ. Just as the pro-
tagonists were, in Church doctrine, antitypes, so the histories were
chosen and distributed on the walls in such a way that, in the tradi-
tional medieval fashion, they provided a typological concordance
between the Old and New Testaments. (See text fig. 2 and figs. 129
and 130.) Over each history was an inscription further emphasizing
the symbolic message of the painted forms. What was given was not
very distant in theological spirit from the *titulus* Abbot Suger put on
the Concordance Window of the royal French Abbey of St. Denis:

*Quod Moyses velat Christi doctrina revelat.*[6]

The play of words on "veils" (*velat*) and "reveals" (*revelat*) indicates
a mystical relationship between the Old and the New Testaments, a
contrast and at the same time a kinship of being alike, parts of a single
grand scheme of Providential salvation. The Sistine histories, in fact,
were called in the *quattrocento* "*picturae qua omnia veteris novique
Testamenti mysteria representantur*" ("paintings which represent all
the sacraments of the Old and New Testaments"). Though painted in
the "modern" style of their day they were related to an older and con-
servative traditional system. The medieval rule of placing the Old
Testament scenes on the cold, dark north wall was observed in the Sis-
tine as well; only because the Chapel was not "oriented" and had its
altar wall to the west rather than to the east, the Old Testament scenes
were placed on the "liturgical north," that is to say the left side of the
altar as one faces it. This arrangement had the unusual result of bring-
ing the light in from the meteorological south to illuminate the wall
with the New Testament scenes opposite. The sequence of subjects
moved from the altar wall toward the entrance.

Recent scholarship on the Sistine Chapel before Michelangelo
(Wilde, Ettlinger) has stressed the continuity of the medieval idea of
a mystical concordance between the two Testaments of the Bible in
the imagery of the histories of Sixtus' decoration. This seems entirely
justifiable in the light of what can be pieced together of Sixtus' court
and its intellectual tone. But even as the histories were being painted
in Sixtus' Chapel, greater emphasis was beginning to be placed on
the Old Testament aspect of revelation. Hebrew sources and com-
mentaries were being sought out in Italy more avidly than ever before.
The experience and example of so brilliant a young Humanist as

6. What Moses veils, the doctrine of Christ reveals. The verse is based
on a text of St. Augustine. Here, "veil" means the words of the old written
law (*lex scripta*), which the new law would illuminate through Christ's
spoken words and example. This is borne out by the inscriptions, or *tituli*,
over the Old and New Testament scenes in the Sistine.

Giovanni Pico della Mirandola offers vivid support for this view. Pico's encyclopedic philosophical program gave a prominent place to Hebrew lore among several other non-Christian sources of wisdom. The opening images of his *Oration on the Dignity of Man* are based not on the New Testament, but on a new and really non-Christian Genesis (see pp. 133–140). Pico's liberal point of view was not immediately accepted in the Rome of the popes and Curia of Sixtus' period. A number of theses among the 900 he proposed to defend in Rome in 1487 were semiheretical—indeed, altogether quite unacceptable. It is possibly open to question whether Pope Julius followed philosophical trends sufficiently to be affected by the new syncretism of Pico. Is it not revealing, however, that Pico's nephew, also a humanist of distinction, was a member of Julius' court, and that in the bitter winter campaign of 1511 in northern Italy, the old, white-bearded Pope struggled, waist-deep in snow drifts, to lead a force in recapturing the mountain stronghold of Mirandola? Perhaps even more striking to others might be the probability that Michelangelo listened personally to Pico, while he was still in his teens and a member of the household of Pico's great Florentine patron, Lorenzo de' Medici (between 1490 and 1492).

Such developments led to a far more liberal view of human aims and to a much broader kind of synthesis in thought, and they may help us to grasp a most important point about Michelangelo's third and final scheme for the Sistine Chapel ceiling. This is quite simply that regardless of Julius' undeniable respect for his uncle's program in the Chapel, and regardless of the continuing influence of the Biblical concordance, the ceiling of 1506–1512 presents a completely new sense of scale. More, too, is a new sense of nature and supernature, of image-form and vision. The differences between Michelangelo's ceiling-forms and those of the preceding generation's histories are almost as great as the differences between those same histories and Suger's stained-glass Concordance Windows at St. Denis.

What we find on the ceiling is a unity on a hitherto unprecedented grandeur of scale, rather than a dialectical interchange between equal pairs of like compositions, stating and then answering a proposition in a dialogue across the width of the Chapel. We find instead an overwhelming totality of extraordinarily diverse yet closely interlocking images, motives, and shapes. The imagery of the ceiling may be read laterally, that is by section from the sides (fig. 8; text fig. 9, p. 215). It may also be read section by section longitudinally with the focus on the altar, at the west end. Only when one looks toward the altar, do the Genesis scenes appear right-side up (fig. 3), a paradoxical reversal of what one might expect in looking at the ceiling as if it were spread out

flat, from left to right (figs. 4–5), or from what one might expect from the order of the subjects of the scenes. The first scene of the Genesis story that meets the observer's eye inside the original entrance is *The Drunkenness of Noah*, which is actually the last unit in the narrative sequence as shown; and the last vault composition to be seen, immediately before the altar, is *The Separation of Light and Darkness*, the first in the Genesis narrative sequence depicted (text fig. 4). By this device, which in effect reverses the expected chronological order of events, the artist in a visual sense lifts those events out of time and into a whole new context of sensation and ideas.

From this new logical system emerges a pervasive and dominating theme, enunciated in one place, rephrased in another, reinforced and enriched further in still others. The closest analogy to that method is perhaps to be found in Western music (as in Josquin's *Missa Pange Lingua*), or in the literary epic (the *Aeneid*, for instance), which progresses incident by incident but whose message absorbs and unites all motives and topics of whatever scale and interest in detail into an overriding whole, where the end is known at the beginning and the beginning is implicit in the end. The rhetoric of the epic is by tradition grandiose, as is indeed the formal rhetoric of the ceiling. Larger than life could ever be, the ceiling is not history, nor even myth, but, like Virgil's *Aeneid*, essentially a celebration of present greatness in the form of prophecy from an imagined past and of future promise in the guise of history.

Thus the largest, most dominant figures change in this epically conceived third version of Michelangelo's ceiling from Apostles to Seers: Old-Testament Prophets alternating with Sibyls of pagan antiquity. Both types are traditionally associated with cryptic announcements of the coming of a Savior. At the entrance end sits Zechariah, the Prophet of the Branch, who is particularly appropriate to the oak-tree family heraldry of Pope Julius II and his uncle, Sixtus IV. Opposite, at the altar end, sits Jonah, and beside him the great fish that symbolizes not only the descent of Christ into the grave before His Resurrection but also the catch of the Apostle-fisherman in whose direct succession both Sixtus and Julius reigned. The smallish scenes on the vault of the earlier projects now enlarge into a succession of nine great moments in the Genesis story of the Creation and *The Flood*. They are not of the same shape or size. Around the smaller scenes, alternating with the larger, are placed in the four corners the figures of nude young men, who are neither Atlantids (for they carry no architectural burden on their shoulders) nor Slaves (for their gestures, so varied and so evocative of mood as much as muscle, are not in any way constrained). They are traditionally called in the literature

Ignudi, nudes; they may also recall "athletes of God" (C. Eisler). While the actions of these Ignudi may vary—for no one pose repeats another—their function is clearly prescribed. It is at times a double function: first to hold up by silken strips slipped through five slits the large medallions that appear in pairs in alternate sections of the vault; and then to support garlands of oak leaves and acorns—an age-old Roman symbol of eternal life and at the same time a clear reference, once again, to the heraldic device of the della Rovere patron (figs. 34, 38, and 55).

Although they have been interpreted in other ways, the medallions supported by the Ignudi look like most medallions proper—that is, they appear to be enlarged images of the reverses of medals in bronze gilt, cast or struck for princes of the Church and lay leaders both and celebrating important events in their lives or reigns. The subject matter of these medallions on the ceiling (figs. 56–58) is taken largely from the First Book of Kings and the Second Book of Samuel. They refer to struggles between factions, to righteous rule as opposed to unwise rule, and in one case, to the moral superiority of the Church authority to lay authority. At the end of the series closest to the altar, the subject matter shifts in tone: Elijah taken up to heaven in his chariot of fire and *The Sacrifice of Isaac* foretell the Ascension and the Sacrifice of Christ.[7]

The theme of Salvation is primarily taken up by the four comparatively large pendentive paintings (figs. 82–85). Each is at one of the corners of the rectangular space of the Chapel, and they make bridges to the arched form of the vault proper. At the entrance end, David kills Goliath (fig. 83) by raising a sword to sever the giant's head (much like Donatallo's Florentine bronze of Judith killing Holofernes), while the companion fresco shows Judith, the Apocryphal Savior of her people, placing the already severed head of Holofernes on a salver carried by her serving maid (fig. 82). At the opposite or altar end of the Chapel, the suggestion of the Christian sacrifice in Old Testament and Apocryphal imagery becomes more pronounced. To the left of the altar is *The Hanging of Haman*, in which the nude figure of Haman is shown not as being hanged but rather as crucified on a rugged tree (fig. 84). To the right is *The Miracle of the Brazen Serpent* (fig. 85), which depicts the deadly rain of fiery serpents on the Children of Israel in the wilderness, and the salvation of those who looked on the Brazen Serpent the Lord commanded Moses to raise up

7. According to Professor Wind (see Bibliography), the subjects of the medallions refer to the Ten Commandments; for a different point of view, see note 9 of this Introduction.

(Numbers 21:7–9). The application should be familiar enough to those who know their Bible:

And as Moses lifted up the serpent in the wilderness,
so even must the Son of Man be lifted up;
That whosoever believeth in him shall not perish but
have eternal life. . . .

For God sent not his Son into the world to condemn
the world, but that the world through him might be saved.

(John 3:14–15, 17)

From this point on, the transition to images directly derived from the New Testament is swift. The spandrels and lunettes over the windows and the lunettes at either end of the Chapel include figures which are identified by rectangular plaques bearing Hebrew names written in Roman characters in their Latin (Vulgate) versions. These are to be identified with the ancestors of Mary and Christ as listed at the beginning of the first chapter of the Gospel of Matthew—indeed, at the beginning of the whole canonical New Testament. Two systems of composition are used by the artist. In the spandrels, one finds a succession of constantly changing variations on the theme of the Flight into Egypt—a husband with a young wife and an infant or child, a roll of baggage.[8] The figure is always seen in a moment of exhaustion or in more contemplative repose (consult carefully figs. 86–93). In the lunettes the suggestion of the family is repeated in many differing ways—sometimes a child is present, sometimes not; sometimes a single lovely figure appears in a compartment next to a window (fig. 104); sometimes there is a caricature (fig. 105): at no time is there an explicit image of Christ as Savior, although at all times one feels the reference without the image. In the same way, underneath all this Biblical imagery, one continually feels the patriarchal and paternal presence and influence of the bearded Julius II even though he is not specifically represented (Hartt).

It is not possible to end the catalogue of the images of Michelangelo's vision of the ceiling even here. There are charming supporting putti beneath the thrones of the Prophets and Sibyls (figs. 70–77). Decorating the thrones are pairs of putti (figs. 78 and 79) simulating marble statuary (like the little Christ of the beautiful Madonna by Michelangelo now in Bruges, shown in figure 132). In the spandrels are earthen or bronze figures of a decorative nature that ingeniously

8. Just as Moses brought his people out of Egypt, so, according to prophecy, the Messiah also was to have come out of Egypt before beginning his mission of redemption.

repeat in each pair a single image in reverse relationship (figs. 80–81). And finally, there is the architectural framework itself—a whole structure of simulated marble or limestone (see text figs. 8–9, p. 215)—with its own novel ornamental motifs in which the Rovere acorn figures prominently (fig. 81), and with its own framing mouldings, complex cornices, and string-courses (figs. 4–5, 8, and 9). It would be fair to say that Michelangelo did not merely paint an existing vault, but rather constructed by illusionistic means a whole new vault and peopled it with a seemingly inexhaustible supply of figures—all based on the human form, yet some on the scale of remote giants; others made of bronze or stone, others of the spirit of undying epic, and still others in the lunettes—these closest to the observer—of the very stuff of common mortality.

Four years would not seem nearly sufficient for the planning and completion of the ceiling. The achievement is all the more remarkable when we consider the relentless interruptions and delays. These included accidents requiring repair, and an obvious example was the mould problem, which may have meant that thereafter the wet winter months must be eliminated as suitable for the actual painting process. There were illnesses, such as that suffered by the artist in June, 1509, and times when the Pope would be away from Rome when designs were completed and had to be approved, as in the fall of 1510. There was even Michelangelo's work-stoppage to dun his patron for payments-in-compensation, such as happened in February, 1511.

There is general agreement today on certain broad divisions of the chronology of the work. We know, for example, from the *Diary* of the papal master of ceremonies, Paris de Grassis, that all the scaffolding was cleared away temporarily in 1511 by the time of the Feast of the Assumption of the Virgin (to whom the Chapel, of course, was dedicated by the founder); some, but not all, scholars think that this event marked the close of the work on both the vault proper and the adjacent spandrels and pendentives. This might have left the lunettes (which were placed at a lower level, and so required a quite different adjustment of scaffold height) to be completed in the ensuing fourteen-month period before the entire ceiling was to be unveiled on the Vigil of the Feast of All Saints—which was again a dedication day falling on the last day of October, in 1512.

Within this timetable there are refinements of detail about which scholars have found much to discuss. From the evidence of style, the first three Genesis histories with adjacent Prophets, Sibyls, and Ignudi seem to form a cohesive unit. Then, for the section comprising *The Temptation* and *The Creation of Eve*, there appears to be a stylistic change, most noticeable in the scale of the figures and, to some slight

extent, in the color. For an earlier historian like Wölfflin, both these sections, which take us halfway down the vault, were completed by September 15, 1509, when a large payment was made to the artist. On the other hand, it has been argued that by that date only the *first* section of the Genesis histories (and not the first two sections) was done (Tolnay). By the beginning of September, 1510, Michelangelo himself writes in a letter that he is ready to begin a new section of the ceiling. One can choose between two conclusions: that the artist had finished the first half of the histories up to and including *The Creation of Eve* by this date and was ready to work on the second half of the vault (Tolnay); or that the whole vault was by then complete (Wölfflin). This writer, for purely visual reasons of style, inclines toward the former (Tolnay's) position, and at this time he is unwilling to admit that a persuasive interpretation of the documentation based on what the artist evidently later told Condivi would tend to support Wölfflin. A later statement by the artist himself to Fatucci in 1523 indicates that having gained, after a delay, the Pope's approval, Michelangelo had begun in January, 1511, to work on the cartoons of the lunettes. We may now ask: Do *all* the designs for the spandrels and lunettes, as well as those for the pendentives date from this period (Wölfflin)? Or is it only the designs of the first eight lunettes (Tolnay)? Again, the visual evidence makes this writer tend to side with the latter theory. Doubts must remain; there may be still other unknown factors on this delicate historical equation that have yet to come to light. Early testimony (*i.e.*, Condivi) favors Tolnay's revision of Wölfflin's earlier theory especially when put together with visual as well as documentary evidence (Freedberg). A diagram (text fig. 4, p. 75) cannot provide all the nuances just detailed, but may prove a help to the reader in visualizing this rather densely packed and abbreviated accounting.

A few final questions now remain that deserve attention here. What of the process of this achievement? What technical procedures need further elucidation? What of the visual thinking that could produce such vivid shapes and images?

The problem of process is one of the most difficult and risky issues that may face art historians. The scholar's normal inclination is to look at conclusions of the creative process: at results, at completed acts, at works of art rather than at artists at work. Michelangelo's ceiling certainly belongs to the category of completed acts; but it encourages questions that have a great deal to do with the problem of process in art, if only by the extent of time required to create it and the very challenges of finding solutions to so many varied problems of composition.

One inevitable first question concerns the relative independence of the artist and his own ideas. Who conceived the elaborate program of imagery we see in the ceiling? Was there an advisor to suggest the content of the ceiling's program just as the Pope must have had in Bramante an advisor as well as an executor for his architectural projects? We can surely eliminate Bramante himself in the case of Michelangelo. But for the architectural aspects, as well as some technical aspects of the ceiling, we cannot entirely put aside the influence of Giuliano da San Gallo: remember once again the crucial letter of 1506, and the incident of the mould in 1509. There is the possibility that the major source of direction for the over-all content of the imagery was the influence of Pope Julius (Hartt) or other theologians (Wind); or there were indirect influences, current philosophical trends such as Neoplatonism, which might have worked through the artist's poetically trained imagination (Tolnay). In any event, we don't know for sure either what consultations Michelangelo may have made with learned authorities, or how much these talks may have influenced him in his work on the ceiling (a subject that opens vast possibilities).[9] In the letter to Fatucci of December, 1523, Michelangelo took the credit for himself of remonstrating against what he called the "poverty" of the first project as provided by the Pope and his advisors and said that because of his complaint Pope Julius had given him permission "to make what I wanted, whatever would please me." Aiming for a rich-

9. Several approaches to the meaning of the ceiling imagery have been advanced; none of them has up to now clearly outdistanced or superseded the others. The principal theories and methodologies may be characterized as follows: 1) Tolnay (*The Sistine Ceiling*, vol. II of *Michelangelo* [Princeton, 1945], pp. 20 ff.) stresses a movement of the mind, such as in Florentine Neoplatonism, from darkness and corporeality to spiritual enlightenment; 2) Wind (in a series of carefully worked out articles, all listed in the Bibliography) has placed emphasis on Dominican theological commentaries (such as Savonarola and Santi Pagnini), typological exegeses of a kind used by such early Church fathers as Origen, and the influence of Renaissance humanists such as Egidio da Viterbo, with as yet, however, no dominant theme emerging; 3) Hartt (principally in the *Art Bulletin*, XXXII [1950],. pp. 239 ff.) has seen a correspondence between the symbolism of the Rovere papal power (oak tree) and the mystical *lignum vitae* (tree of life), in general stressing Franciscan theology rather than Dominican; 4) most recently, Sinding-Larsen (in *Acta ad Archeologicam et Artium Historiam Pertinentia*, Institutum Romanum Norvegiae, IV [1969], pp. 143 ff.) has stressed instead a more general ecclesiological content in the ceiling's Genesis scenes and has been the first to begin to relate more closely than ever the Mosaic and Christological series designed for Sixtus IV (as interpreted by Ettlinger, but before the emergence of the important *tituli*) to the ceiling's imagery designed for Julius II. In the present writer's view this last approach has great promise and may well mark the beginning of a more coherent and convincing trend of interpretation than has been advanced so far.

ness of effect, such features as expensive blues, gold leaf, and brilliant colors, along with elaborately packed and complex compositional devices mark the first phase of the ceiling. As the work progressed the colors became more muted; at times they even suggest somber and ambivalent changes in the light, quite like shot silk, as the mood of the painter changed and the forms grew heavier. This change reflects probably a full two years' difference in the artist's own development, and to sense it one has only to look at the reproduction in this volume of the Delphic Sibyl of 1509 (fig. 59) and the Jonah of 1511 (fig. 75). The work of the last year on the lunettes moves further along this line of progress than even the Jeremiah. And now it is the Pope who, according to Condivi, complains of the "poor" effect of the Ancestors of Christ; Michelangelo is reported to have replied with a pun by saying that this was fitting since the ancestors were mostly "poor people" themselves.

Gold leaf had earlier in the Renaissance been theoretically banned by Alberti from the painter's palette. Alberti had also suggested what one may call "color chords," or triads of hues such as ash-gray, white, and crocus-yellow, a system which Michelangelo adapted to his own uses, as indeed he adapted Alberti's idea that "dark colors stand among light with dignity" and that "rose near green and sky-blue gives both honor and life." It is worth noting that in this last connection, whenever the Eternal is shown in the ceiling, He is usually clothed in rose-colored robes, just as some fifty years earlier Piero della Francesca had draped in a rose-colored robe his *Risen Christ* of Borgo San Sepolcro. For his nudes Michelangelo seems to have been mainly inspired by the patinated surfaces of antique marbles or terra cottas; in pose, color, and modeling, his Adam of *The Creation of Man* is conceived more as a statue than as a living human (fig. 26). Against the abstract world of a bleak primitive Eden or imaginary architecture, these sculpturally derived and sculpturally monumental nudes take on a life of their own.

In discovering and then consolidating the personal painting-style which so aptly expresses the "epic" content of the ceiling, Michelangelo turned also to sculpture. In his own earlier painting, the so-called *Doni Madonna* (fig. 131), done in Florence shortly before 1505, he had emphasized the smooth, firm forms of idealized polished marble; and in the background he had placed nude male figures which already prefigured the athletic Ignudi. But the ceiling style goes further in breadth and suggestion of scale. The Genesis scenes of the ceiling owe a debt to the practitioner of an earlier "epic style" in sculpture—Jacopo della Quercia. At San Petronio, Michelangelo must have studied Quercia's monumental portal sculptures, for the first time in 1495–1496, when he

stayed and worked in Bologna, and again in 1506–1508, when he evidently was an advisor in the moving forward of the lower part of the San Petronio façade (and with it the portal by Jacopo della Quercia) in order to make sufficient space for a niche to carry his colossal bronze of Pope Julius. In the early Genesis scenes of the ceiling, there are also echoes of the sculpturesque painter who was a younger contemporary of Quercia, the Florentine Masaccio. The effects of strong modeling that convey to our eyes so moving a sense of mass and volume in the figures of the ceiling are not to be found in nature but in the observation of more obviously contrasting light, shadow, and shade in marble sculpture. Although the device that appears over and over again in the ceiling, that of placing a very strong, heavily accented, dark silhouette of a form against a much lighter background, occurs rarely in nature, it is not so hard to find in sculpture. This stylized device in the finshed forms of painting did not preclude preliminary study of nature. The beautiful sheet of drawings for the Libyan Sibyl in the Metropolitan Museum of Art shows how the artist, evidently working directly from a live model, studied the action of the muscles of the arm and twisting torso and the effect of that torsion which carries down even to the toes of the left foot (fig. 118). Unfortunately, only a handful of the hundreds of study drawings for the ceiling that once must have existed have survived. These are sufficient, however, to show the difference in style between that of the first period of 1508–1509 and those of the second, 1510–1511 (figs. 115 and 121). It seems clear that the powerfully conceived foreshortenings of the figure of the crucified Haman could have only been worked out in a series of exploratory drawings. Surely this Haman (fig. 119), which was fairly well along in the series, is one of the most remarkable feats of draftsmanship of the entire Renaissance.

From such drawings the so-called cartoons, or working drawings, were built up using the scale selected for the finished paintings. The outlines of the shapes were transferred directly to the plaster by holding the cartoon, or a section of it, against the final *intonaco* plaster coating while it was still soft, by means of the pressure of a stylus or dulled scalpel. This left an incised guide-line for the artist to follow, although often with some modifications in the actual painting. The head of the Adam of *The Creation of Man* is usually pointed out as an example of this technique (fig. 28). In the way in which the shadows are built up, the same head also reveals a cross-hatching system of fine brush-strokes that are very similar to Michelangelo's cross-hatching in carving marble with a toothed chisel. Once more the sculptural analogy seems inescapable.

Not even the barest fragments of any of the cartoons for the ceil-

ing have come down to us. Nor do we have any trace of the painter's preliminary work for his color schemes. In the margin of the autograph of the satirical "Sonnet to Giovanni da Pistoia," he did leave a caricature of himself in the act of painting the ceiling, thereby illustrating his difficulties (fig. 140). This drawing would seem to demolish the popular tradition that Michelangelo painted the ceiling while he lay on his back. It is far more likely that he painted (as one would naturally expect) standing up, although with his head back so that he could watch the work. When he writes in the poem that his feet wander aimlessly, he must have simply meant that when painting even one day's patch of plaster he had to move about quite a bit—so great was the scale at which he was working. The record of the painting, such as it can be pieced together from many small bits of information, would seem to indicate that Michelangelo proceeded by spurts of activity interspersed by periods of inaction, some of it unwelcome to him. The lunettes, which represent the last phase of the work, though remarkable in many ways, seem to show the effects of prolonged effort. Even the poses of some of the figures (figs. 103 and 106) appear to reflect the artist's own physical and mental fatigue. He wrote on July 24, 1512:

> I struggle more than any man ever has, in bad health and with the greatest labor [*fatica*], and still I remain patient in order to reach the desired goal.

The ceiling is, all told, not so much a triumph of patience, though it entailed suffering and stubborn will power both, as it is a triumph of the human spirit.

Whether one interprets the program in terms of Neoplatonism, or of Franciscan or Dominican theology, or again of papal political ideas, it still remains essentially an animation—that is to say it that would transform the physical mold of our lives by spiritual means. The single image that best carries this message is that of *The Creation of Man*, in which the finger of the right hand of God is just about to touch and "animate" the listless body of the First Man (fig. 29). Sometimes, and without any historical justification, the detail of the two fingers that approach but do not touch is interpreted as the transmission of a physical power something like an electric charge. The motive actually goes back to the deepest part of the Church's spiritual tradition. It could have been derived from only one source: the famous medieval hymn that is sung at Vespers of Whitsunday according to the Roman rite: the *Veni Creator Spiritus* of which the first stanza is traditionally sung while kneeling. The third stanza contains these words *"Digitus paternae dexterae,"* referring directly to the extended

index finger of God's right hand in the fresco. The hymn can apply not only to the image but to the ideal world of Pope Julius' salvation, which the imagery of the ceiling as a whole eloquently suggests in extended visual metaphor:

| | |
|---|---|
| Tu septiformis munere, | The seven-fold gift of grace is thine, |
| Digitus paternae dexterae, | Thou finger of the hand divine; |
| Tu rite promissum Patris, | The Father's promise true, to teach |
| Sermone ditans guttura. | Our earthly tongues Thy heavenly speech. |
| | |
| Accende lumen sensibus, | Thy light to every sense impart; |
| Infunde amorem cordibus, | Pour forth Thy love in every heart; |
| Infirma nostri corporis, | Our weakened flesh do thou restore |
| Virtute firmans perpeti. | To strength and courage evermore. |
| | |
| Hostem repellas longius, | Drive far away our spirits' foe, |
| Pacemque dones protinus: | Thine own abiding peace bestow; |
| Ductore sic te praevio, | If thou dost go before as guide, |
| Vitemus omne noxium. | No evil can our steps betide. |

[Translation: American Episcopal Hymnal of 1940.]

A still earlier commentary on the Gospel source for the metaphor of finger-Spirit was fully available to those who established the program of the ceiling's imagery. It was in St. Augustine's treatise "De Spiritu et Littera":

> That Holy Spirit, through whom charity which is the fulness of the law is shed abroad in our hearts, is also called in the Gospel the finger of God. That those tables of the law were written by the finger of God, and that the finger of God is God's Spirit through whom we are sanctified, so that living by faith we may do good works through love—how striking here is at once the agreement and the difference! Fifty days are counted from the celebration of Passover, which was commanded through Moses to be a figure, signifying by the killing of a lamb the Lord's passion that was to be, unto the day when Moses received the law on tables written by the finger of God; and in like manner after the fulfilment of fifty days from the killing and the resurrection of him who was "led as a lamb to the slaughter," the faithful assembled together were filled by the finger of God which is the Holy Spirit.[10]

The juxtaposition of Moses and Christ here is striking.

10. St. Augustine, "De Spiritu et Littera," trans. from *Library of Christian Classics* (Philadelphia, 1965), VII, pp. 216–217. The Gospel passages referred to are: Matthew 12:28 and Luke 11:20; Matthew uses "spirit," while Luke uses "finger" in otherwise identical passages. The Pentecostal meaning in the Sistine imagery was pointed out in 1898 by the Polish historian

Since these lines were first written, there have been partially un-covered two series of inscriptions (*tituli*), in splendid Roman majus-cule letters, superimposed in gilt on the marble moulding over the fifteenth-century frescoes of the Sistine Chapel. From the point of view of form alone the lettering adds a note of richness to the wall decora-tion of the Chapel, and in a striking way the *tituli* provide a new visual aid to unity between the history scenes and the more architectonic images of popes above them. The cleaning of the Mosaic and Christo-logical series of frescoes had, as of April, 1971, proceeded successfully through the Old Testament series and most of the New Testament series.

According to Dr. Redig de Campos, who is in charge of the works of art in the Vatican and to whom I am indebted for information on the discoveries, the inscriptions were coated over with paint in the sixteenth century; at that time (between 1534 and 1541, when the altar wall was entirely covered by *The Last Judgment*), the first letters of each fifteenth-century *titulus* text were destroyed. The true text has in each case been restored with the help of a rare early sixteenth-cen-tury engraving (recording the conclave held in the Sistine that elected Leo X as Pope in 1513). Apparently this is the only extant visual rec-ord of the inscriptions. The publication of the texts of all the inscrip-tions with commentary on their meaning for the "histories" under them will come in due time when the sizeable job of cleaning is com-pleted. Meanwhile, from what has been uncovered and made available to public view, the following *tituli* are recorded thus far (for subjects, please turn back to text figure 2, p. 71):

*Right Wall* (reading *from* the altar):
1. OBSERVATIO · ANTIQUE · REGENERATIONIS · A · MOISE · PER · CIRCONCISIONEM ·
2. TEMPTATIO · MOISI · LEGIS · SCRIPTAE · LATORIS ·
3. CONGREGATIO · POPULI · A · MOISE · LEGEM · SCRIPTAM · ACCEPTURI ·
4. PROMULGATIO · LEGIS · SCRIPTE · PER · MOISEM ·
5. CONTURBATIO · MOISI · LEGIS · SCRIPTAE · LATORIS ·
6. REPLICATIO · LEGIS · SCRIPTAE · A · MOISE ·

*Left Wall* (reading *from* the altar):
1. INSTITUTIO · NOVAE · REGENERATIONIS · A · CHRISTO · IN · BAPTISMO ·

Klaczko: J. Bialostocki, in *Accademia Polacca di Scienze e Lettere . . . di Roma Conferenze*, fasc. 29 (1966), p. 20.

2. TEMPTATIO · IESU · CHRISTI · LATORIS ·
EVANGELICAE · LEGIS ·
3–6. Still covered while this essay was in press.

*Entrance Wall* (left side of portal):
. . . ASCENSIO · CHRISTI · EVANGELICAE · LEGIS ·
LATORIS ·

From this newly uncovered evidence on the walls of the Chapel itself certain preliminary conclusions may be suggested here:

1) The Old Testament series, so far uncovered, carries texts that, with but one exception (the last), mention not only Moses but the written law (*legis scriptae, legem scriptam*). The first extant Old Testament scene carries over it a reference to the "old regeneration" (*antique regenerationis*), while the New Testament "history" opposite is beneath a reference to the "new regeneration" (*novae regenerationis*), implicit, of course, in the subject of the Baptism, and proceeds with references to the "new" *lex evangelica* revealed by Jesus.

2) What evidently is to be inferred is a strong typological contrast between the "old" written law (which Michelangelo echoed in the ceiling above in the figures of certain of the Prophets and Sibyls, who are shown with prominently displayed books or scrolls) and a new "fulfillment," which moves beyond and above the written word (as shown by Michelangelo's Libyan Sibyl, who puts her book away, and the two great figures of Jeremiah and Jonah, who alone are shown without book or scroll, as may be ascertained by turning to figs. 71 and 75). Not only is the Jonah to be interpreted as a prototype of the Christ to come (in the terms of the early Church fathers' writings); but it should be remembered that the most widely quoted verses of Jeremiah's prophecy (31:31–33) stress the coming of a "new covenant" with His people in which the Lord will put His "law into their inward parts and write it in their hearts." The promise of redemption through Christ by the "New" and "Living Dispensation" of the Holy Spirit of the *lex evangelica* implies a more direct and mystical method of asserting truth. This would place more stress not only on the spoken word (the Sermon on the Mount, for example) but also on the sacraments (*mysteria*), which are provided by the Church at whose head is the Pope, the Vicar of Christ.

3) Michelangelo's ceiling imagery is thus to be seen more clearly than before as a further aspect of the typology of the wall imagery. It must be seen more than ever as a bridge between the old and the new, between the word and the spirit, just as if it were a physical union in architecture, linking the walls of the Chapel. Moreover, this

provides additional support for the interpretation above, which suggests that the main theme is Pentecostal. This is not to deny the validity of many aspects of earlier interpretations (including the role of Neoplatonism in Michelangelo's own imagery of his Adam). But it does mean that we should probably be thinking much more of a doctrinal content in the ceiling than has been usual in the past—perhaps, to some extent, even a liturgical one as well. It is a striking fact that before the morning scrutiny or vote in the conclave electing a new pope, the Mass of the Holy Spirit must be sung; and before the afternoon scrutiny, the *Veni Creator Spiritus* is sung. The Sistine Chapel was built in the first instance as a more suitable locale for the conclaves than had been available before Sixtus IV. And it was precisely under not only scenes of the Creation of the universe itself but of representations of the creative action of the Holy Spirit as revealed in Genesis 1:2 and the God's transmission of the Spirit to the first created man, in anticipation of a later transmission of that Spirit through Christ to His Church, that such decisions would be made.

# BACKGROUNDS AND SOURCES

# DOCUMENTS

The abbreviations used in the footnotes of the Contemporary Documents section are as follows:

Arch. Buonarroti. Archivio Buonarroti, Biblioteca Laurenziana-Medici, Florence.

Frey, *Briefe.* Frey, K., ed., *Sammlung ausgewahlter Briefe an Michelagniolo Buonarroti,* Berlin, 1899.

Frey, *Dicht.* Frey, K., ed., *Die Dichtungen des Michelagniolo Buonarroti,* Berlin, 1897.

Frey, *Reg.* Frey, K., "Studien zu Michelagniolo. I," *Jahrbuch der preussischen Kunstsammlungen,* XVI, 1895, pp. 91–103.

Gaye. Gaye, G., *Carteggio inedito d'artisti dei secoli XIV, XV, XVI,* Florence, 1839–1840.

G.d.B.-A. *Gazette des Beaux-Arts.*

Gotti. Gotti, A., *Vita di Michelangelo Buonarroti,* Florence, 1875.

Milanesi. Milanesi, G., ed., *Le Lettere di Michelangelo Buonarroti edite ed. inedite coi ricordi ed i contratti artistici,* Florence, 1875.

Pog. Pogatscher, H., *Dokumente zur Sixtinischen Kapelle,* Munich, 1905; also published in Steinmann, *Die Sixtinische Decke,* II, pp. 687 ff.

Spahn. Spahn, M., "Die Datierung von Michelangelos Briefwechsel, 1511 und 1512," *Reportorium für Kunstwissenschaft,* XXIX, 1906, pp. 291 ff.

Steinmann, *Biblio.* Steinmann, E. and Wittkower, R., *Michelangelo Bibliographie, 1510–1926,* Leipzig, 1927.

Thode, I. Thode, H., *Michelangelo und das Ende der Renaissance,* I, second ed., Berlin, 1912.

Selected Passages from
Contemporary Documents—1506–1512 *

*1. May 10, 1506: Piero Roselli in Rome to Michelangelo
in Florence* [1]

Piero Roselli (1474–*ca.* 1531), master mason, in charge of preparation
of the ceiling for painting. (See the Accounts for the Ceiling, no. 3).

* * * When the Pope had finished supper, I showed him certain
drawings. He then sent for Bramante and told him that San Gallo [2]
was going to Florence the next morning and would bring back
Michelangelo.[3] Bramante, replying to the Pope, said: Holy Father,
Michelangelo won't do anything of the sort; [4] I have been on very
familiar terms with him about this matter, and he told me many times
that he did not wish to have anything to do with the Chapel though
you wanted to burden him with it, and that, moreover, you did not
pay any serious attention either to the tomb [of Julius II] or to the
painting of the ceiling. And Bramante continued: Holy Father, I be-
lieve that Michelangelo would lack the necessary courage [5] to attack
the ceiling because he has not had much experience in figure painting,
and in general the figures will be set high and in foreshortening,[6]
and this brings up problems which are completely different from those
met in painting at ground level.[7] * * *

1. Formerly private property, Rome; Frey, *Reg.*, no. 11; Gotti, I, p. 46;
Pog., no. 5; Steinmann, *Biblio.*, p. 439 and facsimile pl. I; Thode, I, p. 348.
2. Giuliano da San Gallo (1445–1516), Florentine architect-sculptor and
Michelangelo's friend.
3. *Rimanere in sue.*
4. *Non ne fara nula.*
5. *No li basti elanimo.*
6. *In iscorcio.*
7. Implied is the *Battle of Cascina*, commissioned earlier of Michelangelo
while he was in Florence.

*2. May 10, 1508:* Ricordo *of Michelangelo* [1]

* * * On this May 10, 1508, I, Michelangelo, sculptor, have re-
ceived on account from our Holy Lord Pope Julius II five-hundred
papal ducats [2] * * * toward the painting of the ceiling of the papal
Sistine Chapel, on which I am beginning to work today according to

* Translated in the editor's seminar from texts provided in Charles de
Tolnay's *The Sistine Ceiling*, vol. II of *Michelangelo*, 5 vols. (Princeton,
1945). Footnotes to the twenty passages in this selection will be found after
each passage.

those conditions and agreements which appear in the contract written by the most reverend Monsignor of Pavia [3] and signed by me.

1. London, British Museum. Add. Ms. 23.208, fol. 4; Frey, *Reg.*, no. 19; Maurenbrecher, *Die Aufzeichnungen des Michelangelo Buonarroti im Britischen Museum*, Leipzig, 1938, pp. 3 ff.; Milanesi, p. 563; Pog., no. 12; Thode, I, p. 350.

2. Ducat (*ducato di camera*), the largest unit of money in Rome at the time Michelangelo was working on the Sistine Chapel ceiling; roughly equivalent to the Venetian ducat and the Florentine florin (*fiorino largo*) and worth at most about fifty dollars (1970).

3. Francesco Alidosi (*ca.* 1450–1511), a close friend of Julius II who held various ecclesiastical positions including that of Treasurer General.

### 3. May 11–July 27, 1508: Accounts for the Ceiling [1]

I, Piero,[2] son of Jacopo Roselli, master mason, have received today this May 11 mentioned above, from Michelangelo the sculptor ten gold papal ducats to roughen [3] the ceiling of the Sistine Chapel and to prepare [4] the surface in anticipation of laying the *intonaco* [5] and to do that which should be needed in the Chapel. * * *
On May 24, fifteen gold papal ducats * * * received * * * from Francesco Granacci.[6] * * *
And on June 3, ten gold papal ducats * * * received * * * from Francesco Granacci. * * *
And on June 13, ten gold papal ducats * * * from Francesco Granacci. * * *
And on July 10, ten gold papal ducats * * * from Francesco Granacci. * * *
And on July 17, ten gold papal ducats counting those received from Michelangelo. * * *
And on July 27, thirty gold papal ducats for the rest of the scaffolding and the plastering. * * *

1. Frey, *Reg.*, no. 20; Milanesi, p. 563, n. 1; Pog., no. 13; Thode I, p. 350.
2. Piero Roselli (see his letter of May 10, 1506, to Michelangelo.
3. *Isciarvare scialbare*, to place a layer of *intonaco* upon an already existing fresco in preparation for new painting.
4. *Arriciare*.
5. Fine plaster layer, as a fresco painting surface.
6. Francesco Granacci (1469–1543), a friend of Michelangelo's youth and a painter who, for a short time, was his assistant in Rome.

### 4. May 13, 1508: Michelangelo in Rome to Father Jacopo of the Order of the Gesuati in Florence [1]

As I have to supervise certain things to be painted here, or rather, I must myself paint them, I have to inform you that I need a certain

quantity of first-quality blue pigment.[2] See that you send whatever you may have of first quality * * * to your Brothers here.

1. Arch. Buonarroti, Cod. V, fol. 2–3; Frey, *Reg.*, no. 21; Milanesi, p. 379; Pog., no. 14; Thode, I, p. 350.
2. *Azzuri begli.*

### 5. *June 10, 1508:* Diary *of Paris de Grassis* [1]

Paris de Grassis was Master of Ceremonies at the court of Pope Julius II.

*Vespers of the Vigil of Pentecost.* * * * In the upper portions [2] of the Chapel, the scaffolding was being constructed causing a lot of dust, and the carpenters [3] did not stop as I ordered. The Cardinals complained of this. Moreover, when I had reproved the carpenters several times and they did not stop, I went to the Pope who was angry with me, as though I had not admonished them. The work continued without permission even though the Pope sent in succession two of his chamberlains who ordered the work stopped, which was finally done with difficulty.

1. Città del Vaticano, Archivio Vaticano, Misc. Arm. XIII, Cod. XV, fol. 213 *recto;* Frey, *Reg.*, no. 22; Muntz, G.d.B.-A., XXIV, 1882, p. 385, n. 2; Pog., no. 16; Thode, I, p. 350.
2. *Cornicibus.*
3. *Operai.*

### 6. *July or August 1508:* Ricordo *of Michelangelo* [1]

For painting assistants that he [2] is to have come down from Florence to Rome this year, because there will be five assistants, twenty gold papal ducats for each one, with this proviso * * * for the account of tomb [3] I need four-hundred gold ducats and henceforth one-hundred ducats a month for the same account according to our first agreement.

1. Arch, Buonarroti, Cod. 1, fol. 2; Frey, *Reg.*, no. 34 (July–August); Milanesi, p. 563 and p. 17, n. 3; Pog., no. 19; Thode, I, p. 351 (July).
2. The reference may be to Francesco Granacci, who is believed to have helped Michelangelo hire assistants for work on the ceiling.
3. The Tomb of Julius II. It is interesting to note that at this rather late date Michelangelo still hoped to continue work on the tomb without interruption.

### 7. *July 22, 1508: Giovanni Michi in Florence to Michelangelo in Rome* [1]

Although Giovanni Michi is known to have helped Michelangelo from 1508–1510, it is not certain whether he was a painter or simply a trustworthy personal agent.

\* \* \* Today I ran into the painter Raffaellino [2] and gathered, in a few words, that if you need him, he will come at your wish when he thinks the wages that Master Permatteo d'Amelia [3] already paid him are spent. He says that he, Permatteo, gave him ten ducats in gold a month. \* \* \* He is a good and faithful master. \* \* \* And if I can do anything else for you, let me know—I shall do it gladly out of my friendship·for you.

1. Arch. Buonarroti, Cod. IX, fol. 544; Frey, *Briefe*, pp. 7 ff.; Frey, *Reg.*, no. 28; Pog., no. 22: Thode, I, p. 351.
2. Raffaellino del Garbo, a Florentine painter (*ca.* 1470–1524), who is also identified as Raffaello de' Carli and Raffaello de' Caponi.
3. Permatteo d'Amelia (1450–*ca.* 1508), a painter active in Spoleto, Rome, and Civita Castellana, to whom the first vault (under Sixtus IV) was given.

## 8. *August 7, 1508: Francesco Granacci in Florence to Michelangelo in Rome* [1]

\* \* \* I waited a long time, thinking that your Piero Basso [2] would come along. \* \* \* I have not gone to anyone for the money, nor am I about to go at this time immediately, as perhaps Ludovico [3] thought I should. I know that he was upset and that he thought I was going to get on my horse right away. The others are talking about finishing off their work first before going to Rome and that it is not possible to do anything else until Easter. At best, Giuliano [4] and Jacopo,[5] although wanting to do so sooner, cannot get off because of pledges they have given for other work. Jacopo would clearly like to know what he is to be paid. I have not spoken with others, but it seems to me that Agnolo di Donnino [6] is handy for fresco work. If you need more help let me know; I will do nothing more until you reply. Something may come up so that I might get away anyway, if necessary, I alone and Sebastiano.[7]

1. Arch. Buonarroti, Cod. VIII, fol. 372; Frey, *Briefe*, pp. 10–11; Frey, *Reg.*, no. 33; Pini-Milanesi, *La scrittura degli artisti italiani*, Florence, 1876, no. 135; Pog., no. 28; Thode, I, p. 351.
2. Piero Basso, possibly the "Bassus" who is identified as a Florentine sculptor who worked in Rome at St. Peter's during the second half of the fifteenth century.
3. Ludovico Buonarroti, Michelangelo's father.
4. Giuliano Bugiardini (1475–1554), Florentine painter who had worked with Michelangelo in Ghirlandaio's *bottega*.
5. Jacopo di Sandro (active during the early sixteenth century), also known as Jacopo del Tedesco, a painter who worker in Ghirlandaio's *bottega* (see Michelangelo's letter of January 27, 1509 to his father, p. 106); or Jacopotorni (1475–1526), also known as l'Indaco Vecchio, who also worked with Ghirlandaio.
6. Agnolo di Donnino (1466–1513), a Florentine painter who is associated with the workshop of Cosimo Rosselli.

7. Probably Bastiano da San Gallo (1481–1551), also known as Aristotile, the nephew of Giuliano da San Gallo and student of Perugino (see Piero Roselli's letter to Michelangelo of May 10, 1506, p. 102).

## *9. October 13, 1508: Account of Payment Sent on October 5*[1]

\* \* \* Three ducats and —*carlini*[2] in cash to Domenico Manini[3] the Florentine for ropes and canvas which he delivered to the Chapel Sacristan of the Vatican.[4]

    1. Città del Vaticano, Archivio Vaticano Intr. et Exit. 543, fol. 226; Frey, *Reg.*, no. 37; Pog., no. 35.
    2. *Carlino*—a silver coin, equal to one tenth of a ducat.
    3. Domenico Manini, at present unidentified.
    4. *Sacri Palatii.*

## *10. January 27, 1509: Michelangelo in Rome to His Father in Florence*[1]

\* \* \* I am still in a quandary—it's been a year since I have had a *grosso*[2] from this Pope; and I don't bother him, because my work is not going along well enough to merit anything. This is the trouble with this work; it's still not my true profession, and I waste my time. Lord help me! If you need money, go to the Bursar of the Hospital[3] and have him give you up to fifteen ducats. \* \* \* Today, that painter Jacopo,[4] who I had come here, left; and since he complained about the housing here[5] I think he'll still complain there in Florence. Turn a deaf ear[6] and leave it at that; he has a thousand things wrong with him[7] and angers me greatly. \* \* \*

    1. London, British Museum, Add. Ms. 23.140; Frey, *Reg.*, no. 43; Milanesi, pp. 17–18; Pog., no. 39; Thode, I, p. 352.
    2. *Grosso*, a small unit of currency.
    3. Of S. Maria Nuova, in Florence, where Michelangelo had his local banking account.
    4. Jacopo di Sandro.
    5. *De casa mia.*
    6. *Orechi merchatanti.*
    7. *Lui a mille torte.*

## *11. February–March, 1509: Michelangelo in Rome to His Father in Florence*[1]

I gather from your last letter that it is rumored I am dead. That matters little because I am indeed alive. \* \* \* I concentrate on my work as much as I can. I have not had any money from the Pope for thirteen months, but, at any rate, I think I'll have some within a month

and a half, because I will have accounted very well for what I have had. If he did not give me any, I would have to borrow money to return home because I don't have a *quattrino*.[2] * * * I am unhappy here, not in good health, and very tired, without a housekeeper, and without money. However, I do have hope that God will help me. * * *

    1. London, British Museum (on exhibition 1939): Frey, *Reg.*, no. 47; Milanesi, p. 11; Pog., no. 41; Thode, I, p. 352.
    2. *Quattrino*, a very small unit of currency, the quarter of a *denaro*.

*12. End of August, 1510: Michelangelo in Rome to His Brother Buonarroto in Florence* [1]

* * * I am working as usual and will have finished painting by the end of next week, that is, the part that I began; and when it is uncovered,[2] I believe that I shall have some money and I will try to get permission to be home for a month. * * * No time to write more. * * *

    1. London, British Museum, Add. Ms. 23.141; Frey, *Reg.*, nos. 55, 56; Milanesi, p. 98; Pog., no. 53; Thode, I, p. 352.
    2. *Cio schoperta.*

*13. September 28, 1510: Giovanni Michi in Rome to Michelangelo in Florence* [1]

* * * This [2] is going directly, according to your order; and, I add, Giovanni [3] and Bernardino [4] are engaged in drawing and are doing you honor by this fidelity. * * *

    1. Arch. Buonarroti, Cod. IX, fol. 544; Frey, *Briefe*, p. 8, n. to no. 4; Frey, *Reg.*, no. 61; Pog., no. 62; Thode, I, p. 353.
    2. *Questa si.*
    3. Giovanni Trignoli (d. 1522), a painter from Reggio Emilia.
    4. Bernardino Zacchetti (no documented activity after 1523), a painter from Reggio.

*14. February 23, 1511: Michelangelo in Rome to His Brother Buonarroto in Florence* [1]

* * * I think that I will soon have to return to Bologna because the papal secretary [2] with whom I came from Bologna promised me when he left from here, Rome, that as soon as he was in Bologna he would provide for me so that I could work. It's been a month since he went; still I've heard nothing.

    1. London, British Museum, Add. Ms. 23.141; Frey, *Reg.*, no. 65; Milanesi, p. 100; Pog., no. 69; Thode, I, p. 353.
    2. *Datario.*

*15. August 14 and 15, 1511:* Diary of Paris de Grassis [1]

*Vespers and Mass in the Great Palatine Chapel on the Vigil and Day of the Assumption of the Most Glorious Virgin.* The Pope wished to be present at Vespers and Mass celebrated * * * in the great Palatine Chapel, for this Chapel is consecrated to the Assumption. The Pope came to the services either to see the new paintings recently exposed in the Chapel or because his devotions led him to do so. * * *

1. Città del Vaticano, Archivio Vaticano, Misc. Arm. XIII, Cod. XVI, fol. 103; Frey, *Reg.,* no. 67; Muntz, G.d.B.-A., XXIV, 1882, p. 386n.; Pog., no. 72; Thode, I, pp. 353f.

*16. Between July 4 and 19, 1512:* Grossino in Rome
*to Isabella d'Este* [1]

The Duke [2] came to the Vatican Palace with his attendants * * * and then they dined in the Papal Chamber. * * * His Excellency wished very much to see the ceiling of the large Chapel which Michelangelo was painting, and Federico [3] * * * arranged to ask the Pope's permission. The Duke went up to the ceiling with several people who, one by one, came down from the ceiling while the Duke stayed above with Michelangelo and could not look enough at those figures. These pleased him so much that his Excellency wished to have Michelangelo paint him a picture and talked with him, offered him money, and had him promise that he would paint for him. * * * After the Duke came down from the scaffolding I wanted to take him to see the papal Stanze which Raphael was painting, but he did not want to go. * * *

1. A. Luzio, "Federico Gonzaga ostaggio alla corte di Giulio II," *Archivio della R. Società Romana di Storia Patria,* IX, 1886, pp. 540 f.; Pog., no. 91. (Grossino was an agent of Isabella d'Este.)
2. Alfonso d'Este, Duke of Ferrara (1476–1534), who had come to regain Julius' favor after their falling out over the new papal alliance with Venice, Alfonso's great rival.
3. Federico Gonzaga, Alfonso's nephew then living at the papal court.

*17. July 24, 1512: Michelangelo in Rome to his Brother
Buonarroto in Florence* [1]

I do not have time to reply to your letter because the night has come and even if I should have the time, I could not answer you definitely inasmuch as I do not see the end of my business here. I will be there in Florence this September and will do as much as I can

for you, as I have done up to now. I struggle more than any man ever has, in bad health and with the greatest labor, and still I remain patient in order to reach the desired goal. You can very well be patient for two months, being ten-thousand times better off than I am. * * *

1. Arch. Buonarroti, Cod. IV, fol. 21; Frey, *Reg.*, no. 80; Milanesi, p. 104; Pog., no. 97; Spahn, *op. cit.*, pp. 307 ff.; Thode, I, p. 356.

*18. August 12, 1512: Michelangelo in Rome to His Brother Buonarroto in Florence* [1]

* * * About my returning home. * * * I cannot return if I do not finish the work which I expect to finish by the end of September. The truth is there is so much to do [2] that I cannot set a day within a fortnight. Let it suffice that in any case I will be home before All Saints' Day if I don't die in the meantime. I shall be as quick as I can, for I long to be home.

1. Arch. Buonarroti, Cod. IV, fol. 23; Frey, *Reg.*, no. 82; Milanesi, p. 106; Pog., no. 100; Spahn, *op. cit.*, pp. 307 ff.; Thode, I, p. 356.
2. *E si gran lavoro.*

*19. About October 3, 1512: Michelangelo in Rome to His Father in Florence* [1]

I understood by your last letter that you carried forward [2] as a balance forty ducats at the Bursar's of S. Maria Nuova. * * * I've finished the Chapel ceiling which I was painting. The Pope is very well satisfied. Other things [3] are not turning out for me as well as I expected; it is the fault of the times, which are very unfavorable to art. I shall not see you this All Saints' Day because I don't have the means to do what I wish to do,[4] and again, there is no time. * * *

1. London, British Museum, Add. Ms. 23.140 (Letter no. 36); Frey, *Reg.*, no. 87; Milanesi, p. 23 (1509); Pog., no. 106; Spahn, *op. cit.*, pp. 307 ff.; Thode, I, p. 357.
2. *Riportati.*
3. Evidently a reference to the tomb of Julius II.
4. *I.e.*, to travel to Florence.

*20. October 31, 1512: Diary of Paris de Grassis* [1]

*Vespers on the Vigil of All Saints.* * * * Today is the first day our Chapel was opened, the painting being finished.

1. Frey, *Reg.*, no. 88; Muntz, G.d.B.-A., XXIV, 1882, p. 387; Pog., no. 108; Thode, I, p. 357.

# MICHELANGELO
Sonnet to Giovanni da Pistoia—*ca.* 1510 *

I've got myself a goiter from this strain,
As water gives the cats in Lombardy
Or maybe it is in some other country;
My belly's pushed by force beneath my chin.

My beard toward Heaven, I feel the back of my brain
Upon my neck, I grow the breast of a Harpy;
My brush, above my face continually,
Makes it a splendid floor by dripping down.

My loins have penetrated to my paunch,
My rump's a crupper, as a counterweight,
And pointless the unseeing steps I go.

In front of me my skin is being stretched
While it folds up behind and forms a knot,
And I am bending like a Syrian bow.

And judgment, hence, must grow,
Borne in the mind, pecular and untrue;
You cannot shoot well when the gun's askew.

John, come to the rescue
Of my dead painting now, and of my honor;
I'm not in a good place, and I'm no painter.

# MICHELANGELO
Letter to Giovanni Francesco Fatucci—December, 1523 **

MESSER GIOVAN FRANCESCO [1]—You ask me in one of your letters how
my affairs stand regarding Pope Julius. I assure you that if damages
could be claimed I should expect rather to be the creditor than the

* From *Complete Poems and Selected Letters of Michelangelo*, translated
by Creighton Gilbert and edited by Robert N. Linscott. © Copyright 1963
by Robert N. Linscott and Creighton Gilbert. Reprinted by permission of
Random House, Inc.
** Trans. E. K. Ramsden from Buonarroti Archives Mil. ccclxxxiii, De-
cember, 1523. (A second version of this letter is dated January, 1524.)
1. Giovanni Francesco Fatucci, Michelangelo's banker.

debtor. Because when he sent for me from Florence, which was, I believe, in the second year of his pontificate, I had undertaken to execute half the Sala del Consiglio of Florence, that is to say, to paint it, for which I was getting three thousand ducats; and I had already done the cartoon, as is known to all Florence, so that the money seemed to me half earned. And of the twelve Apostles that I also had to execute for Santa Maria del Fiore, one was blocked out, as can still be seen, and I had already transported the greater part of the marble. But when Pope Julius took me away from here I got nothing either for the one or for the other.

Then when I was in Rome with the said Pope, and when he had given me a commission for his tomb, into which a thousand ducats' worth of marbles were to go, he had the money paid to me and sent me to Carrara to get them. I remained there eight months to have the marbles blocked out and I transported nearly all of them to the Piazza of St. Peter, but some of them remained at Ripa. Then, after I had completed the payment for the freight for the said marbles, I had no money left from what I had received for the said work, but I furnished the house I had in the Piazza of St. Peter with beds and household goods out of my own money, in anticipation of the tomb, and I brought assistants from Florence, some of whom are still living, to work on it, and I paid them in advance out of my own money. At this point Pope Julius changed his mind and no longer wanted to go on with it. But I, not knowing this, went to ask him for money and was turned away from the audience chamber. Enraged at this, I immediately left Rome, and what I had in the house went to pieces and the said marbles, that I had transported, remained in the Piazza of St. Peter until the election of Pope Leo[X], and in one way and another they came to grief. Among other things which I can prove, two pieces of four and a half *braccia* [a *braccia* measures between 20 and 25 inches] which had cost me over fifty gold ducats, were stolen from me by Agostino Chigi;[2] these could be recovered, because there are witnesses. But to return to the marbles, from the time that I went for them and stayed in Carrara, until I was turned away from the Palace, more than a year went by, and during that time I never had anything and it cost me several tens of ducats.

From the first time that Pope Julius went to Bologna, I was forced to go there, with a rope round my neck, to ask his pardon, whereupon he gave me his figure to do in bronze, which was about seven *braccia*

2. Agostino Chigi (d. 1520), the extremely wealthy Sienese banker who lived in Rome. On January 9, 1524, Lionardo, the saddler, wrote to Michelangelo saying he would be reimbursed for the stolen marbles (Frey, *Briefe*, p. 205).

in height, seated. When he asked me what it would cost, I replied that I believed it could be cast for about a thousand ducats; but that it was not my trade and that I did not want to be obliged to do it. He replied, "Set to work and cast it over and over again till it succeeds, and we will give you enough to content you." To be brief, it was cast twice, and at the end of the two years I had stayed there I found myself four and a half ducats to the good. And from that time I never had anything more. But all the expenses I had in the said two years were included in the thousand ducats for which I had said it could be cast, and these were paid me in installments by Messer Antonio Maria da Legnia, a Bolognese.

When I had set up the figure on the façade of San Petronio and returned to Rome, Pope Julius still did not want me to do the tomb, and set me to paint the vault of Sixtus and we made a bargain for three thousand ducats. The first design for the said work was for twelve Apostles in the lunettes and the usual ornamentations to fill the remaining area.

After the work was begun it seemed to me that it would turn out a poor affair, and I told the Pope that if the Apostles alone were put there it seemed to me that it would turn out a poor affair. He asked me why. I said, "because they themselves were poor."[3] Then he gave me a new commission to do what I liked, and said he would content me and that I should paint down to the histories below. Meanwhile, when the vault was nearly finished the Pope returned to Bologna; whereupon I went there twice for money that was owed me, but effected nothing[4] and wasted all that time until he returned to Rome. When I returned to Rome I began to do the cartoons for the said work, that is for the ends and the sides around the said chapel of Sixtus, in the expectation of having the money to finish the work. I was never able to obtain anything; but one day when I was complaining to Messer Bernardo da Bibbiena[5] and to Attalante[6] that I couldn't remain in Rome any longer but must go with God, Messer Bernardo told Attalante that he would remind him that he intended to have money paid to me in any case. And he had two thousand ducats of the Camera

3. According to Vasari, when the Pope suggested that the figures should be touched up with gold, Michelangelo answered, "Holy Father, in those days they did not wear gold . . . they were holy men, who despised wealth." Condivi, in his *Vita di Michelangelo*, recorded the anecdote. (See below, p. 120.)

4. His memory plays him false; this is not strictly accurate.

5. Afterward the Cardinal da Bibbiena.

6. Attalante (b. 1466) was a natural son of Manetta Migiorotti, a Florentine. From 1513 onwards he was one of the superintendents of the fabric of St. Peter's. Nothing is heard of him after 1535.

paid to me, which, together with the first thousand for the marbles, they are putting to my account for the tomb. But I reckoned that I was owed more for the time I had lost and the works I had done. And from the said money, as Messer Bernardo and Attalante had saved my life, I gave the former a hundred ducats and the latter fifty.

Then came the death of Pope Julius and at the beginning of [the pontificate of] Leo. As Aginensis [7] wished to increase the size of his tomb, that is, to execute a larger work than the one I had first designed, a new contract was drawn up. And when I did not wish them to put to the account the three thousand ducats I had received, and showed that I was owed much more, Aginensis called me an imposter.

[UNSIGNED]

## ASCANIO CONDIVI
from the *Vita di Michelangelo*—Rome, 1553 *

> The biography of Michelangelo by Ascanio Condivi appeared in 1553. It was written in Rome, and most historians of art today tend to look on it largely as a "dictated" *auto*biography of the artist himself. In 1550, Vasari published in Florence his first version of Michelangelo's *Life*. This evidently left something to be desired as far as the subject was concerned. Hence the corrective version doubtlessly written at Michelangelo's personal direction in Rome by his friend Condivi. It should be remembered that forty years or more separate Condivi's writing from the events of the painting of the Sistine ceiling. The artist's memory may have at times been seriously at fault, and it is certain that he would want to see emphasized his own bias in respect to controversial events. Even so, Condivi is the stronger source.

WHEN MICHELANGELO had finished this work [*i.e.*, the Pope's statue in Bologna] he came to Rome, where, since Pope Julius wished to employ him, albeit he was still resolved not to do the tomb,[1] it was

7. Cardinal della Rovere, representing Julius' heirs.
* A new translation by Alice Sedgwick Wohl with notes by Hellmut Wohl, from *Vita di Michelagnolo Buonarroti raccolta per Ascanio Condivi de la Ripa Transone*, Roma, Antonio Blado Stampatore, 1553, fols. 20ʳ-25ᵛ.
1. In 1505 Julius II had commissioned Michelangelo to design his tomb, which he wished to place in St. Peter's. But in April, 1506, after Michelangelo had brought the necessary marble blocks from the quarries at Carrara to Rome, the Pope abandoned the project. According to Condivi, he did so because Bramante "made him change his plans by quoting what common people say, that it is bad luck for anyone to build his tomb in his lifetime." However, the usual explanation is that Julius needed the funds which had been set aside for the tomb, to pay for the rebuilding of St. Peter's with which he had entrusted Bramante earlier that year. After the death of Julius

put into his head by Bramante and other rivals of Michelangelo to have him paint the vault of the chapel of Pope Sixtus IV, which is in the Vatican palace, raising hopes that in this he would accomplish miracles. And they were doing this service with malice, in order to distract the pope from projects of sculpture; and because they took it for certain that either he would turn the pope against him by not accepting such an undertaking, or if he accepted it, he would prove considerably inferior to Raphael of Urbino, to whom, out of hatred for Michelangelo, they showed every favour; it being their opinion that his principal art was the making of statues, as indeed it was. Michelangelo, who had not as yet used colours, and who realized that painting a vault was a difficult thing, made every effort to get out of it, proposing Raphael, and pleading that this was not his art, and that he would not succeed;[2] and he went on refusing to such an extent that the pope almost lost his temper. But then, perceiving the pope's obstinacy, he embarked on that work which is to be seen today in the papal palace to the admiration and amazement of the world; which brought him so great a reputation that it set him above all envy. Of this work I shall give a brief account.

The form of the vault is that which is commonly called a barrel vault; and it rests on lunettes, which are six on the long sides and two on the narrow, so that the whole amounts to two and a half squares.[3]

in 1513, at the behest of his heirs, Michelangelo worked intermittently on individual figures for the ever-changing and ever-more-modest projects for the tomb, which was finally set up in a sadly reduced version, containing only three of the many figures the master had carved for it, in the Roman church of S. Pietro in Vincoli in 1545. [The body of Julius II is buried in the basilica of St. Peter's.]

2. Condivi was neither entirely clear nor quite correct in his account of the machinations surrounding the commissioning of the Sistine ceiling. From a letter written to Michelangelo from Rome in May, 1506 (see Introduction, p. 75), we know that Julius had, even at that time, wanted Michelangelo to paint the ceiling. According to the same source, Bramante had at that time declared to the Pope that Michelangelo had said him that he did not want to do it, and that, in his opinion, Michelangelo would not do it well, for the reason that until then he had painted only at ground level and never high up and in foreshortening. Notwithstanding Condivi, Michelangelo had "used colors" prior to the ceiling, having painted at the very least the Doni tondo (Uffizi), and had begun the lost fresco of *The Battle of Cascina* in the Palazzo della Signoria in Florence, to which Bramante was probably referring. Finally, it is highly unlikely that either Bramante or Michelangelo suggested that Raphael paint the Sistine ceiling, for in April, 1508, Raphael was still in Florence and was as yet little known in Rome. (See Introduction, p. 76.)

3. The proportions of the plan of the Sistine Chapel are 1:3 (13.41 × 40.23 meters). In recording the proportions of the vault as 1:2.5, Condivi was referring to the area down to the beginning of the spandrels between the

In this space Michelangelo painted principally the Creation of the world, but he went on to encompass almost all the Old Testament; and he divided this work in the following way. Starting from the brackets, which support the horns of the lunettes, up to about a third of the arch of the vault, a flat wall is simulated; rising to the top of it there are pilasters and bases of imitation marble projecting outwards from a plane which looks like a parapet, with ledges below and with other small pillars about the same plane against which the Prophets and the Sibyls are seated. Springing from the arches of the lunettes, these first pilasters flank the brackets; however, they exclude a segment of the arches of the lunettes which is greater than the space they include between them. On the said bases are imitation sculptures of little nude children in various poses, which, like terms,[4] support a cornice which surrounds the whole work, leaving the middle of the vault from head to foot like an open sky.[5] This opening is divided into nine segments, because there are beveled arches which rise from the cornice over the pilasters, traverse the highest part of the vault, and rejoin the cornice on the opposite side, leaving between the arches nine spaces, alternating large and small. In each of the small ones there are two imitation marble moldings which divide the space; these are placed in such a way that the middle comprises two parts of the whole, with one part at each side where the medallions are situated, as will be mentioned in due course. And this he did to avoid the sense of surfeit which comes from sameness.

Now at the head of the chapel, in the first space,[6] which is one

---

lunettes, or, as he himself wrote a little further on, "starting from the brackets which support the horns of the lunettes." The ratio 1:2.5 must derive from a flattened-out rendering of the plan of the ceiling, as in Michelangelo's fragmentary sketches in the British Museum and the Detroit Institute of Arts (which also include the full height of the spandrels between the lunettes). Condivi's comment on the proportions of the vault is particularly valuable because it is the only concrete evidence we have for the existence of a schematic rendering of the ceiling as a whole.

4. A "term" is an architectural element consisting of a pedestal and base supporting a bust or figure.

5. It is often worth speculating to what extent Condivi's reports were based on his own observations, and how far they recorded or reflected what Michelangelo may have actually said to him. His description of the architecture of the ceiling—a "flat wall" or "parapet" rising to cornice and surrounding the *istorie* (narrative compositions) so that the center of the vault is left "like an open sky"—singles out the essential features of this complex structure with such clarity that one wonders whether it may not derive from the master himself, and thus disclose, in the simplest terms, Michelangelo's own concept of the ceiling's organization.

6. The "head of the Chapel" is the altar end of the interior space. Condivi's use of the term "first space" for *The Separation of Light and*

of the smaller ones, God Almighty is to be seen in the heavens divid-
ing light from darkness by the motion of His arms. The second space
shows when He created the two great lights; He appears with His
arms outstretched, pointing with His right to the sun and His left to
the moon. There are some little angels with Him, one of whom,
to His left, hides his face and clings to his Creator as if to protect
himself from the evil influence of the moon. In this same space, at the
left side, God appears again, turning to create the grasses and the
plants on earth, so artfully executed that wherever you turn, He seems
to follow you, showing His entire back down to the soles of His feet;
a very beautiful thing, and one which shows what foreshortening can
do.[7] In the third space, the great God appears in the heavens, again
with angels, and gazes upon the waters, commanding them to bring
forth all the kinds of creatures that are nourished by that element,
just as in the second space He commanded [ordered] the earth. In
the fourth is *The Creation of Man*, where God is seen with His arm
and hand reaching out, almost as if imparting to Adam His precepts
as to what he must and must not do, while with His other arm He
gathers His little angels to Him.[8] In the fifth, He draws woman from
Adam's rib, and she, rising with hands joined and held out toward
God, bows meekly as if thanking Him while He blesses her. In the

---

*Darkness* is liturgically accurate and entirely within the context of the order
of the fifteenth-century frescoes on the walls that were executed under
Sixtus IV. However, the Genesis scenes of the vault are to be read from
the *opposite* direction so that *The Separation of Light and Darkness*, though
chronologically the first of the Genesis series, is visually the last. (See Intro-
duction, p. 85.)

7. The subject of left and right in Condivi's account of the Sistine ceiling
is somewhat confusing. In writing that the figure of God foreshortened from
the back is "at the left side" of the *Creation of the Sun, Moon, and Plants*,
Condivi was looking at the composition right side up. Standing in the chapel,
he would have had his back to the entrance and face to the altar wall.
However, farther on he reversed his viewing position. In *The Flood*, he
described the mountain in the foreground as being "at the right side." But
if we look at this composition right side up the mountain peak is at our
left. Condivi must therefore have been looking at it or visualizing it upside
down, with his back to the altar wall and face to the entrance. And he
assumed the same position when he spoke of *The Crucifixion of Haman*
as being "at the right side" of *The Last Judgment*. Condivi's inconsistency
in regard to the left and right may have been due to the contrapuntal rela-
tionship between the sequence of the subjects and the orientation of the
compositions of the ceiling's nine principal *istorie*. As indicated in the pre-
vious note, their chronological sequence moves from the altar wall toward
the entrance though their compositions are oriented in the opposite direc-
tion, to be looked at with one's back to the entrance and face to the altar.

8. It appears Condivi did not know the scriptural interpretation of the
gesture of the Almighty. (See Introduction, p. 94.)

sixth is the devil, his upper half in human form and the rest in that of a serpent, with his legs transformed into tails, coiled around a tree; and, pretending to reason with the man, he induces him to go against his Creator, and to the woman he proffers the forbidden apple. And in the other part of the space, they are both seen, expelled by the angel, stricken with fear and grief, fleeing from the face of God. In the seventh is *The Sacrifice of Abel and Cain:* the former pleasing and acceptable to God, the latter abhorrent and rejected.[9] In the eighth is *The Flood*, where Noah's ark is to be seen in the distance, surrounded by water, and some figures who are clinging to it to be saved. Closer, in the same sea, is a boat laden with various people, which, because of the excessive weight aboard and because of the frequent and violent battering of the waves, its sail lost, bereft of all help or human remedy, is already shipping water and going down: here it is extraordinary to see the human race perish so miserably in the waves. Likewise, closer to the eye, a mountaintop appears still above the waters, like an island, where a multitude of men and women are gathered as they flee the rising waters; they express various emotions, but all pathetic and dreadful; as they draw under a tent stretched over a tree to shelter themselves from the uncommon rain; and overhead, the wrath of God is represented with great art, overwhelming them with waters and thunder and lightning. There is another mountain peak at the right side, still nearer the eye, and a multitude ravaged by the same disaster; as it would be lengthy to describe every detail of it, suffice it to say that they are all life-like and awesome, as one might imagine in such a misfortune. In the ninth, which is the last, is the story of Noah who, when he lay drunk and exposed, was derided by his son Ham and covered by Shem and Japheth.

Under the cornice which has already been mentioned and which terminates the wall, and over the brackets which support the lunettes, between the pilasters are seated twelve large figures, Prophets and Sibyls, all truly admirable, as much for their poses as for the decoration and variety of their draperies. But most admirable of all is the prophet Jonah, situated at the head of the vault, because, contrary to the curve of the vault and owing to the play of light and shadow, the torso which is foreshortened backward is in the part nearest the eye, and the legs which project forward are in the part which is farthest. A stupendous work, and one which proclaims what great knowledge this man has, in his handling of lines, in foreshortening and in perspective. But in the space under the lunettes, and also in the space above, which has the shape of a triangle, is painted the whole of the Geneal-

9. Condivi did not know the true subject. It represents the Sacrifice of Noah and not that of Cain and Abel.

ogy, or let us say the ancestry, of the Saviour, except for the corner triangles [spandrels] which are joined together, making two into one, and forming a double space. In one of these, then, near the wall of *The Last Judgment*, at the right, Haman appears, who was hung upon a cross at the command of King Ahasuerus; and this was because he, in his pride and arrogance, wanted to hang Mordecai, the uncle of Queen Esther, for not showing him honour and reverence as he passed by.[10] In another is the story of the Brazen Serpent which Moses lofted on a pole so that when the people of Israel, who had been wounded and tormented by live snakes, looked upon it, they were healed. Here Michelangelo has depicted remarkable efforts of strength in those who are trying to free themselves from the coils of the snakes. In the third corner, at the lower end, is the revenge of Judith upon Holofernes. And in the fourth, that of David upon Goliath.[11]

And this, briefly, is the entire narrative content. But no less marvellous than this is that part which does not appertain to the narrative. These are certain Ignudi which are seated on bases above the said cornice, and are, one at either side, supporting the medallions mentioned previously, which simulate metal; on these, after the fashion of reverses, various subjects are depicted, all related, however, to the principal one.[12] In all these things, be it in the beauty of the compartments, be it in the diversity of poses, be it in his contradiction of the contours of the vault, Michelangelo demonstrated very great art. But to tell the details of these and other matters would be an infinite labour for which a volume would not suffice. Therefore I have gone over it briefly, wishing merely to cast a little light on the whole rather than

10. According to Edgar Wind (see Bibliography, p. 242), the story of Haman's hanging may be interpreted as a "figure" of the Crucifixion.

11. These are alike scenes of salvation by beheading of powerful enemies, paired like the complementary scenes of salvation by hanging at the altar end of the chapel.

12. Condivi here undoubtedly meant the reverses (*rovesci*) of medals, which in the Renaissance frequently showed narrative scenes, related in some way to the individual who on the obverse was commemorated by a profile portrait. The word in the foregoing passages which has been translated once as "narrative content" and a few lines further down as "subjects" is *storia*. In the first instance Condivi seemingly wanted to make a distinction between the *istorie* in the corner triangles as having "narrative content" and the Ignudi as having none. In the following sentence, however, he seems to have meant that there was an intended relationship between the "subjects" (*storie*) painted in the medallions and the program ([*storia*] *principale*) of the ceiling as a whole, thus suggesting the existence of an underlying thematic unity for its many diverse parts. Although there has been much learned debate as to what this unifying theme might have been, we do not know what it was. Nor do we have more than several conflicting theories as to the meaning of the majority of the scenes of the medallions.

to specify the parts.

Nor, in the midst of all this, was he without anxieties, because when the work was begun and he had completed the picture of *The Flood*, it began to mildew so that the figures could barely be distinguished. Therefore, Michelangelo, reckoning that this must be a sufficient excuse for him to escape this burden, went to the pope and said, "Indeed I told Your Holiness that this is not my art: what I have done is spoiled, and if you do not believe it, send someone to see." The pope sent San Gallo,[13] who, when he saw it, realized that Michelangelo had applied the plaster too wet, and thus the dampness coming down caused that effect; and he informed Michelangelo of this, so that he had to continue, and no excuse was availing.

While he was painting, Pope Julius often wanted to go to see the work; he would climb up by a ladder, and Michelangelo would hold out his hand to him so that he could get up onto the scaffolding. And since he was by nature impetuous and impatient of waiting, when the work was half done, that is from the door to midway on the vault, he wanted Michelangelo to uncover it while it was still incomplete and had not received the last touches. The opinion and the expectation which everyone had of Michelangelo brought all Rome to see this thing, where the pope also went before the dust raised by the dismantling of the scaffold had settled.

After this work, when Raphael had seen the new and wonderful manner of painting, being one who was remarkable at imitation, he sought through Bramante to paint the rest himself.[14] This greatly disturbed Michelangelo, who came before Pope Julius and seriously protested the injury Bramante was doing him; and in his presence he complained to the pope, revealing to him all Bramante's persecutions; and afterwards he exposed many of his deficiencies, and especially that while demolishing the old Saint Peter's, he was tearing down the wonderful columns that were in that temple, taking no care and not mind-

13. The Florentine architect-sculptor and friend of Michelangelo, Giuliano da San Gallo (1445–1516). (See Introduction, p. 76.)

14. If Condivi's report that the pope visited the chapel "before the dust raised by the dismantling of the scaffold had settled" can be relied upon, the ceiling would have been uncovered before 17 August 1510, when Julius left Rome for Bologna at the head of his troops. There is no truth in Condivi's statement that Raphael wanted to finish the ceiling. The basis for it may have been the deep hostility that Michelangelo felt toward both Raphael and Bramante. As late as 1542 he wrote in a letter to a friend that

all the discord that arose between Pope Julius and myself was due to the envy of Bramante and Raphael of Urbino; and this was the cause of his not continuing his tomb while he lived, in order to ruin me: and Raphael had good reason for it, since whatever he had in art he had from me.

ing that they were being smashed to pieces, when he could lower them slowly and preserve them whole. He argued that it was easy enough to put one brick on top of another but that to make such a column was extremely difficult, and many other things which do not need to be told, so that when the pope had heard of these iniquities, he wanted Michelangelo to continue, conferring upon him more favours than ever.

He finished this entire work in twenty months, with no help whatever, not even someone to grind his colours for him.[15] It is true that I have heard him say that it is not finished as he would have wanted it, as he was hampered by the urgency of the pope, who asked him one day when he would finish that chapel. And when Michelangelo answered, "When I can," the pope retorted in a rage, "You want me to have you thrown off that scaffolding?" Hearing this, Michelangelo said to himself, "You shall not have me thrown off"; then he left and had the scaffolding dismantled and on All Saints' Day revealed the work, which was seen with great satisfaction by the pope, who went into the chapel that day, and with admiration by all Rome in crowds. What was missing was the retouching of the work *a secco* with ultramarine and, in a few places, with gold, in order to give it a richer appearance. Julius, when the heat of his enthusiasm had subsided, actually wanted Michelangelo to furnish these touches; but when he thought about the trouble it would be for him to reassemble the scaffolding, he answered that what was missing was nothing which mattered. "Still, it should be retouched with gold," answered the pope, to whom Michelangelo responded familiarly, as was his way with His Holiness, "I do not see that men wear gold." And the pope said, "It will look poor." "Those who are depicted there," he answered, "they were poor, too." This was tossed out in jest; and so it has remained.[16]

15. The length of time between the signing of the contract and the final unveiling of the ceiling was in fact close to fifty-four months (10 May 1508 to 31 October 1512). Condivi's figure of twenty months may refer to the time Michelangelo actually spent painting the ceiling, as might be indicated by the fact that in the same sentence he mentioned the grinding of colours. [Condivi's statement of the lack of assistants "even for grinding" is not verifiable; there must have been some assistants for preparing the cartoons and, *pace* Condivi, for such mechanical work as laying in plaster as well as preparing pigments.]

16. *A secco* passages (additions in tempera or size) and gilt (gold leaf), both of which could be added only after the colors applied to the damp plaster had dried, have in fact been found, but only in the first half of the ceiling. The color scheme in general of the second half is more somber [see Introduction, p. 91]. Condivi may have said that they were missing in order to introduce the anecdote of Michelangelo's play on the word "poor", which he furthermore seems to have misquoted. Michelangelo, referring in a letter

For this work and for all his expenses, Michelangelo received three thousand ducats, of which he was obliged to spend about twenty or twenty-five on colours, according to what I have heard him say.[17] When he had finished this work, because he had spent such a long time painting with his eyes raised to the vault, Michelangelo could then see very little when he looked down; so that if he had to read a letter or other minutiae, he had to hold them with his arms up over his head.[18] Nonetheless, after a while he gradually grew accustomed to looking down to read. From this we may conceive how great were the attention and diligence with which he did this work.

## Excerpts from Genesis *

*1:1–31*

In the beginning God created heaven, and earth.

And the earth was void and empty, and darkness was upon the face of the deep. And the spirit of God moved over the waters.

And God said: Be light made. And light was made.

And God saw the light that it was good; and he divided the light from the darkness.

And he called the light Day, and the darkness Night. And there was evening and morning one day.

And God said: Let there be a firmament made amidst the waters: and let it divide the waters from the waters.

And God made a firmament, and divided the waters that were under the firmament from those that were above the firmament. And it was so.

---

of December 1523 to the first project for the ceiling, of twelve Apostles, wrote that

> then, when the aforesaid work was begun, it seemed to me that it would turn out a poor thing, and I said to the pope how, doing only the Apostles, it seemed to me that it would turn out a poor thing. He asked me why; I said to him, "because they were poor, too."

[See p. 112.]

17. The sum of three thousand ducats was stipulated in the first contract, very probably for the first project of twelve Apostles. For the project that he executed, Michelangelo apparently received six thousand ducats according to Tolnay.

18. Michelangelo himself described his discomforts in painting the ceiling in a sonnet, which he accompanied with a sketch of himself standing up and painting a half-comical, half-frightening figure above him. [The text of the poem is given in translation on p. 110.]

* Douay Version, translated directly from the Vulgate.

And God called the firmament Heaven. And the evening and morning were the second day.

God also said: Let the waters that are under the heaven be gathered together into one place, and let the dry land appear. And it was so done.

And God called the dry land Earth; and the gathering together of the waters, he called Seas. And God saw that it was good.

And he said: Let the earth bring forth the green herb, and such as may seed, and the fruit tree yielding fruit after its kind, which may have seed in itself upon the earth. And it was so done.

And the earth brought forth the green herb, and such as yieldeth seed according to its kind, and the tree that beareth fruit, having seed each one according to its kind. And God saw that it was good.

And the evening and the morning were the third day.

And God said: Let there be lights made in the firmament of heaven, to divide the day and the night, and let them be for signs, and for seasons, and for days and years:

To shine in the firmament of heaven, and to give light upon the earth. And it was so done.

And God made two great lights: a greater light to rule the day; and a lesser light to rule the night: and the stars.

And he set them in the firmament of heaven to shine upon the earth.

And to rule the day and the night, and to divide the light and the darkness. And God saw that it was good.

And the evening and morning were the fourth day.

God also said: Let the waters bring forth the creeping creature having life, and the fowl that may fly over the earth under the firmament of heaven.

And God created the great whales, and every living and moving creature, which the waters brought forth, according to their kinds, and every winged fowl according to its kind. And God saw that it was good.

And he blessed them saying: Increase and multiply, and fill the waters of the sea; and let the birds be multiplied upon the earth.

And the evening and the morning were the fifth day.

And God said: Let the earth bring forth the living creature in its kind, cattle and creeping things, and beasts of the earth, according to their kinds. And it was so done.

And God made the beasts of the earth according to their kinds, and cattle, and every thing that creepeth on the earth after its kind. And God saw that it was good.

And he said: Let us make man to our image and likeness; and

let him have dominion over the fishes of the sea, and the fowls of the air, and the beasts, and the whole earth, and every creeping creature that moveth upon the earth.

And God created man to his own image; to the image of God he created him. Male and female he created them.

And God blessed them, saying: Increase and multiply, and fill the earth, and subdue it, and rule over the fishes of the sea, and the fowls of the air, and all living creatures that move upon the earth.

And God said: Behold I have given you every herb-bearing seed upon the earth, and all trees that have in themselves seed of their own kind, to be your meat:

And to all beasts of the earth, and to every fowl of the air, and to all that move upon the earth, and wherein there is life, that they may have to feed upon. And it was so done.

And God saw all the things that he had made, and they were very good. And the evening and morning were the sixth day.

*2:1–9, 15–20, 21–25*

So the heavens and the earth were finished, and all the furniture of them.

And on the seventh day God ended his work which he had made: and he rested on the seventh day from all his work which he had done.

And he blessed the seventh day and sanctified it: because in it he had rested from all his work which God created and made.

These are the generations of the heaven and the earth, when they were created, in the day that the Lord God made the heaven and the earth:

And every plant of the field before it sprung up in the earth, and every herb of the ground before it grew: for the Lord God had not rained upon the earth and there was not a man to till the earth.

But a spring rose out of the earth, watering all the surface of the earth.

And the Lord God formed man of the slime of the earth, and breathed into his face the breath of life; and man became a living soul.

And the Lord God had planted a paradise of pleasure from the beginning: wherein he placed man whom he had formed.

And the Lord God brought forth of the ground all manner of trees, fair to behold, and pleasant to eat of: the tree of life also in the midst of paradise: and the tree of knowledge of good and evil.

\*     \*     \*

And the Lord God took man, and put him into the paradise of pleasure, to dress it, and to keep it.

And he commanded him, saying: Of every tree of paradise thou shalt eat:

But of the tree of knowledge of good and evil, thou shalt not eat. For in what day soever thou shalt eat of it, thou shalt die the death.

And the Lord God said: It is not good for man to be alone; let us make him a help like unto himself.

And the Lord God having formed out of the ground all the beasts of the earth, and all the fowls of the air, brought them to Adam to see what he would call them: for whatsoever Adam called any living creature the same is its name.

And Adam called all the beasts by their names, and all the fowls of the air, and all the cattle of the field: but for Adam there was not found a helper like himself.

<center>*     *     *</center>

Then the Lord God cast a deep sleep upon Adam: and when he was fast asleep, he took one of his ribs, and filled up flesh for it.

And the Lord God built the rib which he took from Adam into a woman: and brought her to Adam.

And Adam said: This now is bone of my bones, and flesh of my flesh; she shall be called woman, because she was taken out of man.

Wherefore a man shall leave father and mother, and shall cleave to his wife: and they shall be two in one flesh.

And they were both naked, to wit, Adam and his wife: and were not ashamed.

<center>*     *     *</center>

3:1–24

Now the serpent was more subtle than any of the beasts of the earth which the Lord God had made. And he said to the woman: Why hath God commanded you, that you should not eat of every tree of paradise?

And the woman answered him, *saying* Of the fruit of the trees that are in paradise we do eat:

But of the fruit of the tree which is in the midst of paradise, God hath commanded us that we should not eat; and that we should not touch it, lest perhaps we die.

And the serpent said to the woman: No, you shall not die the death.

For God doth know that in what day soever you shall eat thereof, your eyes shall be opened: and you shall be as Gods, knowing good

and evil.

And the woman saw that the tree was good to eat, and fair to the eyes, and delightful to behold: and she took of the fruit thereof, and did eat, and gave to her husband who did eat.

And the eyes of them both were opened: and when they perceived themselves to be naked, they sewed together fig leaves, and made themselves aprons.

And when they heard the voice of the Lord God walking in paradise at the afternoon air, Adam and his wife hid themselves from the face of the Lord God, amidst the trees of paradise.

And the Lord God called Adam, and said to him: Where art thou?

And he said: I heard thy voice in paradise and I was afraid, because I was naked, and I hid myself.

And he said to him: And who hath told thee that thou wast naked, but that thou hast eaten of the tree whereof I commanded thee that thou shouldst not eat?

And Adam said: The woman, whom thou gavest me to be my companion, gave me of the tree, and I did eat.

And the Lord God said to the serpent: Because thou has done this thing, thou art cursed among all cattle, and beasts of the earth. Upon thy breast shalt thou go, and earth shalt thou eat all the days of thy life.

I will put enmities between thee and the woman, and thy seed and her seed: she shall crush thy head, and thou shalt lie in wait for her heel.

To the woman also he said: I will multiply thy sorrows, and thy conceptions. In sorrow shalt thou bring forth children, and thou shalt be under thy husband's power, and he shall have dominion over thee.

And to Adam he said: Because thou hast hearkened to the voice of thy wife, and hast eaten of the tree, whereof I commanded thee that thou shouldst not eat, cursed is the earth in thy work; with labour and toil shalt thou eat thereof all the days of thy life.

Thorns and thistles shall it bring forth to thee; and thou shalt eat the herbs of the earth.

In the sweat of thy face shalt thou eat bread till thou return to the earth, out of which thou wast taken: for dust thou art, and into dust thou shalt return.

And Adam called the name of his wife Eve: because she was the mother of all the living.

And he said: Behold Adam is become as one of us, knowing good and evil: now, therefore, lest perhaps he put forth his hand, and take

also of the tree of life, and eat, and live for ever:

And the Lord God sent him out of the paradise of pleasure, to till the ground from which he was taken.

So he drove out the man, and he placed at the East of the garden of Eden Cherubim and a flaming sword, turning every way, to keep the way of the tree of life.

\*     \*     \*

*5:1–2*

This is the book of the generation of Adam. In the day that God created man, he made him to the likeness of God.

He created them male and female; and blessed them; and called their name Adam, in the day when they were created.

\*     \*     \*

*6:1–22*

And after that men began to be multiplied upon the earth, and daughters were born to them.

The sons of God seeing the daughters of men, that they were fair, took to themselves wives of all which they chose.

And God said: "My spirit shall not remain in man for ever, because he is flesh; and his days shall be a hundred and twenty years.

Now giants were upon the earth in those days. For after the sons of God went in to the daughters of men, and they brought forth children, these are the mighty men of old, men of renown.

And God seeing that the wickedness of men was great on the earth, and that all the thought of their heart was bent upon evil at all times.

It repented him that he had made man on the earth. And being touched inwardly with sorrow of heart,

He said: I will destroy man, whom I have created, from the face of the earth, from man even to beasts, from the creeping thing even to the fowls of the air; for it repenteth me that I have made them.

But Noe found grace before the Lord.

These are the generations of Noe. Noe was a just and perfect man in his generations; he walked with God.

And he begot three sons, Sem, Cham, and Japheth.

And the earth was corrupted before God, and was filled with iniquity.

And when God had seen that the earth was corrupted (for all flesh had corrupted its way upon the earth),

He said to Noe: The end of all flesh is come before me; the earth is filled with iniquity through them; and I will destroy them with the earth.

Make thee an ark of timber planks: thou shalt make little rooms in the ark, and thou shalt pitch it within and without.

And thus shalt thou make it: The length of the ark shall be three hundred cubits; the breadth of it fifty cubits; and the height of it thirty cubits.

Thou shalt make a window in the ark, and in a cubit shalt thou finish the top of it; and the door of the ark thou shalt set in the side; with lower, middle chambers, and third stories shalt thou make it.

Behold I will bring the waters of a great flood upon the earth, to destroy all flesh, wherein is the breath of life, under heaven. All things that are in the earth shall be consumed.

And I will establish my covenant with thee; and thou shalt enter into the ark: thou and thy sons, and thy wife, and the wives of thy sons with thee.

And of every living creature of all flesh, thou shalt bring two of a sort into the ark, that they may live with thee: of the male sex, and the female.

Of fowls according to their kind, and of beasts in their kind, and of every thing that creepeth on the earth according to its kind; two of every sort shall go in with thee, that they may live.

Thou shalt take unto thee of all food that may be eaten, and thou shalt lay it up with thee: and it shall be food for thee and them.

And Noe did all things which God commanded him.

*7:1–24*

And the Lord said to him: Go in thou and all thy house into the ark: for thee I have seen just before me in this generation.

Of all clean beasts take seven and seven, the male and the female.

But of the beasts that are unclean two and two, the male and the female. Of the fowls also of the air seven and seven, the male and the female: that seed may be saved upon the face of the whole earth.

For yet a while, and after seven days, I will rain upon the earth forty days and forty nights; and I will destroy every substance that I have made, from the face of earth.

And Noe did all things which the Lord had commanded him.

And he was six hundred years old, when the waters of the flood overflowed the earth.

And Noe went in, and his sons, his wife and the wives of his sons with him, into the ark, because of the waters of the flood.

And of beasts clean and unclean, and of fowls, and of every thing that moveth upon the earth.

Two and two sent in to Noe into the ark, male and female: as the Lord had commanded Noe.

And after the seven days were passed, the waters of the flood over-flowed the earth.

In the six hundredth year of the life of Noe, in the second month, in the seventeenth day of the month, all the fountains of the great deep were broken up, and the flood gates of heaven were opened:

And the rain fell upon the earth forty days and forty nights.

In the selfsame day, Noe, and Sem, and Cham, and Japheth his sons: his wife, and the three wives of his sons with them, went into the ark:

They and every beast according to its kind, and all the cattle in their kind, and everything that moveth upon the earth according to its kind, and every fowl according to its kind, all birds, and all that fly,

Went in to Noe into the ark, two and two, of all flesh wherein was the breath of life.

And they that went in, went in male and female of all flesh, as God had commanded him: and the Lord shut him in on the outside.

And the flood was forty days upon the earth, and the waters in-creased, and lifted up the ark on high from the earth.

For they overflowed exceedingly and filled all on the face of the earth: and the ark was carried upon the waters.

And the waters prevailed beyond measure upon the earth: and all the high mountains under the whole heaven were covered.

The water was fifteen cubits higher than the mountains which it covered.

And all flesh was destroyed that moved upon the earth, both of fowl, and of cattle, and of beasts, and of all creeping things that creep upon the earth: and all men.

And all things wherein there is the breath of life on the earth, died.

And he destroyed all the substance that was upon the earth, from man even to beast, and the creeping things and fowls of the air; and they were destroyed from the earth. And Noe only remained and they that were with him in the ark.

And the waters prevailed upon the earth a hundred and fifty days.

*8:1–22*

And God remembered Noe, and all the living creatures, and all the cattle which were with him in the ark: and brought a wind upon the earth, and the waters were abated.

The fountains also of the deep, and the flood gates of heaven were shut up: and the rain from heaven was restrained.

And the waters returned from off the earth going and coming: and they began to be abated after a hundred and fifty days.

And the ark rested in the seventh month, the seven and twentieth day of the month, upon the mountains of Armenia.

The waters were going and decreasing until the tenth month: for in the tenth month, the first day of the month, the tops of the mountains appeared.

And after that forty days were passed, Noe, opening the window of the ark which he had made, sent forth a raven:

Which went forth and did not return, till the waters were dried up on the earth.

He sent forth also a dove after him, to see if the waters had now ceased upon the face of the earth.

But she, not finding where her foot might rest, returned to him into the ark: for the waters were upon the whole earth: and he put forth his hand, and caught her, and brought her into the ark.

And having waited yet seven other days, he again sent forth the dove out of the ark.

And she came to him in the evening, carrying a bough of an olive tree with green leaves, in her mouth. Noe therefore understood that the waters were ceased upon the earth.

And he stayed yet seven other days: and he sent forth the dove, which returned not any more unto him.

Therefore in the six hundredth and first year, the first month, the first day of the month, the waters were lessened upon the earth. And Noe opening the covering of the ark, looked, and saw that the face of the earth was dried.

In the second month, the seven and twentieth day of the month, the earth was dried.

And God spoke to Noe, saying:

Go out of the ark, thou and thy wife, thy sons, and the wives of thy sons with thee.

All living things that are with thee of all flesh, as well in fowls as in beasts, and all creeping things that creep upon the earth, bring out with thee, and go ye upon the earth: increase and multiply upon it.

So Noe went out, he and his sons: his wife, and the wives of his sons with him.

And all living things, and cattle, and creeping things that creep upon the earth, according to their kinds, went out of the ark.

And Noe built an altar unto the Lord: and taking of all cattle and fowls that were clean, offered holocausts upon the altar.

And the Lord smelled a sweet savour, and said: I will no more

curse the earth for the sake of man: for the imagination and thought of man's heart are prone to evil from his youth: therefore I will no more destroy every living soul as I have done.

All the days of the earth, seedtime and harvest, cold and heat, summer and winter, night and day, shall not cease.

### 9:1–24

And God blessed Noe and his sons. And he said to them: Increase and multiply, and fill the earth.

And let the fear and dread of you be upon all the beasts of the earth, and upon all the fowls of the air, and all that move upon the earth: all the fishes of the sea are delivered into your hand.

And every thing that moveth and liveth shall be meat for you: even as the green herbs have I delivered them all to you:

Saving that flesh with blood you shall not eat.

For I will require the blood of your lives at the hand of every beast, and at the hand of man. At the hand of every man, and of his brother, will I require the life of man.

Whosoever shall shed man's blood, his blood shall be shed: for man was made to the image of God.

But increase you and multiply; and go upon the earth, and fill it.

Thus also said God to Noe, and to his sons with him:

Behold, I will establish my covenant with you, and with your seed after you.

And with every living soul that is with you, as well in all birds as in cattle and beasts of the earth, that are come forth out of the ark: and in all the beasts of the earth.

I will establish my covenant with you: and all flesh shall be no more destroyed with the waters of a flood: neither shall there be from henceforth a flood to waste the earth.

And God said: This is the sign of the covenant which I give between me and you, and to every living soul that is with you, for perpetual generations.

I will set my bow in the clouds, and it shall be the sign of a covenant between me, and between the earth.

And when I shall cover the sky with clouds, my bow shall appear in the clouds:

And I will remember my covenant with you, and with every living soul that beareth flesh: and there shall no more be waters of a flood to destroy all flesh.

And the bow shall be in the clouds, and I shall see it, and shall remember the everlasting covenant, that was made between God and every living soul of all flesh which is upon the earth.

And God said to Noe: This shall be the sign of the covenant which I have established between me and all flesh upon the earth.

And the sons of Noe who came out of the ark, were Sem, Cham, and Japheth: and Cham is the father of Chanaan.

These three are the sons of Noe: And from these was all mankind spread over the whole earth.

And Noe, a husbandman, began to till the ground, and planted a vineyard.

And drinking of the wine was made drunk, and was uncovered in his tent.

Which when Cham the father of Chanaan had seen, to wit, that his father's nakedness was uncovered, he told it to his two brethren without.

But Sem and Japheth put a cloak upon their shoulders, and going backward covered the nakedness of their father: and their faces were turned away, and they saw not their father's nakedness.

## Matthew 1:1–25 *

The book of the generation of Jesus Christ, the son of David, the son of Abraham:

Abraham begot Isaac. And Isaac begot Jacob. And Jacob begot Judas and his brethren.

And Judas begot Phares and Zara of Thamar. And Phares begot Esron. And Esron begot Aram.

And Aram begot Aminadab. And Aminadab begot Naasson. And Naasson begot Salmon.

And Salmon begot Booz of Rahab. And Booz begot Obed of Ruth. And Obed begot Jesse.

And Jesse begot David the king. And David the king begot Solomon of her that had been the wife of Urias.

And Solomon begot Roboam. And Roboam begot Abia. And Abia begot Asa.

And Asa begot Josaphat. And Josaphat begot Joram. And Joram begot Ozias.

And Ozias begot Joatham. And Joatham begot Achaz. And Achaz begot Ezechias.

And Ezechias begot Manasses. And Manasses begot Amon. And Amon begot Josias.

And Josias begot Jechonias and his brethren in the transmigration of Babylon.

* Reims-Douay Version, translated from the Vulgate.

And after the transmigration of Babylon, Jechonias begot Salathiel. And Salathiel begot Zorobabel.

And Zorobabel begot Abiud. And Abiud begot Eliacim. And Eliacim begot Azor.

And Azor begot Sadoc. And Sadoc begot Achim. And Achim begot Eliud.

And Eliud begot Eleazar. And Eleazar begot Mathan. And Mathan begot Jacob.

And Jacob begot Joseph, the husband of Mary, of whom was born Jesus, who is called Christ.

So all the generations, from Abraham to David are fourteen generations. And from David to the transmigration of Babylon are fourteen generations; and from the transmigration of Babylon to Christ are fourteen generations.

Now the generation of Christ was in this wise. When his mother Mary was espoused to Joseph, before they came together, she was found with child, of the Holy Ghost.

Whereupon Joseph her husband, being a just man and not willing publicly to expose her, was minded to put her away privately.

But while he thought on these things, behold the angel of the Lord appeared to him in his sleep, saying: Joseph, son of David, fear not to take unto thee Mary thy wife, for that which is conceived in her, is of the Holy Ghost.

And she shall bring forth a son: and thou shalt call his name Jesus. For he shall save his people from their sins.

Now all this was done that it might be fulfilled which the Lord spoke by the prophet, saying:

Behold a virgin shall be with child and bring forth a son; and they shall call his name Emmanuel, which being interpreted is, God with us.

And Joseph rising up from sleep did as the angel of the Lord had commanded him and took unto him his wife.

And he knew her not till she brought forth her firstborn son: and he called his name Jesus.

## Giovanni Pico della Mirandola, from the *Oration on the Dignity of Man*—[*ca.* 1486]*

Giovanni Pico della Mirandola (1463–1494) was the youthful stormy petrel of the Florentine Neoplatonic movement, to which at several

* Trans. Elizabeth Livermore Forbes, in *The Renaissance Philosophy of Man*, ed. Ernst Cassirer and others (Chicago, University of Chicago Press, 1948), pp. 223–227.

points in his own lifetime Michelangelo appears to have been strongly attracted. Pico was himself a genius who mastered several ancient languages, including Hebrew, in order to read and then incorporate into a new encyclopedic doctrine the beliefs and lore of all religions known in his time. He "reduced" his system to no less than nine hundred theses which he proposed to argue in Rome in 1485; some thirteen of these were found heretical and the presentation never came off. There remains the text of the introduction intended for the occasion of that ill-fated venture which was ultimately published separately as the *Oration on the Dignity of Man*. This is perhaps the clearest available exposition of the mystical Renaissance Neoplatonic approach to God and knowledge. As a humanist, Pico stands at the highest level of idealistic scholarship. As a member of the circle of Lorenzo de' Medici, he must have been known personally to Michelangelo. It is interesting to place Pico's metaphysical and metaphorical vision of the Creation in the *Oration* against the account given in the Biblical Genesis and against the visual interpretation by Michelangelo of that account in the Sistine ceiling. Only the relevant portions of the *Oration* are given here.

I have read in the records of the Arabians, reverend Fathers, that Abdala the Saracen,[1] when questioned as to what on this stage of the world, as it were, could be seen most worthy of wonder, replied: "There is nothing to be seen more wonderful than man." In agreement with this opinion is the saying of Hermes Trismegistus: "A great miracle, Asclepius, is man." [2] But when I weighed the reason for these maxims, the many grounds for the excellence of human nature reported by many men failed to satisfy me—that man is the intermediary between creatures, the intimate of the gods, the king of the lower beings, by the acuteness of his senses, by the discernment of his reason, and by the light of his intelligence the interpreter of nature, the interval between fixed eternity and fleeting time, and (as the Persians say) the bond, nay, rather, the marriage song of the world, on David's testimony but little lower than the angels.[3] Admittedly great though these reasons be, they are not the principal grounds, that is, those which may rightfully claim for themselves the privilege of the highest admiration. For why should we not admire more the angels themselves and the blessed choirs of heaven? At last it seems to me I have come to understand why man is the most fortunate of creatures and consequently worthy of all admiration and what precisely is that rank which is his lot in the universal chain of Being—a rank to be envied not only by brutes but even by the stars and by minds beyond this world. It is a matter past faith and a wondrous one. Why

1. Abdala, that is, Abd Allah, probably the cousin of Mohammed [Forbes].
2. Asclepius I, 6, *Hermetica*, ed. W. Scott, I, p. 294 [Ed.].
3. Ps. 8:5 [Ed.].

should it not be? For it is on this very account that man is rightly called and judged a great miracle and a wonderful creature indeed.

But hear, Fathers, exactly what this rank is and, as friendly auditors, conformably to your kindness, do me this favor. God the Father, the supreme Architect, had already built this cosmic home we behold, the most sacred temple of His godhead, by the laws of His mysterious wisdom. The region above the heavens He had adorned with Intelligences, the heavenly spheres He had quickened with eternal souls, and the excrementary and filthy parts of the lower world He had filled with a multitude of animals of every kind. But, when the work was finished, the Craftsman kept wishing that there were someone to ponder the plan of so great a work, to love its beauty, and to wonder at its vastness. Therefore, when everything was done (as Moses and Timaeus bear witness), He finally took thought concerning the creation of man. But there was not among His archetypes that from which He could fashion a new offspring, nor was there in His treasure houses anything which He might bestow on His new son as an inheritance, nor was there in the seats of all the world a place where the latter might sit to contemplate the universe. All was now complete; all things had been assigned to the highest, the middle, and the lowest orders.[4] But in its final creation it was not the part of the Father's power to fail as though exhausted. It was not the part of His wisdom to waver in a needful matter through poverty of counsel. It was not the part of His kindly love that he who was to praise God's divine generosity in regard to others should be compelled to condemn it in regard to himself.

At last the best of artisans ordained that that creature to whom He had been able to give nothing proper to himself should have joint possession of whatever had been peculiar to each of the different kinds of being. He therefore took man as a creature of indeterminate nature and, assigning him a place in the middle of the world, addressed him thus: "Neither a fixed abode nor a form that is thine alone nor any function peculiar to thyself have we given thee, Adam, to the end that according to thy longing and according to thy judgment thou mayest have and possess what abode, what form, and what functions thou thyself shalt desire. The nature of all other beings is limited and constrained within the bounds of laws prescribed by Us. Thou, constrained by no limits, in accordance with thine own free will, in whose hand We have placed thee, shalt ordain for thyself the limits of thy

4. *Cf.* Plato, *Protagoras* [Ed.].

nature. We have set thee at the world's center that thou mayest from thence more easily observe whatever is in the world. We have made thee neither of heaven nor of earth, neither mortal nor immortal, so that with freedom of choice and with honor, as though the maker and molder of thyself, thou mayest fashion thyself in whatever shape thou shalt prefer. Thou shalt have the power to degenerate into the lower forms of life, which are brutish. Thou shalt have the power, out of thy soul's judgment, to be reborn into the higher forms, which are divine."

O supreme generosity of God the Father, O highest and most marvelous felicity of man! To him it is granted to have whatever he chooses, to be whatever he wills. Beasts as soon as they are born (so says Lucilius) [5] bring with them from their mother's womb all they will ever possess. Spiritual beings, either from the beginning or soon thereafter, become what they are to be for ever and ever. On man when he came into life the Father conferred the seeds of all kinds and the germs of every way of life. Whatever seeds each man cultivates will grow to maturity and bear in him their own fruit. If they be vegetative, he will be like a plant. If sensitive, he will become brutish. If rational, he will grow into a heavenly being. If intellectual, he will be an angel and the son of God.[6] And if, happy in the lot of no created thing, he withdraws into the center of his own unity, his spirit, made one with God, in the solitary darkness of God, who is set above all things, shall surpass them all. Who would not admire this our chameleon? Or who could more greatly admire aught else whatever? It is man who Asclepius of Athens, arguing from his mutability of character and from his self-transforming nature, on just grounds says was symbolized by Proteus in the mysteries. Hence those metamorphoses renowned among the Hebrews and the Pythagoreans.

For the occult theology of the Hebrews sometimes transforms the holy Enoch into an angel of divinity whom they call *"Mal'akh Adonay Shebaoth"* [Angel of the Lord of Hosts], and sometimes transforms others into other divinities.[7] The Pythagoreans degrade impious men into brutes and, if one is to believe Empedocles, even into plants. Mohammed, in imitation, often had this saying on his tongue: "They who have deviated from divine law become beasts,"

5. Frag. 623 (Marx) [Ed.].
6. *Cf.* Marsilio Ficino, *Theologia platonica de immortalitate animorum,* XIV, 3 [Ed.].
7. Book of Enoch 40:8 [Ed.].

and surely he spoke justly. For it is not the bark that makes the plant but its senseless and insentient nature; neither is it the hide that makes the beast of burden but its irrational, sensitive soul; neither is it the orbed form that makes the heavens but their undeviating order; nor is it the sundering from body but his spiritual-intelligence that makes the angel. For if you see one abandoned to his appetites crawling on the ground, it is a plant and not a man you see; if you see one blinded by the vain illusions of imagery, as it were of Calypso, and, softened by their gnawing allurement, delivered over to his senses, it is a beast and not a man you see. If you see a philosopher determining all things by means of right reason, him you shall reverence: he is a heavenly being and not of this earth. If you see a pure contemplator, one unaware of the body and confined to the inner reaches of the mind, he is neither an earthly nor a heavenly being; he is a more reverened divinity vested with human flesh.

Are there any who would not admire man, who is, in the sacred writings of Moses and the Christians, not without reason described sometimes by the name of "all flesh," sometimes by that of "every creature," inasmuch as he himself molds, fashions, and changes himself into the form of all flesh and into the character of every creature? For this reason the Persian Euanthes, in describing the Chaldaean theology, writes that man has no semblance that is inborn and his very own but many that are external and foreign to him; whence this saying of the Chaldaeans: *Hanorish tharah sharinas*," that is, "Man is a being of varied, manifold, and inconstant nature." [8] But why do we emphasize this? To the end that after we have been born to this condition—that we can become what we will—we should understand that we ought to have especial care to this, that it should never be said against us that, although born to a privileged position, we failed to recognize it and became like unto wild animals and senseless beasts of burden, but that rather the saying of Asaph the prophet should apply: "Ye are all angels and sons of the Most High," [9] and that we may not, by abusing the most indulgent generosity of the Father, make for ourselves that freedom of choice He has given into something harmful instead of salutary. Let a certain holy ambition invade our souls, so that, not content with the mediocre, we shall pant after the highest and (since we may if we wish) toil with all our strength to obtain it.

Let us disdain earthly things, despise heavenly things, and, finally, esteeming less whatever is of the world, hasten to that court which

8. The source of this quotation could not be discovered [Ed.].
9. *Cf.* Ps. 82:6 [Ed.].

is beyond the world and nearest to the Godhead. There, as the sacred mysteries relate, Seraphim, Cherubim, and Thrones hold the first places; let us, incapable of yielding to them, and intolerant of a lower place, emulate their dignity and their glory. If we have willed it, we shall be second to them in nothing.

But how shall we go about it, and what in the end shall we do? Let us consider what they do, what sort of life they lead. If we also come to lead that life (for we have the power), we shall then equal their good fortune. The Seraph burns with the fire of love. The Cherub glows with the splendor of intelligence. The Throne stands by the steadfastness of judgment. Therefore if, in giving ourselves over to the active life, we have after due consideration undertaken the care of the lower beings, we shall be strengthened with the firm stability of Thrones. If, unoccupied by deeds, we pass our time in the leisure of contemplation, considering the Creator in the creature and the creature in the Creator, we shall be all ablaze with Cherubic light. If we long with love for the Creator himself alone, we shall speedily flame up with His consuming fire into a Seraphic likeness. Above the Throne, that is, above the just judge, God sits as Judge of the ages. Above the Cherub, that is, above him who contemplates, God flies, and cherishes him, as it were, in watching over him. For the spirit of the Lord moves upon the waters, the waters, I say, which are above the firmament [10] and which in Job praise the Lord with hymns before dawn. Whoso is a Seraph, that is, a lover, is in God and God in him, nay, rather, God and himself are one. Great is the power of Thrones, which we attain in using judgment, and most high the exaltation of Seraphs, which we attain in loving.

But by what means is one able either to judge or to love things unknown? Moses loved a God whom he saw and, as judge, administered among the people what he had first beheld in contemplation upon the mountain. Therefore, the Cherub as intermediary by his own light makes us ready for the Seraphic fire and equally lights the way to the judgment of the Thrones. This is the bond of the first minds . . . the chief of contemplative philosophy. This is the one for us first to emulate, to court, and to understand; the one from whence we may be rapt to the heights of love and descend, well taught and well prepared, to the functions of active life. But truly it is worth while, if our life is to be modeled on the example of the Cherubic life, to have before our eyes and clearly understood both its nature and its quality and those things which are the deeds and the labor of Cherubs. But

10. Gen. 1, 2 [Ed.].

since it is not permitted us to attain this through our own efforts, we who are but flesh and know of the things of earth, let us go to the ancient fathers who, inasmuch as they were familiar and conversant with these matters, can give sure and altogether trustworthy testimony. Let us consult the Apostle Paul, the chosen vessel,[11] as to what he saw the hosts of Cherubim doing when he was himself exalted to the third heaven. He will answer, according to the interpretation of Dionysius,[12] that he saw them being purified, then being illuminated, and at last being made perfect. Let us also, therefore, by emulating the Cherubic way of life on earth, by taming the impulses of our passions with moral science, by dispelling the darkness of reason with dialectic, and by, so to speak, washing away the filth of ignorance and vice, cleanse our soul, so that her passions may not rave at random nor her reason through heedlessness ever be deranged.

Then let us fill our well-prepared and purified soul with the light of natural philosophy, so that we may at last perfect her in the knowledge of things divine. And lest we be satisfied with those of our faith, let us consult the patriarch Jacob, whose form gleams carved on the throne of glory. Sleeping in the lower world but keeping watch in the upper, the wisest of fathers will advise us. But he will advise us through a figure (in this way everything was wont to come to those men) that there is a ladder extending from the lowest earth to the highest heaven, divided in a series of many steps, with the Lord seated at the top, and angels in contemplation ascending and descending over them alternately by turns.[13]

If this is what we must practice in our aspiration to the angelic way of life, I ask: "Who will touch the ladder of the Lord either with fouled foot or with unclean hands?" As the sacred mysteries have it, it is impious for the impure to touch the pure. But what are these feet? What these hands? Surely the foot of the soul is that most contemptible part by which the soul rests on matter as on the soil of the earth, I mean the nourishing and feeding power, the tinder of lust, and the teacher of pleasurable weakness. Why should we not call the hands of the soul its irascible power, which struggles on its behalf as the champion of desire and as plunderer seizes in the dust and sun

11. Acts 9:15 [Ed.].
12. Dionysius the Areopagite. The writings current under that name, composed by an unknown author probably about A.D. 500, were long attributed to Dionysius, the disciple of Paul, and hence enjoyed an enormous authority [Forbes].
13. Gen. 28:12 [Ed.].

what desire will devour slumbering in the shade? These hands, these feet, that is, all the sentient part whereon resides the attraction of the body which, as they say, by wrenching the neck holds the soul in check, lest we be hurled down from the ladder as impious and unclean, let us bathe in moral philosophy as if in a living river. Yet this will not be enough if we wish to be companions of the angels going up and down on Jacob's ladder, unless we have first been well fitted and instructed to be promoted duly from step to step, to stray nowhere from the stairway, and to engage in the alternate comings and goings. Once we have achieved this by the art of discourse or reasoning, then, inspired by the Cherubic spirit, using philosophy through the steps of the ladder, that is, of nature, and penetrating all things from center to center, we shall sometimes descend, with titanic force rending the unity like Osiris into many parts, and we shall sometimes ascend, with the force of Phoebus collecting the parts like the limbs of Osiris into a unity, until, resting at last in the bosom of the Father who is above the ladder, we shall be made perfect with the felicity of theology.

Let us also inqure of the just Job, who entered into a life-covenant with God before he himself was brought forth into life, what the most high God requires above all in those tens of hundreds of thousands who attend him. He will answer that it is peace, in accord with what we read in him: "He maketh peace in his high places." [14] And since the middle order expounds to the lower orders the counsel of the highest order, let Empedocles the philosopher expound to us the words of Job the theologian. He indicates to us a twofold nature present in our souls, by one side of which we are raised on high to the heavenly regions, and by the other side plunged downward into the lower, through strife and friendship or through war and peace, as he witnesses in the verses in which he makes complaint that he is being driven into the sea, himself goaded by strife and discord into the semblance of a madman and a fugitive from the gods. [15]

Surely, Fathers, there is in us a discord many times as great; we have at hand wars grievous and more than civil, [16] wars of the spirit which, if we dislike them, if we aspire to that peace which may so raise us to the sublime that we shall be established among the exalted of the Lord, only philosophy will entirely allay and subdue in us. In the first place, if our man but ask a truce of his enemies, moral phi-

14. Job 25:2 [Ed.].
15. Frag. 115, 13–14 (Diels) [Ed.].
16. *Cf.* Lucan, *Pharsalia*, I, 1 [Ed.].

losophy will check the unbridled inroads of the many-sided beast and the leonine passions of wrath and violence. If we then take wiser counsel with ourselves and learn to desire the security of everlasting peace, it will be at hand and will generously fulfil our prayers. After both beasts are felled like a sacrificed sow, it will confirm an inviolable compact of holiest peace between flesh and spirit. Dialectic will appease the tumults of reason made confused and anxious by inconsistencies of statement and sophisms of syllogisms. Natural philosophy will allay the strife and differences of opinion which vex, distract, and wound the spirit from all sides. But she will so assuage them as to compel us to remember that, according to Heraclitus, nature was begotten from war, that it was on this account repeatedly called "strife" by Homer, and that it is not, therefore, in the power of natural philosophy to give us in nature a true quiet and unshaken peace but that this is the function and privilege of her mistress, that is, of holiest theology. She will show us the way and as comrade lead us to her who, seeing us hastening from afar, will exclaim "Come to me, ye who have labored. Come and I will restore you. Come to me, and I will give you peace, which the world and nature cannot give you." [17]

When we have been so soothingly called, so kindly urged, we shall fly up with winged feet, like earthly Mercuries, to the embraces of our blessed mother and enjoy that wished-for peace, most holy peace, indivisible bond, of one accord in the friendship through which all rational souls not only shall come into harmony in the one mind which is above all minds but shall in some ineffable way become altogether one. This is that friendship which the Pythagoreans say is the end of all philosophy. This is that peace which God creates in his heavens, which the angels descending to earth proclaimed to men of good will,[18] that through it men might ascend to heaven and become angels. Let us wish this peace for our friends, for our century. Let us wish it for every home into which we go; let us wish it for our own soul, that through it she shall herself be made the house of God, and to the end that as soon as she has cast out her uncleanness through moral philosophy and dialectic, adorned herself with manifold philosophy as with the splendor of a courtier, and crowned the pediments of her doors with the garlands of theology, the King of Glory may descend and, coming with his Father, make his stay with her. If she show herself worthy of so great a guest, she shall, by the boundless mercy which is his, in golden raiment like a wedding gown, and surrounded by a varied throng of sciences, receive her beautiful guest

17. Matt. 11:28 and John 14:27 [Ed.].
18. Luke 2:14 [Ed.].

not merely as a guest but as a spouse from whom she will never be parted. She will desire rather to be parted from her own people and, forgetting her father's house and herself, will desire to die in herself in order to live in her spouse, in whose sight surely the death of his saints is precious [19]—death, I say, if we must call death that fulness of life, the consideration of which wise men have asserted to be the aim of philosophy.[20] * * *

# GIORGIO VASARI
## [On the Technique of Painting in the Sixteenth Century—1568]*

Giorgio Vasari (1511-1574) was a practicing painter and architect as well as the author of the *Lives of the Most Excellent Florentine Painters, Sculptors and Architects* in which he published first in 1550 and then in 1568 his biography of Michelangelo. These *Lives* are among the best-known products of Renaissance literary talent. Less well known is the theoretical Introduction with technical discussions of the three major arts that Vasari originally published at the beginning of the 1550 edition of the *Lives*. That Introduction, with its invaluable information on techniques and artistic practice of the first half of the sixteenth century, is usually omitted from popular editions of the *Lives*. Vasari was not only a Florentine painter in fresco, he was also a friend and a follower of Michelangelo. Consequently, what he has to say about the way one actually drew and painted in the Florentine style in his day should prove a most trustworthy guide to our surface knowledge of the frescoes painted by Michelangelo. The excerpts provided here are restricted to topics that might directly apply to one's modern understanding of the technique of the Sistine ceiling frescoes.

*Uses of Drawing in the Arts*

&ast;  &ast;  &ast;

In Sculpture, drawing is of service in the case of all the profiles, because in going round from view to view the sculptor uses it when he wishes to delineate the forms which please him best, or which he intends to bring out in every dimension, whether in wax, or clay, or marble, or wood, or other material.

In Painting, the lines are of service in many ways, but especially in

19. *Cf.* Ps. 116:15 [Ed.].
20. *Cf.* Plato, *Phaedo*, 81a [Ed.].
* From L. S. Maclehose and G. B. Brown, *Vasari on Technique* (New York, Dover, 1960; first published ed. London, Constable & Company Ltd., 1907).

outlining every figure, because when they are well drawn, and made correct and in proportion, the shadows and lights that are then added give the strongest relief to the lines of the figure and the result is all excellence and perfection. Hence it happens, that whoever understands and manages these lines well, will, with the help of practice and judgment, excel in each one of these arts. Therefore, he who would learn thoroughly to express in drawing the conceptions of the mind and anything else that pleases him, must, after he has in some degree trained his hand to make it more skilful in the arts, exercise it in copying figures in relief either in marble or stone, or else plaster casts taken from the life, or from some beautiful antique statue, or even from models in relief of clay, which may either be nude or clad in rags covered with clay to serve for clothing and drapery. All these objects being motionless and without feeling, greatly facilitate the work of the artist, because they stand still, which does not happen in the case of live things that have movement. When he has trained his hand by steady practice in drawing such objects, let him begin to copy from nature and make a good and certain practice herein, with all possible labour and diligence, for the things studied from nature are really those which do honour to him who strives to master them, since they have in themselves, besides a certain grace and liveliness, that simple and easy sweetness which is nature's own, and which can only be learned perfectly from her, and never to a sufficient degree from the things of art. Hold it moreover for certain, that the practice that is acquired by many years of study in drawing, as has been said above, is the true light of design and that which makes men really proficient. Now, having discoursed long enough on this subject let us go on to see what painting is.

### Of the Nature of Painting

A painting, then, is a plane covered with patches of colour on the surface of wood, wall, or canvas filling up the outlines spoken of above, which, by virtue of a good design of encompassing lines, surround the figure. If the painter treat his flat surface with right judgment, keeping the centre light and the edges and the background dark and medium colour between the light and dark in the intermediate spaces, the result of the combination of these three fields of colour will be that everything between the one outline and the other stands out and appears round and in relief. It is indeed true that these three shades cannot suffice for every object treated in detail, therefore it is necessary to divide every shade at least into two half shades, making of the light two half tints, and of the dark two lighter, and of the

medium two other half tints which incline one to the lighter and the other to the darker side. When these tints, being of one colour only whatever it may be, are gradated, we see a transition beginning with the light, and then the less light, and then a little darker, so that little by little we find the pure black. Having then made the mixtures, that is, these colours mixed together, and wishing to work with oil or tempera or in fresco, we proceed to fill in the outlines putting in their proper place the lights and darks, the half tints and the lowered tones of the half tints and the lights. I mean those tints mixed from the three first, light, medium and dark, which lights and medium tints and darks and lower tones are copied from the cartoon or other design which is made for any work before we begin to put it into execution. It is necessary that the design be carried out with good arrangement, firm drawing, and judgment and invention, seeing that the composition in a picture is not other than the parcelling out of the places where the figures come, so that the spaces be not unshapely but in accordance with the judgment of the eye, while the field is in one place well covered and in another void. All this is the result of drawing and of having copied figures from the life, or from models of figures made to represent anything one wishes to make. Design cannot have a good origin if it [has] not come from continued practice in copying natural objects, and from the study of pictures by excellent masters and of ancient statues in relief, as has been said many times. But above all, the best thing is to draw men and women from the nude and thus fix in the memory by constant exercise the muscles of the torso, back, legs, arms, and knees, with the bones underneath. Then one may be sure that through much study attitudes in any position can be drawn by help of the imagination without one's having the living forms in view. Again having seen human bodies dissected one knows how the bones lie, and the muscles and sinews, and all the order and conditions of anatomy, so that it is possible with greater security and more correctness to place the limbs and arrange the muscles of the body in the figures we draw. And those who have this knowledge will certainly draw the outlines of the figures perfectly, and these, when drawn as they ought to be, show a pleasing grace and beautiful style.

He who studies good painting and sculpture, and at the same time sees and understands the life, must necessarily have acquired a good method in art. Hence springs the invention which groups figures in fours, sixes, tens, twenties, in such a manner as to represent battles and other great subjects of art. This invention demands an innate propriety springing out of harmony and obedience; thus if a figure move to greet another, the figure saluted having to respond should not turn away. As with this example, so it is with all the rest. The sub-

ject may offer many varied motives different one from another, but the motives chosen must always bear relation to the work in hand, and to what the artist is in process of representing. He ought to distinguish between different movements and characteristics, making the women with a sweet and beautiful air and also the youths, but the old always grave of aspect, and especially the priests and persons in authority. He must always take care however, that everything is in relation to the work as a whole; so that when the picture is looked at, one can recognize in it a harmonious unity, wherein the passions strike terror, and the pleasing effects shed sweetness, representing directly the intention of the painter, and not the things he had no thought of. It is requisite therefore, for this purpose, that he form the figures which have to be spirited with movement and vigour, and that he make those which are distant to retire from the principal figures by means of shade and colour that gradually and softly become lower in tone. Thus the art will always be associated with the grace of naturalness and of delicate charm of colour, and the work be brought to perfection not with the stress of cruel suffering, so that men who look at it have to endure pain on account of the suffering which they see has been borne by the artist in his work, but rather with rejoicing at his good fortune in that his hand has received from heaven the lightness of movement which shows his painting to be worked out with study and toil certainly, but not with drudgery; so will it be that the figures, every one in its place, will not appear dead to him who observes them, but alive and true. Let painters avoid crudities, let it be their endeavour that the things they are always producing shall not seem painted, but show themselves alive and starting out of the canvas. This is the secret of sound design and the true method recognized by him who has painted as belonging to the pictures that are known and judged to be good.

### Sketches, Drawings, and Cartoons of Different Kinds

Sketches, of which mention has been made above, are in artists' language a sort of first drawing made to find out the manner of the pose, and the first composition of the work. They are made in the form of a blotch, and are put down by us only as a rough draft of the whole. Out of the artist's impetuous mood they are hastily thrown off, with a pen or other drawing instrument or with charcoal, only to test the spirit of that which occurs to him, and for this reason we call them sketches. From these come afterwards the drawings executed in a more finished manner, in the doing of which the artist tries with all possible diligence to copy from the life, if he does not feel himself

strong enough to be able to produce them from his own knowledge. Later on, having measured them with the compasses or by the eye, he enlarges from the small to a larger size according to the work in hand. Drawings are made in various materials, that is, either with red chalk, which is a stone coming from the mountains of Germany, soft enough to be easily sawn and reduced to a fine point suitable for marking on leaves of paper in any way you wish; or with black chalk that comes from the hills of France, which is of the same nature as the red. Other drawings in light and shade are executed on tinted paper which gives a middle shade; the pen marks the outlines, that is, the contour or profile, and afterwards half-tone or shadow is given with ink mixed with a little water which produces a delicate tint: further, with a fine brush dipped in white lead mixed with gum, the high lights are added. This method is very pictorial, and best shows the scheme of colouring. Many work with the pen alone, leaving the paper for the lights, which is difficult but in effect most masterly; and innumerable other methods are practised in drawing, of which it is not needful to make mention, because all represent the same thing, that is drawing.

The designs having been made in this way, the artist who wishes to work in fresco, that is, on the wall, must make cartoons; many indeed prepare them even for working on panel. The cartoons are made thus: sheets of paper, I mean square sheets, are fastened together with paste made of flour and water cooked on the fire. They are attached to the wall by this paste, which is spread two fingers' breadth all round on the side next the wall, and are damped all over by sprinkling cold water on them. In this moist state they are stretched so that the creases are smoothed out in the drying. Then when they are dry the artist proceeds, with a long rod, having a piece of charcoal at the end, to transfer to the cartoon (in enlarged proportions), to be judged of at a distance, all that in the small drawing is shown on the small scale. In this manner little by little he finishes, now one figure and now another. At this point the painters go through all the processes of their art in reproducing their nudes from the life, and the drapery from nature, and they draw the perspectives in the same schemes that have been adopted on a small scale in the first drawing, enlarging them in proportion.

If in these there should be perspective views, or buildings, these are enlarged with the net, which is a lattice of small squares that are made large on the cartoon, reproducing everything correctly, for of course when the artist has drawn out the perspectives in the small designs, taking them from the plan and setting up the elevations with the right contours, and making the lines diminish and recede by means of the intersections and the vanishing point, he must reproduce

them in proportion on the cartoon. But I do not wish to speak further of the mode of drawing these out, because it is a wearisome theme and difficult to explain. It is enough to say that perspectives are beautiful in so far as they appear correct when looked at, and diminish as they retire from the eye, and when they are composed of a varied and beautiful scheme of buildings. The painter must take care, too, to make them diminish in proportion by means of delicate gradations of colour that presuppose in the artist correct discretion and good judgment. The need of this is shown in the difficulty of the many confused lines gathered from the plan, the profile, and the intersection; but when covered with colour everything becomes clear, and in consequence the artist gains a reputation for skill and understanding and ingenuity in his art.

Many masters also before making the composition on the cartoon, adopt the plan of fashioning a model in clay on a plane and of setting up all the figures in the round to see the projections, that is, the shadows caused by a light being thrown on to the figures, which projections correspond to the shadow cast by the sun, that more sharply than any artificial light defines the figures by shade on the ground; and so portraying the whole of the work, they have marked the shadows that strike across now one figure, now another, whence it comes that on account of the pains taken the cartoons as well as the work reach the most finished perfection and strength, and stand out from the paper in relief. All this shows the whole to be most beautiful and highly finished.

### The Use of Cartoons in Mural and Panel Painting

When these cartoons are used for fresco or wall painting, every day at the junction with yesterday's work a piece of the cartoon is cut off and traced on the wall, which must be plastered afresh and perfectly smoothed. This piece of cartoon is put on the spot where the figure is to be, and is marked; so that next day, when another piece comes to be added, its exact place may be recognized, and no error can arise. Afterwards, for transferring the outlines on to the said piece, the artist proceeds to impress them with an iron stylus upon the coat of plaster, which, being fresh, yields to the paper and thus remains marked. He then removes the cartoon and by means of those marks traced on the wall goes on to work with colours; this then is how work in fresco or on the wall is carried out. This same tracing is done on panels and on canvas, but in this case the cartoon is all in one piece, the only difference being that it is necessary to rub the back of the cartoon with charcoal or black powder, so that when marked

afterwards with the instrument it may transmit the outlines and tracings to the canvas or panel. The cartoons are made in order to secure that the work shall be carried out exactly and in due proportion. There are many painters who for work in oil will omit all this; but for fresco work it must be done and cannot be avoided. Certainly the man who found out such an invention had a good notion, since in the cartoons one sees the effect of the work as a whole and these can be adjusted and altered until they are right, which cannot be done on the work itself.

## Foreshortenings

Our artists have had the greatest skill in foreshortening figures, that is, in making them appear larger than they really are; a foreshortening being to us a thing drawn in shortened view, which seeming to the eye to project forward has not the length or height that it appears to have; however, the mass, outlines, shadows, and lights make it seem to come forward and for this reason it is called foreshortened. Never was there painter or draughtsman that did better work of this sort than our Michelagnolo Buonarroti, and even yet no one has been able to surpass him, he has made his figures stand out so marvellously. For this work he first made models in clay or wax, and from these, because they remain stationary, he took the outlines, the lights, and the shadows, rather than from the living model. These foreshortenings give the greatest trouble to him who does not understand them because his intelligence does not help him to reach the depth of such a difficulty, to overcome which is a more formidable task than any other in painting. Certainly our old painters, as lovers of the art, found the solution of the difficulty by using lines in perspective, a thing never done before, and made therein so much progress that today there is true mastery in the execution of foreshortenings. Those who censure the method of foreshortening, I speak of our artists, are those who do not know how to employ it; and for the sake of exalting themselves go on lowering others. We have however a considerable number of master painters who, although skilful, do not take pleasure in making foreshortened figures, and yet when they see how beautiful they are and how difficult, they not only do not censure but praise them highly. Of these foreshortenings the moderns have given us some examples which are to the point and difficult enough, as for instance in a vault the figures which look upwards, are foreshortened and retire. We call these foreshortenings 'dal di sotto in su' (in the 'up from below' style), and they have such force that they pierce the vaults. These cannot be executed without study from the

life, or from models at suitable heights, else the attitudes and movements of such things cannot be caught. And certainly the difficulty in this kind of work calls forth the highest grace as well as great beauty, and results in something stupendous in art. You will find, in the *Lives of Our Artists,* that they have given very great salience to works of this kind, and labored to complete them perfectly, whence they have obtained great praise. The foreshortenings from beneath upwards (*di sotto in su*) are so named because the object represented is elevated and looked at by the eye raised upwards, and is not on the level line of the horizon: wherefore because one must raise the head in the wish to see them, and perceives first the soles of the feet and the other lower parts we find the said name justly chosen.

## On Colouring

Unity in painting is produced when a variety of different colours are harmonized together, these colours in all the diversity of many designs show the parts of the figures distinct the one from the other, as the flesh from the hair, and one garment different in colour from another. When these colours are laid on flashing and vivid in a disagreeable discordance so that they are like stains and loaded with body, as was formerly the wont with some painters, the design becomes marred in such a manner that the figures are left painted by the patches of colour rather than by the brush, which distributes the light and shade over the figures and makes them appear natural and in relief. All pictures then whether in oil, in fresco, or in tempera ought to be so blended in their colours that the principal figures in the groups are brought out with the utmost clearness, the draperies of those in front being kept so light that the figures which stand behind are darker than the first, and so little by little as the figures retire inwards, they become also in equal measure gradually lower in tone in the colour both of the flesh tints and of the vestments. And especially let there be great care always in putting the most attractive, the most charming, and the most beautiful colours on the principal figures, and above all on those that are complete and not cut off by others, because these are always the most conspicuous and are more looked at than others which serve as the background to the colouring of the former. A sallow colour makes another which is placed beside it appear the more lively, and melancholy and pallid colours make those near them very cheerful and almost of a certain flaming beauty. Nor ought one to clothe the nude with heavy colours that would make too sharp a division between the flesh and the draperies when the said draperies

pass across the nude figures, but let the colours of the lights of the drapery be delicate and similar to the tints of the flesh, either yellowish or reddish, violet or purple, making the depths either green or blue or purple or yellow, provided that they tend to a dark shade and make a harmonious sequence in the rounding of the figures with their shadows; just as we see in the life, that those parts that appear nearest to our eyes, have most light and the others, retiring from view, lose light and colour.

In the same manner the colours should be employed with so much harmony that a dark and a light are not left unpleasantly contrasted in light and shade, so as to create a discordance and a disagreeable lack of unity, save only in the case of the projections, which are those shadows that the figures throw one on to the other, when a ray of light strikes on a principal figure, and makes it darken the second with its projected shadow. And these again when they occur must be painted with sweetness and harmony, because he who throws them into disorder makes that picture look like a coloured carpet or a handful of playing cards, rather than blended flesh or soft clothing or other things that are light, delicate, and sweet. For as the ear remains offended by a strain of music that is noisy, jarring or hard—save however in certain places and times, as I said of the stron̪ shadows—so the eye is offended by colours that are overcharged or crude. As the too fiery mars the design; so the dim, sallow, flat, and overdelicate makes a thing appear quenched, old, and smokedried; but the concord that is established between the fiery and the flat tone is perfect and delights the eye just as harmonious and subtle music delights the ear. Certain parts of the figures must be lost in the obscure tints and in the background of the group; for, if these parts were to appear too vivid and fiery, they would confound the distinction between the figures, but by remaining dark and hazy almost as background they give even greater force to the others which are in front. Nor can one believe how much grace and beauty is given to the work by varying the colours of the flesh, making the complexion of the young fresher than that of the old, giving to the middle-aged a tint between a brickcolour and a greenish yellow; and almost in the same way as in drawing one contrasts the mien of the old with that of youths and young girls and children, so the sight of one face soft and plump, and another fresh and blooming, makes in the painting a most harmonious dissonance.

In this way one ought, in working, to put the dark tints where they are least conspicuous and make least division, in order to bring out the figures, as is seen in the pictures of Raffaello da Urbino and of other

excellent painters who have followed this manner. One ought not however to hold to this rule in the groups where the lights imitate those of the sun and moon or of fires or bright things at night, because these effects are produced by means of hard and sharp contrasts as happens in life. And in the upper part, wherever such a light may strike there will always be sweetness and harmony. One can recognize in those pictures which possess these qualities that the intelligence of the painter has by the harmony of his colours assured the excellence of the design, given charm to the picture, and prominence and stupendous force to the figures.

### The Fresco Process

Of all the methods that painters employ, painting on the wall is the most masterly and beautiful, because it consists in doing in a single day that which, in the other methods, may be retouched day after day, over the work already done. Fresco was much used among the ancients, and the older masters among the moderns have continued to employ it. It is worked on the plaster while it is fresh and must not be left till the day's portion is finished. The reason is that if there be any delay in painting, the plaster forms a certain slight crust whether from heat or cold or currents of air or frost whereby the whole work is stained and grows mouldy. To prevent this the wall that is to be painted must be kept continually moist; and the colours employed thereon must all be of earths and not metallic and the white of calcined travertine. There is needed also a hand that is dexterous, resolute and rapid, but most of all a sound and perfect judgment; because while the wall is wet the colours show up in one fashion, and afterwards when dry they are no longer the same. Therefore in these works done in fresco it is necessary that the judgement of the painter should play a more important part than his drawing, and that he should have for his guide the very greatest experience, it being supremely difficult to bring fresco work to perfection. Many of our artists excel in the other kinds of work, that is, in oil or in tempera, but in this do not succeed, fresco being truly the most manly, most certain, most resolute and durable of all the other methods, and as time goes on it continually acquires infinitely more beauty and harmony than do the others. Exposed to the air fresco throws off all impurities, water does not penetrate it, and it resists anything that would injure it. But beware of having to retouch it with colours that contain size prepared from parchment, or the yolk of egg, or gum or tragacanth, as many painters do, for besides preventing the wall from showing

up the work in all clearness, the colours become clouded by that re-
touching and in a short time turn black. Therefore let those who de-
sire to work on the wall work boldly in fresco and not retouch in
the dry [*a secco*], because, besides being a very poor thing in itself,
it renders the life of the pictures short. * * *

# CRITICAL ESSAYS

# CRITICISM AND ESTHETICS

## SIR JOSHUA REYNOLDS
Discourse XV—[1790]*

Sir Joshua Reynolds (1723–1792) was the first (and, without question, the most distinguished) president of the Royal Academy. In this capacity he gave to the members and students over a number of years a famous series of lectures, known as the *Discourses on Art*. Reynolds was himself an extremely gifted writer, a member of the close literary circle called the Club, and thus a friend of such literary lights as Boswell, Johnson, and Edmund Burke. In his younger days Reynolds made the virtually prescribed journey to Italy where he studied not only the "timeless" monuments of the antique but the works of the so-called Moderns among whom in the mid-eighteenth century Michelangelo was placed with Raphael, at the summit. Reynolds wrote in the style of the Augustan Age of English letters; his esthetics, much like those of Burke, centered ultimately on the notions of the "Grand Style" and of the "Sublime." The following passages on the Sistine ceiling come from the last of all the *Discourses*, published only two years before Reynolds' death.

\*      \*      \*

I WOULD ASK any man qualified to judge of such works, whether he can look with indifference at the personification of the Supreme Being in the center of the Capella Sestina [*sic*], or the figures of the Sybils [*sic*] which surround that chapel, to which we may add the statue of Moses; and whether the same sensations are not excited by those works, as what he may remember to have felt from the most sublime passages of Homer? I mention those figures more particularly, as they come nearer to a comparison with his Jupiter, his demi-gods, and heroes; those Sybils and Prophets being a kind of intermediate beings between men and angels. Though instances may be produced in the

* From *Discourses on Art*, ed. R. W. Wark (San Marino, Cal., Huntington Library, 1959; reissued in paperback by Collier Books, 1966), pp. 275–279.

works of other Painters, which may justly stand in competition with those I have mentioned, such as the *Isaiah*, and *The Vision of Ezekiel*, by Raffaelle, the *St. Mark* of Frate Bartolomeo, and many others; yet these, it must be allowed, are inventions so much in Michael Angelo's manner of thinking, that they may be truly considered as so many rays, which discover manifestly the center from whence they emanated.

The sublime in Painting, as in Poetry, so overpowers, and takes such a possession of the whole mind, that no room is left for attention to minute criticism. The little elegancies of art in the presence of these great ideas thus greatly expressed, lose all their value, and are, for the instant at least, felt to be unworthy of our notice. The correct judgment, the purity of taste, which characterise Raffaele, the exquisite grace of Correggio and Parmegiano, all disappear before them.

That Michael Angelo was capricious in his inventions, cannot be denied; and this may make some circumspection necessary in studying his works; for though they appear to become him, an imitation of them is always dangerous, and will prove sometimes ridiculous. "Within that circle none durst walk but he." To me, I confess, his caprice does not lower the estimation of his genius, even though it is sometimes, I acknowledge, carried to the extreme: and however those eccentrick excursions are considered, we must at the same time recollect, that those faults, if they are faults, are such as never could occur to a mean and vulgar mind; that they flowed from the same source which produced his greatest beauties, and were therefore such as one but himself was capable of committing; they were the powerful impulses of a mind unused to subjection of any kind, and too high to be controlled by cold criticism.

Many see his daring extravagance, who can see nothing else. A young Artist finds the works of Michael Angelo so totally different from those of his own master, or of those with whom he is surrounded, that he may be easily persuaded to abandon and neglect studying a style, which appears to him wild, mysterious, and above his comprehension, and which he therefore feels no disposition to admire; a good disposition, which he concludes that he should naturally have, if the style deserved it. It is necessary therefore that Students should be prepared for the disappointment which they may experience at their first setting out; and they must be cautioned, that probably they will not, at first sight, approve.

It must be remembered, that as this great style itself is artificial in the highest degree, it presupposes in the spectator, a cultivated and prepared artificial state of mind. It is an absurdity therefore to suppose that we are born with this taste, though we are with the seeds of it,

which, by the heat and kindly influence of his genius, may be ripened in us.

<div align="center">*     *     *</div>

In pursuing this great Art, it must be acknowledged that we labour under greater difficulties than those who were born in the age of its discovery, and whose minds from their infancy were habituated to this style; who learnt it as language, as their mother tongue. They had no mean taste to unlearn; they needed no persuasive discourse to allure them to a favourable reception of it, no abstruse investigation of its principles to convince them of the great latent truths on which it is founded. We are constrained, in these later days, to have recourse to a sort of Grammar and Dictionary, as the only means of recovering a dead language. It was by them learned by rote, and perhaps better learned that way than by precept.

The style of Michael Angelo, which I have compared to language, and which may, poetically speaking, be called the language of the Gods, now no longer exists, as it did in the fifteenth century; yet, with the aid of diligence, we may in a great measure supply the deficiency which I mentioned, of not having his works so perpetually before our eyes, by having recourse to casts from his models and designs in Sculpture; to drawings or even copies of those drawings; to prints, which however ill executed, still convey something by which this taste may be formed; and a relish may be fixed and established in our minds for this grand style of invention. Some examples of this kind we have in the Academy; and I sincerely wish there were more, that the younger Students might in their first nourishment, imbibe this taste; whilst others, though settled in the practice of the commonplace style of Painters, might infuse, by this means, a grandeur into their works.

I shall now make some remarks on the course which I think most proper to be pursued in such a study. I wish you not to go so much to the derivative streams, as to the fountain-head; though the copies are not to be neglected; because they may give you hints in what manner you may copy, and how the genius of one man may be made to fit the peculiar manner of another.

To recover this lost taste, I would recommend young Artists to study the works of Michael Angelo, as he himself did the works of the ancient Sculptors; he began, when a child, a copy of a mutilated Satyr's head, and finished in his model what was wanting in the original. In the same manner, the first exercise that I would recommend to the young artist when he first attempts invention, is to select every figure, if possible, from the inventions of Michael Angelo. If such borrowed figures will not bend to his purpose, and he is constrained

to make a change to supply a figure himself, that figure will necessarily be in the same style with the rest, and his taste will by this means be naturally initiated, and nursed in the lap of grandeur. He will sooner perceive what constitutes this grand style by one practical trial than by a thousand speculations, and he will in some sort procure to himself that advantage which in these later ages has been denied him; the advantage of having the greatest Artists for his master and instructor.

The next lesson should be, to change the purpose of the figures without changing the attitude, as Tintoret has done with the *Sampson* of Michael Angelo. Instead of the figure which Sampson bestrides, he has placed an eagle under him, and instead of the jawbone, thunder and lightening in his right hand; and thus it becomes a Jupiter. Titian, in the same manner, has taken the figure which represents God dividing the light from the darkness in the vault of the Capella Sestina, and has introduced it in the famous battle of Cadore, so much celebrated by Vasari; and extraordinary as it may seem, it is here converted to a General, falling from his horse. A real judge who should look at this picture, would immediately pronounce the attitude of that figure to be in a greater style than any other figure of the composition. These two instances may be sufficient, though many more might be given in their works, as well as in those of other great Artists.

When the Student has been habituated to this grand conception of the Art, when the relish for this style is established, makes a part of himself, and is woven into his mind, he will, by this time, have got a power of selecting from whatever occurs in nature that is grand, and corresponds with that taste which he has now acquired, and will pass over whatever is common-place and insipid. He may then bring to the mart such works of his own proper invention as may enrich and increase the general stock of invention in our Art.

## JOHN RUSKIN
from The Aesthetic and Mathematical
Schools of Art in Florence—[1874]*

John Ruskin (1819–1900) is still well known today for his altruistic, socio-esthetic theories in England and his doctrine of the inherent morality of great art. He brought art down from the peaks of the sublime to the man in the street, or more accurately, the man in the

* Lecture IV from John Ruskin, *Works*, Library Edition (1906), XXIII, pp. 212–214.

shop. After entering Christ Church College, Oxford, and while still an undergraduate, he spent two years in Italy, where he became fascinated by pre-1500—or "pre-Raphael"—Italian art. *The Stones of Venice* of 1851–1853 reflect his first enthusiasm for forms of art before 1500; consequently Michelangelo figures only in a minor way in Ruskin's characteristic thinking and writing of his first period. In 1869 he became Slade Professor of Art at Oxford, and his chief method of discourse turned to lecturing, where his vivid prose style, with its rolling cadences, was particularly effective. The excerpts printed here are from two lectures of the 1870's. They reveal a strikingly ambivalent attitude toward Michelangelo as an artist and, in esthetic attitude, a latent sympathy with the aims of the English Preraphaelite painters of his own day.

THE CONDITIONS OF aesthetic perception admit of no proof whether we are right or wrong; the contemplative painter, as such, is neither proud of what he sees without effort, nor angry if other people don't see the same, and this state of calm and modesty is very good for him. But the mathematic painter, laboriously ascertaining that he is right in every particular that may be tested, not only exults in his own knowledge, but is scornful of everybody who will not take the same pains and arrive at the same results—that is to say, very often scornful of persons much greater than himself—and he therefore becomes incapable of taking pleasure in their perceptions.

\*        \*        \*

Chiefly, with respect to Florentine art the greatest subjects on which it was occupied involved the exercise of the aesthetic faculty in what I ventured in my last lecture to call an insane degree of intensity; that is to say, to the point of actually seeing and hearing sights and sounds which had apparently no external cause. Now the mathematic mind, requiring demonstration and examination, necessarily refuses both its faith and its industry to visions of this nature, and therefore occupies itself necessarily with material objects only, or with abstract theorems.

For instance, Michael Angelo, who is the culminating power of the Mathematic school, paints his angels without wings. The masters of the Aesthetic school always had seen them with wings, and painted them so without asking any questions; but Michael Angelo, who never saw any, but only reasoned them out, and produced them by mathematic processes, necessarily felt; as an anatomist, the impossibility of their having wings, and could not, therefore, either logically or with any pleasure, represent them. And as it appears almost equally unreasonable to suppose that human bodies should float in the air without wings,—although in some cases, especially that of *The Crea-*

*tion of Adam,* he gives entire buoyancy by the help of drapery and cloud, and in others by gesture,—on the whole he likes to have his figure well down on the ground, and will always take more pains with a reeling Bacchus, a dying Adonis, or a recumbent Leda, than a flying Victory.

Nevertheless, and in face of all these dangers, the discipline of the Mathematic school is necessary to the perfection of the Aesthetic; and the group of consummate painters, with whom our study terminates, unite the inexplicable grasp of the one, with the indisputable accuracy of the other.

Today, however, we are to examine the character of the men who belonged specially to the Mathematic as an antagonist, or at least a distinct, body of artists, unsympathetic with the earlier visionary masters, and by their influence bringing about the victory, afterwards total, of scientific methods of art.

The Mathematic school begins with Niccola Pisano; culminates in Michael Angelo; its central captain is Brunelleschi. * * * Niccola Pisano taught * * * physical truth and trustworthiness in all things; Brunelleschi the dignity of abstract mathematical law; Michael Angelo the majesty of the human frame. To Niccola you owe the veracity, to Brunelleschi the harmony, and to Michael Angelo the humanity, of mathematic art.

## JOHN RUSKIN
from Ariadne Fiorentina—[1872]*

"Tu ne cede malis, sed contra fortior ito." [1]

Now I GOT THIS LINE out of the tablet in the engraving of *Raphael's Vision* [2] and had forgotten where it came from. And I thought I knew my sixth book of Virgil so well, that I never looked at it again * * * and it was only here at Assisi, the other day, wanting to look more accurately at the first scene by the lake Avernus, that I found I had been saved by the words of the Cumaean Sibyl.

"*Quam tua te Fortuna sinet,*" the completion of the sentence, has yet more and continual reaching in it for me now; as it has for all

---

* Lecture VI from John Ruskin, *Works,* Library Edition (1906), XXII, pp. 447–449.
1. Virgil, *Aeneid,* VI, 95: "*Tu ne cede malis, sed contra audentior ito,/ Quam tua te Fortuna sinet.*"
2. A plate by Marc Antonio that is called by this name since it is supposed to be after Raphael [Ed.].

men. Her opening words, which have become hackneyed, and lost all present power through vulgar use of them, contain yet one of the most immortal truths ever yet spoken for mankind; and they will never lose their power of help for noble persons. But observe, both in that lesson, "*Facilis descensus Averni,*" etc.; and in the still more precious, because universal, one on which the strength of Rome was founded,—the burning of the books, the Sibyl speaks only as the voice of Nature, and of her laws;—not as a divine helper, prevailing over death; but as a mortal teacher warning us against it, and strengthening us for our mortal time; but not for eternity. Of which lesson her own history is a part, and her habitation by the Avernus lake. She desires immortality, fondly and vainly, as we do ourselves. She receives, from the love of her *refused* lover, Apollo, not immortality, but length of life;—her years to be as the grains of dust in her hand. And even this she finds was a false desire; and her wise and holy desire at last is—to die. She wastes away; becomes a shade only, and a voice. The Nations ask her, What wouldst thou? She answers, Peace; only let my last words be true. "*L'ultimo mio parlar sie verace.*"

Therefore, if anything is to be conceived, rightly, and chiefly, in the form of the Cumaean Sibyl, it must be of fading virginal beauty, of enduring patience, of far-looking into futurity. "For after my death there shall yet return," she says, "another virgin."

"Jam redit et virgo;—redeunt Saturnia regna,
Ultima Cumaei venit jam carminis aetas." [3]

Here then is Botticelli's Cumaean Sibyl.[4] She is armed, for she is the prophetess of Roman fortitude;—but her faded breast scarcely raises the corselet; her hair floats, not falls, in waves like the currents of a river,—the sign of enduring life; the light is full on her forehead: she looks into the distance as in a dream. It is impossible for art to gather together more beautifully or intensely every image which can express her true power, or lead us to understand her lesson.

Now you do not, I am well assured, know one of Michael Angelo's sibyls from another: unless perhaps the Delphian, whom of course he makes as beautiful as he can. But of this especially Italian prophetess, one would have thought he might, at least in some way, have shown that he knew the history, even if he did not understand it. She might have had more than one book, at all events, to burn. She

3. Virgil, *Eclogues*, IV, 4, 5; but Ruskin transposes the lines [Ed.].
4. Plate XXXI of vol. XXII, Library edition of *Works*: actually an engraving believed by Ruskin to have been by Botticelli. (See fig. 139) [Ed.].

might have had a stray leaf or two fallen at her feet. He could not indeed have painted her only as a voice; but his anatomical knowledge need not have hindered him from painting her virginal youth, or her wasting and watching age, or her inspired hope of a holier future.

Opposite [5] fortunately, photographed from the figure itself, so that you can suspect me of no exaggeration,—is Michael Angelo's Cumaean Sibyl, wasting away. It is by a grotesque and most strange chance that he should have made the figure of this Sibyl, of all others in the chapel, the most fleshly and gross, even proceeding to the monstrous license of showing the nipples of the breast as if the dress were moulded over them like plaster. Thus he paints the poor nymph beloved of Apollo,—the clearest and queenliest in prophecy and command of all the sibyls,—as an ugly crone, with the arms of Goliath, poring down upon a single book.

## WALTER PATER
### from The Poetry of Michelangelo—[1871]*

Walter Horatio Pater (1839–1894), the "hermit of Brasenose College, Oxford," has been called a "pagan," an "Epicurean," and a "sensualist." Certainly his interests and the character of his writings were in contrast with Ruskin's; but as a stylist of English prose he was as great a master of the finely chiseled phrase and evocative image as his predecessor. These qualities mark his best known work, *Studies in the History of the Renaissance*, a collection of essays bound together by a unifying conclusion and published in 1873. In 1865 Pater had visited Italy. The essay on Michelangelo and his poetry (in which the Sistine ceiling figures prominently) of 1871, which was to become an important part of the *Studies*, evidently grew directly from intense visual impressions aroused by direct experience of Michelangelo's painting.

CRITICS OF Michelangelo have sometimes spoken as if the only characteristic of his genius were a wonderful strength, verging, as in the things of the imagination great strength always does, on what is singular or strange. A certain strangeness, something of the blossoming of the aloe, is indeed an element in all true works of art: that they shall excite or surprise us is indispensable. But that they shall give pleasure and exert a charm over us is indispensable too; and this

5. Plate XXXII of vol. XXII, Library edition of *Works*. (See fig. 68) [Ed.].

* From *Works of Walter Pater* (London-New York, Library Edition, 1900–1917), I, *The Renaissance*, pp. 73–97.

strangeness must be sweet also—a lovely strangeness. And to the true admirers of Michelangelo this is the true type of the Michelangelesque —sweetness and strength, pleasure with surprise, an energy of conception which seems at every moment about to break through all the conditions of comely form, recovering, touch by touch, a loveliness found usually only in the simplest natural things—*ex forti dulcedo.*

In this way he sums up for them the whole character of medieval art itself in that which distinguishes it most clearly from classical work, the presence of a convulsive energy in it, becoming in lower hands merely monstrous or forbidding, and felt, even in its most graceful products, as a subdued quaintness or grotesque. Yet those who feel this grace or sweetness in Michelangelo might at the first moment be puzzled if they were asked wherein precisely such quality resided. Men of inventive temperament—Victor Hugo, for instance, in whom, as in Michelangelo, people have for the most part been attracted or repelled by the strength, while few have understood his sweetness—have sometimes relieved conceptions of merely moral or spiritual greatness, but with little aesthetic charm of their own, by lovely accidents or accessories, like the butterfly which alights on the bloodstained barricade in *Les Misérables,* or those sea-birds for whom the monstrous Gilliatt comes to be as some wild natural thing, so that they are no longer afraid of him, in *Les Travailleurs de la Mer.* But the austere genius of Michelangelo will not depend for its sweetness on any mere accessories like these. The world of natural things has almost no existence for him; "When one speaks of him," says Grimm, "woods, clouds, seas, and mountains disappear, and only what is formed by the spirit of man remains behind"; and he quotes a few slight words from a letter of his to Vasari as the single expression in all he has left of a feeling for nature. He has traced no flowers, like those with which Leonardo stars over his gloomiest rocks; nothing like the fretwork of wings and flames in which Blake frames his most startling conceptions. No forest-scenery like Titian's fills his backgrounds, but only blank ranges of rock, and dim vegetable forms as blank as they, as in a world before the creation of the first five days.

Of the whole story of the creation he has painted only the creation of the first man and woman, and, for him at least, feebly, the creation of light. It belongs to the quality of his genius thus to concern itself almost exclusively with the making of man. For him it is not, as in the story itself, the last and crowning act of a series of developments, but the first and unique act, the creation of life itself in its supreme form, off-hand and immediately, in the cold and lifeless stone. With him the beginning of life has all the characteristics of resurrection; it is like the recovery of suspended health or animation, with its

gratitude, its effusion, and eloquence. Fair as the young men of the Elgin marbles, the Adam of the Sistine Chapel is unlike them in a total absence of that balance and completeness which express so well the sentiment of a self-contained, independent life. In that languid figure there is something rude and satyr-like, something akin to the rugged hillside on which it lies. His whole form is gathered into an expression of mere expectancy and reception; he has hardly strength enough to lift his finger to touch the finger of the creator; yet a touch of the finger-tips will suffice.

This creation of life—life coming always as relief or recovery, and always in strong contrast with the rough-hewn mass in which it is kindled—is in various ways the motive of all his work, whether its immediate subject be Pagan or Christian, legend or allegory; and this, although at least one-half of his work was designed for the adornment of tombs—the tomb of Julius, the tombs of the Medici. Not the Judgment but the Resurrection is the real subject of his last work in the Sistine Chapel; and his favourite Pagan subject is the legend of Leda, the delight of the world breaking from the egg of a bird. As I have already pointed out, he secures that ideality of expression which in Greek sculpture depends on a delicate system of abstraction, and in early Italian sculpture on lowness of relief, by an incompleteness, which is surely not always undesigned, and which, as I think, no one regrets, and trusts to the spectator to complete the half-emergent form. And as his persons have something of the unwrought stone about them, so, as if to realise the expression by which the old Florentine records describe a sculptor—*master of live stone*—with him the very rocks seem to have life. They have but to cast away the dust and scurf that they may rise and stand on their feet. He loved the very quarries of Carrara, those strange grey peaks which even at mid-day convey into any scene from which they are visible something of the solemnity and stillness of evening, sometimes wandering among them month after month, till at last their pale ashen colours seem to have passed into his painting; and on the crown of the head of the *David* there still remains a morsel of uncut stone, as if by one touch to maintain its connexion with the place from which it was hewn.

And it is in this penetrative suggestion of life that the secret of that sweetness of his is to be found. He gives us indeed no lovely natural objects like Leonardo or Titian, but only the coldest, most elementary shadowing of rock or tree; no lovely draperies and comely gestures of life, but only the austere truths of human nature; "simple persons"—as he replied in his rough way to the querulous criticism of Julius the Second, that there was no gold on the figures of the Sistine Chapel—"simple persons, who wore no gold on their garments"; but

he penetrates us with a feeling of that power which we associate with all the warmth and fulness of the world, the sense of which brings into one's thoughts a swarm of birds and flowers and insects. The brooding spirit of life itself is there; and the summer may burst out in a moment. * * *

* * *

Some of those whom the gods love die young. This man, because the gods loved him, lingered on to be of immense, patriarchal age, till the sweetness it had taken so long to secrete in him was found at last. Out of the strong came forth sweetness, *ex forti dulcedo*. The world had changed around him. The "new catholicism" had taken the place of the Renaissance. The spirit of the Roman Church had changed: in the vast world's cathedral which his skill had helped to raise for it, it looked stronger than ever. Some of the first members of the *Oratory* [1] were among his intimate associates. They were of a spirit as unlike as possible from that of Lorenzo, or Savonarola even. The opposition of the Reformation to art has been often enlarged upon; far greater was that of the Catholic revival. But in thus fixing itself in a frozen orthodoxy, the Roman Church had passed beyond him, and he was a stranger to it. In earlier days, when its beliefs had been in a fluid state, he too might have been drawn into the controversy. He might have been for spiritualising the papal sovereignty, like Savonarola; or for adjusting the dreams of Plato and Homer with the words of Christ, like Pico of Mirandola. But things had moved onward, and such adjustments were no longer possible. For himself, he had long since fallen back on that divine ideal, which above the wear and tear of creeds has been forming itself for ages as the possession of nobler souls. And now he began to feel the soothing influence which since that time the Roman church has often exerted over spirits too independent to be its subjects, you brought within the neighborhood of its action; consoled and tranquilized, as a traveler might be, resting for one evening in a strange city, by its stately aspect and the sentiment of its many fortunes, just with those fortunes he has nothing to say. So he lingers on; a *revenant*, as the French say, a ghost out of another age, in a world too coarse to touch his faint sensibilities very closely; dreaming, in a worn-out society, theatrical in its life, theatrical in its art, theatrical even in its devotion, on the morning of the world's history, on the primitive form of man, on the images under which that primitive world had conceived of spiritual forces.

---

1. A Roman religious association of the sixteenth century [Ed.].

I have dwelt on the thought of Michelangelo as thus lingering beyond his time in a world not his own, because, if one is to distinguish the peculiar savour of his work, he must be approached, not through his followers, but through his predecessors; not through the marbles of Saint Peter's, but through the work of the sculptors of the fifteenth century over the tombs and altars of Tuscany. He is the last of the Florentines, of those on whom the peculiar sentiment of the Florentines, of those on whom the peculiar sentiment of the Florence of Dante and Giotto descended. * * *

This discipleship of Michelangelo, this dependence of his on the tradition of the Florentine schools, is nowhere seen more clearly than in his treatment of the Creation. The Creation of Man had haunted the mind of the middle age like a dream; and weaving it into a hundred carved ornaments of capital or doorway, the Italian sculptors had early impressed upon it that pregnancy of expression which seems to give it many veiled meanings. As with other artistic conceptions of the middle age, its treatment became almost conventional, handed on from artist to artist, with slight changes, till it came to have almost an independent and abstract existence of its own. It was characteristic of the medieval mind thus to give an independent traditional existence to a special pictorial conception, or to a legend, like that of *Tristram* or *Tannhäuser*, or even to the very thoughts and substance of a book, like the *Imitation* [attributed to Thomas à Kempis], so that no single workman could claim it as his own, and the book, the image, the legend, had itself a legend, and its fortunes, and a personal history; and it is a sign of the medievalism of Michelangelo, that he thus receives from tradition his central conception, and does but add the last touches, in transferring it to the frescoes of the Sistine Chapel. * * *

## BERNARD BERENSON
### from *The Florentine Painters of the Renaissance*—[1896]*

Of all recent writers, Bernard Berenson is without much question the most familiar, by name, to English-speaking and English-reading students of Italian Renaissance painting today. His span of activity as a critic and historian of art was unusually long. He was writing acutely and with brilliance on his own, always interesting, reactions to works of art, to people, and to ideas right up to his death in 1962. He had be-

* Bernard Berenson, *The Florentine Painters of the Renaissance* (New York and London, G. P. Putnam's Sons, 1896; also appearing in several paperback editions).

gun to publish his works on art in the 1890's. This selection from
*The Florentine Painters of the Renaissance* dates from that early
period, when he was enthusiastically investigating the application of
the Jamesian concept of "ideated sensation" to works of Florentine
art and proposed the famous notion of "tactile values"—of which, of
course, the sculptural painting of Michelangelo could have stood as a
paradigm. Instead, in the passage on the Sistine ceiling he chose to
accent in a more poetic way the theme of nostalgic preoccupation
with tradition; in this there is an obvious and interesting connection
with Pater's view of the ceiling, to which Berenson's makes a fitting
pendant.

\* \* \*

THE GREAT Florentine artists, as we have seen, were, with scarcely an
exception, bent upon rendering the material significance of visible
things. This, little though they may have formulated it was the con-
scious aim of most of them; and in proportion as they emancipated
themselves from ecclesiastical dominion, and found among their em-
ployers men capable of understanding them, their aim became more
and more conscious and their striving more energetic. At last ap-
peared the man who was the pupil of nobody, the heir of everybody,
who felt profoundly and powerfully what to his precursors had been
vague instinct, who saw and expressed the meaning of it all. The seed
that produced him had already flowered into a Giotto, and once again
into a Masaccio; in him, the last of his race, born in conditions artisti-
cally most propitious, all the energies remaining in his stock were
concentrated, and in him Florentine art had its logical culmination.

Michelangelo had a sense for the materially significant as great as
Giotto's or Masaccio's, but he possessed means of rendering, inherited
from Donatello, Pollaiuolo, Verrocchio, and Leonardo—means that
had been undreamt of by Giotto or even by Masaccio. Add to this
that he saw clearly what before him had been felt only dimly, that
there was no other such instrument for conveying material significance
as the human nude. This fact is as closely dependent on the general
conditions of realizing objects as tactile values are on the psychology
of sight. We realize objects when we perfectly translate them into
terms of our own states, our own feelings. So obviously true is this,
that even the least poetically inclined among us, because we keenly
realize the movement of a railway train, to take one example out of
millions, speak of it as *going* or *running,* instead of *rolling on its
wheels,* thus being no less guilty of anthropomorphizing than the most
unregenerate savages. Of this same fallacy we are guilty every time
we think of anything whatsoever with the least warmth—we are
lending this thing some human attributes. The more we endow it
with human attributes, the less we merely know it, the more we
realize it, the more does it approach the work of art. Now there is

one and only one object in the visible universe which we need not anthropomorphize to realize—and that is man himself. His movements, his actions, are the only things we realize without any myth-making effort—directly. Hence, there is no visible object of such artistic possibilities as the human body; nothing with which we are so familiar; nothing, therefore, in which we so rapidly perceive changes; nothing, then, which if represented so as to be realized more quickly and vividly than in life, will produce its effect with such velocity and power, and so strongly confirm our sense of capacity for living.

Values of touch and movement, we remember, are the specifically artistic qualities in figure painting (at least, as practised by the Florentines), for it is through them chiefly that painting directly heightens life. Now while it remains true that tactile values can, as Giotto and Masaccio have for ever established, be admirably rendered on the draped figure, yet drapery is a hindrance, and, at the best, only a way out of a difficulty, for we *feel* it masking the really significant, which is *the form underneath*. A mere painter, one who is satisfied to reproduce what everybody sees, and to paint for the fun of painting, will scarcely comprehend this feeling. His only significant is the obvious—in a figure, the face and the clothing, as in most of the portraits manufactured nowadays. The artist, even when compelled to paint draped figures, will force the drapery to render the nude, in other words the material significance of the human body. But how much more clearly will this significance shine out, how much more convincingly will the character manifest itself, when between its perfect rendering and the artist nothing intervenes! And this perfect rendering is to be accomplished with the nude only.

If draperies are a hindrance to the conveyance of tactile values, they make the perfect rendering of movement next to impossible. To realize the play of muscle everywhere, to get the full sense of the various pressures and resistances, to receive the direct inspiration of the energy expended, we must have the nude; for here alone can we watch those tautnesses of muscle and those stretchings and relaxings and ripplings of skin which, translated into similar strains on our own persons, make us fully realize movement. Here alone the translation, owing to the multitude and the clearness of the appeals made, is instantaneous, and the consequent sense of increased capacity almost as great as can be attained; while in the draped figure we miss all the appeal of visible muscle and skin, and realize movement only after a slow translation of certain functional outlines, so that the sense of capacity which we receive from the perception of movement is increased but slightly.

We are now able to understand why every art whose chief preoc-

cupation is the human figure must have the nude for its chief interest; why, also, the nude is the most absorbing problem of classic art at all times. Not only is it the best vehicle for all that in art which is directly life-confirming and life-enhancing, but it is itself the most significant object in the human world. The first person since the great days of Greek sculpture to comprehend fully the identity of the nude with great figure art was Michelangelo. Before him it had been studied for scientific purposes—as an aid in rendering the draped figure. He saw that it was an end in itself, and the final purpose of his art. For him the nude and art were synonymous. Here lies the secret of his successes and his failures.

First, his successes. Nowhere outside of the best Greek art shall we find, as in Michelangelo's works, forms whose tactile values so increase our sense of capacity, whose movements are so directly communicated and inspiring. Other artists have had quite as much feeling for tactile values alone—Masaccio, for instance; others still have had at least as much sense of movement and power of rendering it—Leonardo, for example; but no other artist of modern times, having at all his control over the materially significant, has employed it as Michelangelo did, on the one subject where its full value can be manifested—the nude. Hence of all the achievements of modern art, his are the most invigorating. Surely not often is our imagination of touch roused as by his Adam in *The Creation* [fig. 26], by his Eve in *The Temptation* [fig. 22], or by his many nudes in the same ceiling of the Sistine Chapel [figs. 33–55]—there for no other purpose, be it noted, than their direct tonic effect! Nor is it less rare to quaff such draughts of unadulterated energy as we receive from the *God Creating Adam* [fig. 26], the *Boy Angel* standing by Isaiah [fig. 65], or—to choose one or two instances from his drawings (in their own kind the greatest in existence)—the *Gods Shooting at a Mark* or the *Hercules and the Lion.*

And to this feeling for the materially significant and all this power of conveying it, to all this more narrowly artistic capacity, Michelangelo joined an ideal of beauty and force, a vision of a glorious but possible humanity, which, again, has never had its like in modern times. Manliness, robustness, effectiveness, the fulfilment of our dream of a great soul inhabiting a beautiful body, we shall encounter nowhere else so frequently as among the figures in the Sistine Chapel. Michelangelo completed what Masaccio had begun, the creation of the type of man best fitted to subdue and control the earth, and, who knows! perhaps more than the earth.

\*     \*     \*

That Michelangelo had faults of his own is undeniable. As he got older, and his genius, lacking its proper outlets, tended to stagnate and thicken, he fell into exaggerations—exaggerations of power into brutality, of tactile values into feats of modelling. No doubt he was also at times as indifferent to representation as Botticelli! But while there is such a thing as movement, there is no such thing as tactile values without representation. Yet he seems to have dreamt of presenting nothing but tactile values: hence his many drawings with only the torso adequately treated, the rest unheeded. Still another result from his passion for tactile values. I have already suggested that Giotto's types were so massive because such figures most easily convey values of touch. Michelangelo tended to similar exaggerations, to making shoulders, for instance, too broad and too bossy, simply because they make thus a more powerful appeal to the tactile imagination. Indeed, I venture to go even farther, and suggest that his faults in all the arts, sculpture no less than painting, and architecture no less than sculpture, are due to this self-same predilection for salient projections. But the lover of the figure arts for what in them is genuinely artistic and not merely ethical, will in Michelangelo, even at his worst, get such pleasures as, excepting a few, others, even at their best, rarely give him.

In closing, let us note what results clearly even from this brief account of the Florentine school, namely that, although no Florentine merely took up and continued a predecessor's work, nevertheless all, from first to last, fought for the same cause. There is no opposition between Giotto and Michelangelo. The best energies of the first, of the last, and of all the intervening great Florentine artists were persistently devoted to the rendering of tactile values, or of movement, or of both. Now successful grappling with problems of form and of movement is at the bottom of all the higher arts; and because of this fact, Florentine painting, despite its many faults, is, after Greek sculpture, the most serious figure art in existence.

## ROMAIN ROLLAND
from *La Vie de Michelange*—[1905]*

Romain Rolland belongs to the great French tradition of the man-of-letters–art-critic of which a prominent representative today would be André Malraux. Rolland was fascinated by Michelangelo. He wrote a

* Romain Rolland, *La Vie de Michelange*, trans. from the French by Frederick Street as *Michelangelo* (New York, Collier Books, 1962), pp. 44–48.

famous large-scale study of the artist published in 1904, and in 1905 a beautifully succinct biography. The excerpt on the ceiling reprinted here is from the biography; it presents in smaller compass the kind of sensitive visual analysis that characterizes the longer study.

* * * ABOVE that ceiling and those vaults built up of huge bodies, where tumultous confusion and powerful unity combine to evoke the monstrous dream of a Hindu and the imperious logic and iron will of ancient Rome, there blooms a beauty that is natural and pure. There has never been anything like it. It is at once both bestial and divine, the exquisite perfume of Hellenic grace mingles with the savage odour of primitive humanity. These giants with their Olympian shoulders and huge thighs and loins wherein we feel, as the sculptor Guillaume said, "the weight of heavy entrails" are as yet hardly free from their double origin, their two progenitors, the beast and the god. A series of drawings at Oxford University shows in what springs of realism the genius of Michelangelo bathed itself and of what common clay his heroes are moulded.

On the flat part of the vault, in the centre, are the nine scenes from Genesis, Aeschylean visions: the divine solitude, the dreadful moment of the creation, the athletic god carried by clouds of spirits, man just rousing from the sleep of earth and regarding as an equal, face to face, the God who awakes him—both in silent readiness for the struggle—the calm and powerful woman in whom sleeps humanity —those human frames like temples of flesh and blood, torsos like trunks of trees, arms like columns and great thighs; those beings great with power and passion and crime and the results and punishments of their crimes—the Temptation, Cain and the Deluge.

At the angles of the cornice which frames these scenes are the twenty savage Ignudi, living statues, either struggling in convulsions of fear and fury or falling back, overwhelmed and exhausted—a symphony of mad force which sweeps in every direction and beats against the walls.

As gigantic supporters of the ceilings are seated in the pendentives twelve prophets and sibyls who suffer and dream; disdainful Libyca; Persica, purblind and restless; Cumaea, with huge arms and pendent breasts; the beautiful Erythraea, strong, calm and scornful; Delphica, the virgin with the lovely body and fierce eyes; Daniel, his lips compressed, his eyes fixed; Isaiah, bitter and contemptuous; Ezekiel at war with himself and with a Genius of sombre beauty who seems to be pointing out to him the one who is to come; Jeremiah, plunged in the depths of silence, and Jonah, panting and breathless, cast out from the jaws of death—all those tragic torches of thought which burned in the night of the pagan and Jewish world; all the human knowledge

which awaited the Saviour.

Above the twelve windows the Precursors and Ancestors of Christ also wait and dream in the midst of the storm. The night is long and full of evil visions. They try to sleep, they try to forget how long they must wait; they are silent and they ponder, anxious and overwhelmed. A seated woman alone dares to look squarely in the face of the menacing future. In her fixed and dilated eyes I can see that secret feeling which weighs on all these beings, a burden they dare not acknowledge—fear. At the four angles of the ceiling are displayed the sinister acts which saved the people of God—David slaying Goliath, Judith bearing the head of Holofernes, the Hebrews writhing under the bites of the serpents of Moses, and Haman crucified. Fierce barbaric stories of murderous fanaticism—a roundhead in Cromwell's time would have chosen no other subjects.

Fear, sadness, suspense. We who know how thirty years later Michelangelo completed with the Last Judgment the cycle of his dream, we know what they awaited—the Christ who comes to destroy.

## JULIUS MEIER-GRAEFE
from *Die Entwicklungsgeschichte der
modernen Kunst—*[1904]*

> Julius Meier-Graefe is known today as *the* pioneer of the art history of modern painting. His work on Corot, Van Gogh, Cézanne, and Degas, to mention only a part of his production, first introduced those artists to a wide, international audience of serious students; it has in many respects still to be superseded today. In his classic *Entwicklungsgeschichte der modernen Kunst* of 1904 the author brought together a number of studies, among them some penetrating analyses of older artists' work which he considered of particular relevance to the art of his own time. The short passage on the emotional impact of the Sistine ceiling reprinted below is characteristic of his insight at that time.

*     *     *

MICHELANGELO reveals to the beholder a beauty that emerges from form, whereas the ancients, of whose forms he reminds us, contained beauty in complete solution. The antique stands still and allows us to approach it. Michelangelo hurls beauty into us. A power which seems compounded of the power to create forms inherent in thousands of

* Julius Meier-Graefe, *Die Entwicklungsgeschichte der modernen Kunst*, trans. from the German by Florence Simmonds and G. W. Chrystal as *Modern Art* (London, Heinemann, 1908), I, pp. 25–26.

artists, gives the subject he handles an expression that turns the strongest peculiarities outwards, and makes them credible and acceptable. Faith grows strong, because it accomplishes a work of its own in every spectator, and anchors itself in the soul of each with reflection peculiar to each. It reaches its consummation in a manner directly opposed both to the unreflecting antique worship of beauty and to the mysticism of our early hieratic art. It may become so powerful as to go far beyond all the logical means that approach the same subject, and when, as with Michelangelo, it treats of divinity, it may give mortals a foothold that will enable them to approach the Godhead by new paths. Rembrandt achieves the same result by means that have no sort of apparent relation to the antique.

This effect is happiest, where it appears utterly unconscious. If art is to have its true value, it must give its first rapture in the sphere that is peculiarly its own, re-acting from this on the intellect, not vice versa. A work may express the deepest truths, and yet fail utterly to satisfy artistic requirements; a conscious insistence on ideas will always injure the artistic side. Michelangelo did not always hold fast this truth. Wherever he appears as the analyst, his art foregoes something of that ligitimate effect he never fails to produce in synthesis. His famous *Creation of Man* [fig. 26], which is often pronounced his greatest work, is an extraordinary example of intellectual invention. In spite of the mastery with which the composition utilises the idea, the immensity of the giant is not so impressively suggested here as in certain studies of the nude, which are by no means definite reproductions of actual facts, but mere fragments. But this does not prevent them from inspiring thought in those who behold them. The man of a special capacity will be more easily swayed thereby than another; the direction in which his thoughts will move will be determined by a hundred things—his degree of culture, his temperament, etc., and not least, by his momentary mood. No two persons will follow out the same train of thought before such works, but both will perceive the same force, urging their thoughts onward. * * *

An Italian, the latest and greatest, made a final effort * * * to offer the highest that individual art could give, and to unite all the arts to beautify an interior. This was the dream of Michelangelo!

But this giant's life-work served only to bring the tragedy of modern art to a climax. He, the purest, most abstract artist that ever lived, attempted to accomplish what can never be combined with the abstract. The fact that his noble frescoes in the Sistine Chapel can only be seen by a dislocation of our limbs, and that we have to examine them in photographs in order to enjoy them, suffices to condemn them from the architectonic point of view. There is unquestionably

more genius in the finger of God, calling Adam to life, than in the whole work of any of Michelangelo's forerunners; but the secondary purpose he, the master of all arts, bound up with his art, he never accomplished, because it was impossible for him to avoid the natural consequences of his brilliant gifts. And therefore the decorative effect of his magnificent ceiling is monstrous, just as, in spite of the beauty of the marble figures on the Medici tombs at Florence, the ensemble of limbs and the stones on which they rest, i.e., the sarcophagi as such, are monstrous. The objection, that powers far inferior to his would have sufficed to achieve harmony, is unmeaningful, and quite beside the question. If, in our quest for a certain good, we light on another far greater, the fact that we have not found what we set out to look for remains unchanged. Michelangelo was conscious of the tragedy. The number of unfinished works he left prove how greatly he feared to forget the result in the process. He became the bane of the epigoni, who took what could not satisfy him, and made it a definite formula, from which they evolved the sinister beauty of the Baroque Style—the beginning of the end of European architecture. * * *

# HISTORY OF ART AND IDEAS

## HEINRICH WÖLFFLIN
from *Die klassische Kunst*—[1899]*

In 1857 the Swiss historian Jakob Burckhardt published a rather short but trenchant analysis of the Sistine ceiling in his famous Italian guide-book, *Der Cicerone*. This differed from earlier treatments of the ceiling in that it did not take as a point of departure written source-material (as in the case of Stendhal), or use the imagery of the ceil-ing as the basis for an eloquent, if rather sweeping, commentary in the spirit of the Renaissance (as in the case of Michelet); for his basis, Burckhardt simply took what could be seen by an educable observer. Heinrich Wölfflin, also Swiss and, like Burckhardt, at one time a Professor at the University of Basel, carried this approach into historical territory in an important study published in *Repertorium für Kunstwissenschaft*, XIII (1890). There he made a penetrating analysis valid today in some respects only of the chronology of the ceiling on the basis of observable shifts and nuances of style. In his popular and influential *Die klassische Kunst* of 1899 he incorporated in more readable form the results of his earlier study. The section on the Sistine ceiling from *Die klassische Kunst*, itself a classic, is re-printed here in the most recent translation into English.

### The Ceiling of the Sistine Chapel

THE SPECTATOR may justly complain that the Sistine ceiling is a tor-ture to him, for he is forced, with head bent back, to survey a row of episodes and a great crowd of bodies, all demanding attention and drawing him hither and thither, so that he has no choice but to capitu-late to weight of numbers and renounce the exhausting sight. This was Michelangelo's own doing, for the original project was far simpler, with the twelve Apostles in the spandrels and the central field deco-

* Heinrich Wölfflin, *Die klassische Kunst*, trans. from the German by Peter and Linda Murray as *Classic Art* (London, Phaidon, 1968), pp. 50–67.

rated only with geometric ornament. A drawing in London (British Museum) [fig. 114a] shows how this would have looked [1] and there are some critics, of good judgement, who believe that it was a pity this scheme was not adhered to, as it would have been 'more organic'. It would certainly have had the advantage of being easier to look at than the present one, for the Apostles along the sides would have been comfortably visible and the central part, with its ornamental patterns, would have given no trouble.

Michelangelo struggled for a long time to get out of the commission. When, eventually, he undertook the task, it was by his own desire that it was so lavishly done, for it was he who represented to the Pope that the Apostles alone would make but a poor show, so that he finally got permission to paint whatever he liked. Were it not that the joy of the creator is evident in the figures of the ceiling, it might be thought that the artist was venting his spleen and revenging himself for having had to undertake the ungrateful task—the Lord of the Vatican should have his ceiling, but he would have to crick his neck to see it.

In the Sistine Chapel, Michelangelo first advanced the thesis, which became deeply significant for the whole century, that no beauty exists outside the human form. On principle, he abandons the decoration of flat surfaces with linear designs derived from vegetable forms, and where one would expect entwined foliage decoration one finds human forms and nothing but human forms, with not a trace of ornamental filling-in where the eye can rest. True, Michelangelo made distinctions and subordinated some of the categories of figures, as well as introducing variety into the colour by making some figures of stone- or bronze-colour, but this is not the same thing, and, look at it how you will, the covering of the entire surface with human bodies betrays a sort of recklessness which furnishes material for reflection.

Yet the Sistine ceiling remains a revelation which is hardly to be matched in Italy; these paintings are like the thunderous manifestations of a new force compared to the works of the preceding generation on the walls below. These Quattrocento frescoes should always be looked at first, and only after some study of them should one raise one's eyes upwards; then the surging, living power of the ceiling will have its full effect, and one will more readily appreciate the grandiose rhythm which binds and articulates these huge masses. In any case, it is to be recommended that on first entering the Chapel the visitor should ignore *The Last Judgement* on the altar wall; that

1. Published in *Jahrbuch der preussischen Kunstsammlungen*, 1892 (Wölfflin), and more recently in E. Steinmann's great work, *Die Sixtinische Kapelle*, vol. II.

is, he should turn his back on it, for in this work of his old age Michelangelo greatly damaged the effect of his own ceiling by throwing everything out of proportion with this colossal picture which sets a standard of scale that dwarfs even the ceiling.

If one seeks to analyse the causes of the effect produced by this ceiling it becomes clear that the very arrangement of parts depends upon ideas which Michelangelo was the first to conceive. In the first place, he treats the whole surface of the vault as a unity to be maintained, where any other artist would have separated the triangular spandrels from the remainder, as, for example, Raphael did in the Villa Farnesina. Michelangelo wanted to avoid a fragmentary treatment of the space, and so planned a comprehensive tectonic system with the Prophets' thrones growing out of the spandrels, so interlocked with parts of the central fields that it is impossible to think of them as separate entities. The main divisions take little account of the existing ceiling formation, for it was not the artist's intention to accept and explain the existing structure and proportions. True, he carried round the main cornice so that it corresponds roughly to the vertices of the pointed arches, but as the thrones of the Prophets in the spandrels disregard the triangular shape of these parts, a rhythm is introduced into the whole system which is entirely independent of the actual structure. The rhythm of the broad and narrow intervals in the central bays and the alternation of large and small fields between the transverse ribs, combined with the spandrel groups which coincide with the smaller fields, give so splendidly rhythmic a movement to the whole that in this alone Michelangelo surpasses all earlier achievements. He adds to it by the darker colour-scheme of the subordinate parts—the medallion fields are violet, the triangular segments near the thrones, green—so that the bright, principal parts are set off and the shifting of accent from centre to sides and back again is made more palpably evident. Again, there is a new scale of proportions and a new set of distinctions of size between the figures; the seated Prophets and Sibyls are of colossal proportions but alongside them are smaller and still smaller figures and one hardly notices the gradation of diminishing scales since one is absorbed in the apparently inexhaustible wealth of forms. A further factor in the composition as a whole is the distinction made between figures of intentionally plastic effect and the histories, which appear as pictures only. Prophets and Sibyls and all their attendant figures and accompaniments exist, as it were, in the actual room-space and possess a different degree of reality from the figures in the histories, and it even happens that the picture-plane is overlapped by the figures seated on the frame (the 'Slaves'). This distinction is linked with the contrast of axial directions, by which the

figures of the spandrels are at right angles to those of the histories, so that both cannot be considered together and yet it is impossible to separate one entirely from the other; a part of one system is always included in any view of the other, so that the imagination is continually on the alert.

The wonder is that an assembly of so many forms could, in fact, be made to produce a unified impression, and it would have been impossible without the great simplicity of the strongly accentuated architectural frame-work, for the beams, cornice and thrones are all plain white; this is the first major instance of the use of monochrome. Indeed, the pretty, brightly-coloured patterns of the Quattrocento would have been meaningless, while the repeated whites and simple forms admirably attain the goal of bringing repose to the tumult.

### The Histories

From the first, Michelangelo claims the right to tell his stories by means of nude figures. Essentially, *The Sacrifice of Noah* [fig. 21] and *The Drunkenness of Noah* [fig. 18] are compositions of nude figures; buildings, costumes, accessories, all the magnificent trappings which Benozzo Gozzoli provides in his Old Testament scenes, are either entirely lacking, or cut down to the barest minimum. There is no landscape, not even a blade of grass if it is not essential; here and there, tucked away in a corner, there is an indication of fern-like vegetation—this expresses the appearance of vegetation on the earth, and one tree signifies the Garden of Eden. All the means of expression are sparingly employed in these pictures; linear rhythm and spatial depth are combined to increase the expressiveness and the story is told with unparalleled conciseness, although this applies not so much to the earliest pictures, as to those where Michelangelo had got into his stride. The commentary on the frescoes follows the order in which they were developed.

*The Drunkenness of Noah* [fig. 18] takes foremost place, in the first three pictures, on account of its concentrated composition; *The Sacrifice* [fig. 21] stands on a lower plane, in spite of its fine motive, used to advantage by later artists, and *The Deluge* [fig. 19], related in subject to *The Bathing Soldiers* [*The Battle of Cascina*, fig. 133], has too many important figures and appears somewhat disjointed as a whole. The spatial idea is important, with its suggestion of figures coming towards the spectator from behind the mountain, so that one does not know how many people there are and one can only imagine a vast crowd. Such insight into the means of producing a desire effect would have been desirable in many another painter, confronted with

the Crossing of the Red Sea or similar crowd-scenes, and the Sistine Chapel itself has an example of the old, poorer, style in the frescoes along the walls.

As soon as Michelangelo found himself with more space at his disposal, his powers increased, so that in *The Fall and Expulsion* [fig. 22] he was able to spread his wings, now fully grown, and soar to heights which no one else has attained. In earlier art, the Fall of Man had been represented as a group of two standing figures, only slightly turned towards each other and only loosely related by the act of proffering the apple. In the middle stands the tree. Michelangelo creates a new configuration: his Eve reclines in an antique Roman pose expressive of indolence, with her back to the tree, turning momentarily towards the serpent and taking the apple almost indifferently. Adam, who is standing, reaches over the woman into the branches—the meaning of this gesture is not very comprehensible and the action of the limbs not altogether clear, but the figure of Eve indicates that the story is in the hands of an artist who has not only created new forms but is also expressing the idea that the luxurious idleness of the woman engenders sinful thoughts. The Garden of Eden consists merely of a few leaves. Michelangelo did not wish to characterize the place in a material way, yet he contrives to give an effect of richness and animation by the sweep of the lines of the ground and the spatial depth, all of which contrast pointedly with the single, barren horizontal of the other half of the picture where the misery of the expulsion is portrayed. The figures of the unfortunate sinners are driven to the extreme edge of the picture, creating between them and the tree an empty, yawning gap, as nobly grandiose as one of Beethoven's pauses. The woman hastens her steps, her back bowed and her head turned, lamenting as she goes, and stealing a backward glance, while Adam moves with more dignity and calm, yet he tries to ward off the menacing sword of the angel with a significant gesture, which had been created earlier by Jacopo della Quercia.

In *The Creation of Eve* [fig. 24], God the Father appears for the first time in an act of creation, accomplished solely by His command, without any of the grasping of Eve's fore-arms and more or less violent dragging of her from Adam's side which is usual in the older masters: in fact, He does not even touch her. Without force, with a calm gesture, He speaks: 'Arise!' and Eve does so in such a way that her complete dependence upon her Creator's movement is made manifest, while there is infinite beauty in her wondering gesture as she rises, a gesture which becomes the act of adoration. Here Michelangelo was able to portray his conception of physical beauty, and it is of Roman lineage. Adam lies sleeping against a rock, crumpled up

like a corpse, with his left shoulder slumped forward, and his limbs appear the more distorted in that his hand hangs limply over a stump of wood. The outline of a hill follows the shape of his body, and encloses it, and the main direction of Eve's body is repeated by a lopped-off branch. Everything is closely packed into the space and brought so near to the edges of the picture that there is not room for God the Father to stand upright.[2] Four more times the act of creation is repeated, ever new and ever more vivid in the power of movement. First, *The Creation of Man* [fig. 26], where God does not stand before the recumbent Adam, but sweeps down to him, accompanied by a choir of angels enclosed within the billowing folds of His mantle, and the act of creation is performed by contact, God just touching with the tip of His finger the outstretched hand of the man. [fig. 29]. This figure of Adam lying on the hillside [fig. 27] is one of the most famous of all Michelangelo's inventions, with its combination of latent power and complete helplessness, for he lies in such a way that one knows he cannot rise of his own accord—the drooping fingers of his outstretched hand make that clear—he can only turn his head towards God. And yet what colossal movement there is in that motionless body, in the upraised leg and the twist of the hips, in the torso seen from the front and the lower limbs in profile!

The *God Hovering over the Waters* [fig. 30] is the unsurpassed rendering of omnipotent and all-pervading benediction. Sweeping out of the background, the Creator extends His hands in benediction over the face of the waters, His right arm strongly foreshortened and the whole brought up sharply against the frame. Next, comes *The Creation of the Sun and Moon* [fig. 31], still more dynamic, so that one recalls Goethe's words, 'A mighty crash heralds the coming of the sun.' The figure of God thunders forward, His arms outstretched, checking Himself in His course, so that the upper part of His body is thrown backwards, and the Sun and Moon are created in this momentary pause. Both arms make gestures of creation simultaneously, but the right has the stronger accent, not only because God looks in that direction, but also on account of the sharper foreshortening, since foreshortened movement always appears more vigorous than unforeshortened. The area taken up by the figure is even greater than before

2. The spiritual meaning of the scene has been variously interpreted and there is room for conjecture when one considers the differences of opinion advanced by the interpreters. Klaczko (*Jules II*, Paris, 1899) calls Eve "*toute ravie et ravissante . . . elle témoigne de la joie de vivre et en rend grâce à Dieu*". Justi (*Michelangelo*, Leipzig, 1901) finds her look empty and cold as if she were posturing, "composing herself quickly and adroitly, she knows exactly what is required for so exalted an occasion; with a gesture at once obsequious and devout, pleasing and self-assured, she performs the obligatory adoration."

and there is not a finger's breadth of superfluous space. This picture contains the curious licence of having a second figure of God, seen from behind and rushing into the depth of the picture like a cyclone. At first, one might take this to be the retreating spirit of Darkness, but it is, in fact, *The Creation of Vegetable Life* for which Michelangelo thought a mere hasty gesture of the Creator's hand was sufficient, and His face is already directed towards a new goal. The duplication of the figure in the same picture has a somewhat old-fashioned air, but if one covers half the picture it will at once be recognised that the doubling of the figure in flight is an essential part of the general effect of movement.

In the final scene [fig. 32], where God the Father is borne along on sweeping clouds—the customary title, *The Division of Light from Darkness* is certainly not correct—it is scarcely possible for us to follow the artist's intentions completely. Yet this fresco, more than any other, serves to demonstrate Michelangelo's astonishing technique, for it is clearly apparent that, at the very last moment (that is, during the actual painting) he abandoned the roughly incised preparatory outlines and tried out a different idea, and all this was done with a figure of colossal proportions, painted by a man lying on his back, so that he was unable to judge the effect of the whole.

It has been said that Michelangelo was interested only in formal motives as such, and did not think of them as the necessary symbols of expression for a programme of ideas. While this may be true of many of the single figures, where he had to tell a story he always respected the content, as one may see both in his Sistine ceiling and in the very last paintings, the Cappella Paolina frescoes. At the corners of the Sistine ceiling there are four triangular, curved spandrels which include the scene of *Judith Handing the Head of Holofernes to Her Servant* [fig. 82], a scene which had often been painted before, but always as a more or less indifferent act of giving and receiving. At the moment when the servant girl bends forward to take the head on her uplifted charger, Michelangelo makes his Judith glance back at the bed on which Holofernes lies; it is as if the corpse had moved. In this way, the tension of the scene is immeasurably heightened, so that even if this were the only work known by Michelangelo it would show him as a dramatic painter of the first rank.

## The Prophets and Sibyls

In Florence, Michelangelo had been commissioned to carve twelve standing Apostles for the Cathedral; twelve seated Apostles were included in the first project for the Sistine ceiling but were replaced by

Prophets and Sibyls. The unfinished St. Matthew indicated Michel-angelo's intention of increasing the outward movement and inward emotion in the figure of an Apostle; what may one not expect when he creates the type of a seer! He did not feel himself bound by any prescribed iconographical ideas, and indeed, he even omitted the usual inscribed scrolls, advancing beyond a conception in which the names of the figures were the principal interest, and the figures themselves simply gesticulated to indicate that, when they were alive, they had said something of importance. He catches moments of spiritual life, inspiration itself, contemplative soliloquy and deep silent thought, calm study and excited searchings through the pages of a book, and once, a commonplace, everyday motive—that of reaching for a book on its shelf—where all the interest is concentrated on the physical action.

The series contains both old and young figures but the expression of prophetic vision is reserved for the youthful figures. This is not a yearning, ecstatic, upward gaze of Peruginesque sentimentality, nor a passive receptivity, a self-surrender, as it so often is in Guido Reni, where one finds it hard to distinguish a Danae from a Sibyl; for Michelangelo it is an active state, a journey outwards from the self towards the Divine. The types have practically nothing of the indi-vidual in them and the costumes are completely idealised. What is it that distinguishes the Delphic Sibyl [fig. 59] from all Quattrocento figures? What gives such grandeur to the action, and endows the whole with an appearance of necessary inevitability? The motive is the sudden attention of the Seer as she turns her head and momen-tarily pauses, holding up the scroll. The head is seen from the simplest viewpoint, not tilted, and full front, but this attitude is held only un-der strain, for the upper part of the torso is bent sideways and for-ward and the arm, reaching across, is another contradiction of the direction of the head; yet, despite the difficulties, it is just this which gives the pose with the head seen from the front its force, and the vertical axis is maintained among opposing elements. Further, the sharp conjunction of head and horizontal arm gives added energy to the twist of the head, and again, the direction of the light adds an-other element by putting exactly half the face in shadow, thus accen-tuating the central axis, a vertical which is again taken up by the peaked fold of the head-cloth. The eyes of the prophetess follow the direction of the head by their own movement to the right, and the ef-fect of these searching, wide-open eyes carries at all distances, al-though they alone would not produce this effect were it not that the accompanying lines repeat and extend the movement of head and eyes. The hair is blown in the same direction and so is the great sweep

of the mantle which encloses the whole figure like a sail. The handling of the drapery is an example of contrast which Michelangelo so often employs between the right and left silhouettes—one side a simple closed line, the other jagged and full of movement—and the same principle of contrast is applied to limbs, for one arm is held high and tense and the other is a dead weight. The fifteenth century thought it necessary to animate every part equally; the sixteenth found it more effective to accentuate a few isolated points only.

The Erythraean Sibyl [fig. 62] is sitting with legs crossed and seen partly in profile, one arm reaching forward and the other hanging down, completing the closed outlines. The drapery is quite exceptionally monumental. An interesting comparison can be made by glancing back at the figure of Rhetoric on Pollaiuolo's Tomb of Sixtus IV (St. Peter's) where a very similar motive produces a very dissimilar effect because of the caprices and artifices of the Quattrocento sculptor. Michelangelo represents the aged Sibyls as crouching with bowed backs—the Persian Sibyl [fig. 69] holding her book up to her dim, bleary eyes, the Cumaean [fig. 68] grasping with both hands a book which lies beside her so that a *contrapposto* effect is obtained between the upper part of the body and the legs. The Libyan Sibyl [fig. 74] has a highly complicated pose, pulling down a book from the wall behind her throne without standing up, by reaching backward with both arms and at the same time looking in another direction. Much ado about nothing.

The process of development among the male figures begins with Isaiah [fig. 64] and Joel [fig. 61] (not with Zacharias [fig. 60]) and goes on to the figure of the writing Daniel [fig. 70], already conceived on a different and grander scale, through the strikingly simple Jeremiah [fig. 71] to Jonah [fig. 75], who bursts all tectonic bounds with his tremendous action. One cannot properly appreciate these figures without an exact analysis of the motives, taking into account, in every case, the pose of the figures as a whole and the movement of the limbs in detail. Our eyes are so unaccustomed to grasping these spatial and physical relationships that it is rare to be able to remember one of these motives even immediately after looking at it. Any description is bound to seem pedantic, and at the same time misleading, if it makes it seem that the limbs were arranged according to recipe, whereas the outstanding feature really consists of the union of formal qualities and the convincing expression of a moment of spiritual experience. This is not always maintained: the Libyan Sibyl [fig. 74], one of the latest figures of the ceiling, is exceedingly rich in formal variety but quite superficial in conception, while the same group of later figures also contains the aloof and withdrawn

Jeremiah [fig. 71], simplest of all in form but touching our hearts
the most.

## *The* '*Slaves*'

Above the piers of the Prophets thrones sit nude youths [figs. 33–
55], arranged in pairs facing each other with one of the bronze me-
dallions between them, apparently engaged in encircling them with
garlands of fruit. These are the so-called Slaves. They are smaller in
scale than the Prophets and their compositional function is to echo
the piers in the upper zone; as finials they have the widest freedom of
gesture. Thus there are twenty more seated figures, presenting new
opportunities, for they are not frontal but seated in profile on very
low seats; more than this—and this is the chief thing—they are nude
figures. Michelangelo wanted to sate himself with the nude and he re-
turned to the domain which he had entered with his cartoon of *The
Soldiers*, so that one may well believe that here, if anywhere in the
commission for the ceiling, his heart and soul were in the job. Boys
with fruit garlands were by no means an unusual subject, but Michel-
angelo wanted more fully developed bodies, though one must not
seek to enquire too closely into the individual action of the figures.
The motive was chosen because it offered the greatest variety of ac-
tion in pulling, dragging and carrying, and the artist is not to be
bound down to a more factual explanation for his choice of motives.
There are no particularly strong muscular exertions, but this series of
naked bodies has indeed the power of transfusing a current of vitality
into the spectator—'a life-communicating art', as Berenson puts it. The
muscular development is so powerful and the limbs make such an
impression by their contrasts of direction that one feels oneself at
once in the presence of a new phenomenon. What can the whole of
the fifteenth century show, in the way of herculean figures, to com-
pare with these? The variation from the normal in the structure of
these bodies is insignificant by comparison with the way Michel-
angelo disposes the limbs, for which he discovers new and effective
formal relationships; here, he brings one arm and both legs together
as a series of parallels; there, he brings the downward-reaching arm
across the thigh so that it forms almost a right-angle; there again, he
encloses the figure from head to heels in an almost unbroken sweep
of line; and these are not mathematical variations which he sets him-
self as an exercise, for even the most unusual action is made convinc-
ing in its effect. He has the human body in his power because he has
mastered its articulations, and that is the strength of his draughtsman-

ship—whoever has seen the right arm of the Delphic Sibyl [fig. 59] knows that there is yet more to come. He treats a simple problem, such as a supporting arm, in such way that one gets an entirely new impression from it, as may be seen by comparing the naked youth in Signorelli's *Testament of Moses* in the Sistine Chapel with Michelangelo's Slaves above the Prophet Joel [figs. 36–37], and these slaves are among the earliest and tamest. Later, he added stronger and stronger effects of foreshortening up to the violent *scorzi* [foreshortenings] of the final pair [figs. 54–55], the variety of action becomes even more marked, and where, at the beginning, the corresponding figures in each pair are roughly symmetrical, towards the end they present ever increasing contrasts with one another. So far from becoming tired of the tenfold repetition of the same problem, it seems clear that Michelangelo's invention was more and more stimulated. To get a clear idea of the phases of development, a comparison may be made between a pair at the beginning—the Slaves above Joel [figs. 36–37], and those above Jeremiah [figs. 54–55] at the end. In the former, we see a simple, profile pose with only slight differences between the limbs and almost symmetrical correspondence between the figures; in the latter, two bodies which have nothing in common, either in structure, movement or lighting, but which, by their very contrasts, increase the effect. The indolent figure in this pair may perhaps be accounted the finest of them all, not merely on account of the nobility of his features: the figure is entirely calm, yet it contains grandiose contrasts of direction and the curious pose, with the forward tilt of the head, leaves a marvellous impression. The most abrupt foreshortening is immediately followed by the absolute clarity of planes seen in their greatest breadth. If the rich effects of light are also taaken into consideration it becomes still more surprising that the figure appears so calm and still, and this would not be the case were it not for the clear relief-like development of the planes in breadth. At the same time, the whole form is grasped as a single compact mass which could almost be circumscribed by a regular, geometric figure. The centre of gravity is high up, hence the appearance of feather-lightness in spite of the herculean limbs. Later art never surpassed this example of any easy and lightly balanced seated pose and it is notable that something from the distant and foreign world of Greek art comes involuntarily to mind—the so-called *Theseus* of the Parthenon.

The remaining decorative figures on the ceiling cannot be dealt with here. The small fields with lightly indicated figures seem as if they were a sketch-book of Michelangelo's containing a number of interesting motives, including the dawning possibilities of the figures

on the Medici Tombs. More important are the spandrels over the windows [consult again figs. 86–95], where groups of resting people spread out over broad, triangular fields, such as were often used in later art, and the accompanying lunettes [figs. 96–113] doubly noteworthy in Michelangelo's work for being genre scenes and the most extraordinary subjects in such a place; and every one of them is an improvisation. The artist himself seems to have felt the need to allow the tension to die away here, after the intense physical and spiritual life of the vault. These Ancestors of Christ depict peaceful, everyday existence—the common destiny of humanity.[3]

By way of conclusion, a few words may be said on the progress of the work. The ceiling is not all of a piece: there are joins in it, and everyone observes that *The Deluge* [fig. 19] and the two pictures accompanying it—*The Drunkenness of Noah* [fig. 18] and *The Sacrifice* [fig. 21]—are painted with figures on a far smaller scale than in the other histories, and, since this part was painted first, one may well assume that Michelangelo found the scale insufficient when seen from the ground. Yet it was a pity that the scale had to be altered, for it was clearly the original intention to diminish the size of the figures upwards, according to their category: from the Prophets to the Slaves, and from these to the histories was originally a uniform progression which gave a pleasantly restful effect. Later, the inner figures (those in the histories) grew far bigger than the Slaves and the balance was upset, while the original proportions also allowed the smaller histories to harmonise with the alternating larger ones since the scale was constant, but the alteration led to a necessary, though disadvantageous, change here as well. In *The Creation of Adam* [fig. 26], for example, God the Father is large, but the same figure in *The Creation of Eve* [fig. 24] is considerably smaller.[4]

3. For the correlation of subject-matter between Ancestors and Prophets cf. P. Weber, *Geistliches Schauspiel und Kirchliche Kunst*, 1894, p. 54. A later interpretation (Steinmann and Thode) makes the spandrels depict the Jews in Exile, connected with the Lamentations of Jeremiah. [Still another, and important, interpretation was given in 1948 by E. Wind (see Bibliography).–Ed.]

4. Could the change of scale have led also to a change of programme and to the substitution of a new set of histories? It is unbelievable that the scenes of creation, with their few essential figures, could have filled the available space if the figures were on the scale adopted for *The Deluge*, and it seems to me unlikely that Michelangelo was resigned to discrepancies of scale from the very beginning. The idea of such a change in general plan may be supported by the fact that *Noah's Sacrifice* is obviously out of order in its present place, so that even early writers (Condivi) interpreted it as *The Sacrifice of Cain and Abel* to avoid the break in chronology; but this is untenable.

The second join is in the middle of the ceiling, where a sudden increase in scale is again noticeable, but this time it applies to all parts and the Prophets and Slaves grow so large that the architectonic system can no longer be continued on the old scale. The engravers have to some extent concealed these discrepancies, but photographs afford convincing proofs. At the same time, the colour scheme was altered, and where the earlier histories are brightly coloured, with blue sky, green fields and a range of clear, bright colours and light shadows, the later ones are muted, the sky greyish-white and the draperies dull, the colours less opaque and more watery, while gold disappears altogether and the shadows become darker.

*       *       *

## SYDNEY J. FREEDBERG
### Michelangelo: The Sistine Ceiling—[1961]*

Sydney J. Freedberg is Professor of the History of Art at Harvard University, where he has been active as teacher and scholar of Renaissance Italian painting since World War II. Prominent in his published work is his prize-winning *Painting of the High Renaissance in Rome and Florence* of 1961, from which the excerpt below on the Sistine Chapel ceiling has been selected. Professor Freedberg first approaches the ceiling for its visual impact; then into the data of form and color he interweaves his interpretation of the delicate problems of content and chronology. The result is a unity so organically composed that no single idea, no single aspect of subject or form could be eliminated without doing irreparable damage to the whole. His section on the ceiling is given here complete. Some changes, however, have been made by the author for the republication. They are mainly concerned with the ceiling's chronology; the version given here represents the author's most recently formulated views.

THE PAINTING OF THE Sistine Ceiling [figs. 4–5] was forced upon Michelangelo in substitution for his first commission for the Julius Tomb, and he proceeded to make of it a compensation for that unfulfilled sculptural commission. The vocabulary of forms he projected on the ceiling was basically derived from his Tomb design (Justi [see Bibliography]), unfolded flat upon the ceiling space. Three of the major elements in both designs are the same: the great enthroned

* Reprinted by permission of the publishers from S. J. Freedberg, *Painting of the High Renaissance in Rome and Florence*, 2 vols. (Cambridge, Mass., Harvard University Press, © copyright, 1961, by the President and Fellows of Harvard College), pp. 92–110.

figures attended by putti; the Ignudi who are like the captives on the Tomb; and the architectural system of superimposed, interlocking shapes. Into this architecture, projected in paint on the ceiling (in a perspective internally "correct," but not illusionistic to the spectator) the Prophets, Sibyls, and Ignudi have been placed quite in the manner of single sculptured forms, as units of mass inserted in a niche or set up on an architectural base. The scenes from Genesis, in the central panels of the ceiling, are enclosed in the architectural frames as reliefs would be on the surface of an actual monument; and these scenes are in themselves more plastic than pictorial in style. In general they deny any strong sense either of spatial extrusion from, or of deep intrusion into, the plane of the ceiling. That they are conceived as parts of a closed monumental structure is affirmed by the arbitrary turning of these scenes out of perspective and into parallel with the ceiling plane.

The whole system of design of the ceiling is classically sculptural, densely built of solids and evading voids. Even the painter's coloring of this design remains dependent on the sculptural conception of its forms: the dominant tone is that of the fictive stone of its architecture and of the population of nude figures that inhabit it, whose flesh is muted toward the tones of ancient marble. Where the figures are clothed, as are the Seers, their colors—though they become, as painting proceeds, increasingly fluid and harmonious—seem often like the varied patinas of old bronze; the draperies evoke the memory of metal.

The whole scheme for the ceiling retains the sculptor's habit of thinking in terms of single figure units, and the concept of relations among them remains precisely that first formulated in the ideas for the Julius Tomb. Unity depends first on the formal interdependence of the mass of figures with the plastic mass of architecture, then on the progressive interlocking of units of architectural form, and finally —here more visibly than in what we can deduce of the first Tomb design—on balancing repetitive concordances among all the forms. With this sculptor's aesthetic Michelangelo achieves a unity as compelling as, and more vast than, any in his contemporary art. There is no wish to pursue, for the Sistine Ceiling, the idea of a unity of many figures in a single, naturally coherent space, which Michelangelo had explored in the *Cascina;* the shape of the ceiling was such as to exclude such a possibility for any artist of the time. The shape was still, however, not such as to dictate an arrangement so peculiarly sculpturesque as this.

In each of the longer transverse strata of his scheme Michelangelo builds an interlocking and balancing sequence of forms [fig. 8]. The small narrative panel in the center is framed by an architecture that builds outward in successive steps, first to the bases of the Ignudi, and

then to the prophetic thrones. The Ignudi are disposed around the central panel in attitudes that are each in themselves contrapposto, and which are then set in concordant counterpoise to one another. Their figures move, with the architecture that supports them, more outward from the plane of the wall, shifting to a diagonal direction that serves as a transition to the mainly frontal plane of the enthroned Seers: these are the forms of greatest size and most massive formal impact in each long transverse bay. The progression of counterpoised and concordant forms builds outward and downward in balancing opposite directions, from relief-like planarity to architecturally and sculpturally substantial mass below.

Each major form in this system retains its sculpturesque identity, but it is bound to its companions in the order of concordances of placing and of postures. Each figure is distinct from the architecture, but it is also—in the way invented for the Tomb—at the same time a living function of the architecture, an elaboration or completion of its form; conversely, the architecture is the geometrical function of the figures, and the locking together of its energized masses completes this tissue of a plastic unity. In its formal order each long bay assumes a musicality, but it is unlike the yielding, cursive musicality that Leonardo had conceived. This concord is of brasses, sounding in massive chords across the ceiling.

The intervening shorter bays, given almost altogether to the narrative scenes in "relief," lie in the topmost stratum of the whole painted monument; they are for the most part simply planar and, architecturally, recessive. They are, by contrast with their neighbors, broader and simpler in form. The complex force of each long bay is resolved into this broader and simpler resonance of the large relief, and this in turn is succeeded by a structure richly chorded like the first. The sequence of expansion and contraction in these alternating bays is like the respiration of a vital being, deep, alternating and regular in measure. And, as the bays succeed each other, they build into a system of great balances of triads of which the emphasis and direction is inverted, as by the turning of an X, with each successive step. The progression of the ceiling, from entrance to altar, becomes a measured alternating sequence of great forms, interlocked, and irreversible in direction. As Michelangelo himself develops in the course of painting on the ceiling the dimension of form and the temper of energy that inhabits it progressively increase: the logic of the structure, at the beginning irresistible, is expressed increasingly in crescendo. The ceiling, cover for a Christian chapel, articulates the Christian concept of the processional way, but it scans this progress with the most majestic classic dignity.

The actual scheme of the Sistine Ceiling is far more elaborate than the original intention Michelangelo had for it when he began to plan it in the spring of 1508. The first project we know, documented in a drawing in the British Museum (1859-6-25-567r) [fig. 114a], was for twelve figured spandrels with Apostles in them with the rest of the ceiling treated only by abstract patterning of geometric fields. The motives that led Michelangelo to expand this simple scheme into its present complexity are not clear but we have his own account (letter to Fattucci, December 1523 [Milanesi, *Le lettere di Michelangelo Buonarroti*, pp. 426-30] of his remonstrance to the Pope about the poverty of the first project and his assertion that he was then given permission to "make what I wanted, whatever would please me." What pleased him, structurally, was the painted substitution of the Julius Tomb we have described. But we do not know surely to what degree the subject matter of the Ceiling, with its necessary effect upon the structure, was Michelangelo's own invention or the result of consultation with authorities available in person or in print.

As has long since been pointed out the theme of the Ceiling is, in general, a complement of the preexistent decoration of the walls below and illustrates the history of man *ante legem*, in prelude to the history *sub lege* and *sub gratia* that Sixtus' artists had depicted. The Ceiling dwarfs these two succeeding chapters, but its conception of subject is not, for this, less according to its character of prelude. It tells, in its middle range of panels, a summary history of Genesis: the creation of the world and man; man's first sin and fall and its echo in a second fall. The core of meaning of this story is in the central ones among these panels where man is made who then makes sin, and so requires redemption by the Christ. Around this history, in the prophetic thrones, are those who foretell man's redemption by the Son of Man, alternating Prophets of the Old Testament and Sibyls of classical Antiquity; the Sibyls appear in Christian context and are taken in the sense of their meaning for Christian dogma. Below these Seers are the Ancestors of Christ, in whose line is the long generation of his coming, and in the four pendentives there are Old Testament narratives which refer prophetically to Christ's mission of salvation and to his sacrifice of Crucifixion. The elements of subject matter in the Ceiling, with their intrinsic literary content of tragedy and prophecy, are deeply moving in their common theme, in which they cohere to make one general and unmistakable sense. With entirely adequate internal logic and with surpassing power of conviction, the Sistine Ceiling basically means what it instantly and evidently says.

Despite recent profound research it is not yet wholly certain how, in a more specific dogmatic or theological sense, all the various single

elements of theme relate precisely to each other. It seems certain that the Prophets, and consequently the Sibyls as well, are connected by literary allusion with the scenes of Genesis they adjoin, and that so also are the subjects of the bronze-colored medallions which are hung between them. However, the explanations given for the specific motive of association of these elements are not always sure. It is not even possible, in every instance, to interpret the type or action of the single Seers in the sense of illustration of their writings, or of the personalities "officially" defined for them. The literary justifications that they may have seem to have been absorbed in, and in some cases obscured by, the transcendent expressive and aesthetic identity Michelangelo has invented for them; it is in this Michelangelesque personality of the Seers, singly and as a group, that they are meaningful, rather than for their precise literary connection with the surrounding scheme.

For the secondary figures who attend the Seers the available iconographic explanations are still less clearly specific or definitive. It is not likely that this vast population of nude forms—caryatid putti on the Prophets' thrones, bronze-colored men in the spaces between the thrones, and the great Ignudi above them—has no more than decorative meaning; Michelangelo could not have meant this by his assertion, which Vasari reports (VII, 226), that the artist need not use foliage as ornament because the human figure was so adequate for the purpose. It is true that any human form of Michelangelo's making—unlike those of Vasari—would create a content also: the question here is not of content but of its motivation in a subject matter.

There is no trace of evidence for the genesis of meaning, among these nudes, for the bronze-colored ones, and only little, and then not very helpful evidence of how the roles of the caryatid putti and the Ignudi were determined. In the first project for the ceiling (in the British Museum drawing cited before) the Apostles are accompanied by caryatid angels placed above their thrones. In a subsequent idea, preserved in a sketch in Detroit [fig. 115], the angels remain but are no longer caryatids: they stand in a place above the thrones which corresponds exactly to that of the present Ignudi and serve as supporters for a medallion of which the content is not certainly defined. The angels of the first sketch, unwinged and descended from their perch, have become the caryatid putti of the actual design; the angels of the second sketch, in place and function, are the precise antecedents of the Ignudi. There is, in these angelic motives of both the drawings, no more precise meaning than that of an appropriate, and inspiring, heavenly company for the Apostles—it is doubtful that in the Detroit design they had yet become Prophets. The original angelic meaning cannot attach to either category of their descendants, in the caryatid

putti or the Ignudi; both lack, or quite deny angelic appearance or attributes. The Ignudi, surely, are not any longer angels: their explicit sex, their sensuousness and the kinds of mood that they express are contradictions of angelic personality. It may be that the caryatid putti have been transformed from angelic beings into an antique counterpart as Genii, and symbolize some inspirational force upon the Prophets they attend. But their appearance and their actions are little in accord with such a role; if there is such meaning in them it has been almost entirely submerged. They do not inspire, or even consistently react, to the inspiration of the Seers. Their conduct is that of children, uncomprehending innocents at play. The forms in general of two of the present categories of nude beings descend from their antecedents in the two designs for early versions of the decorative scheme, but their meanings do not. The precise present types of nudes and their meanings were conceived only when the basic subject matter of the Ceiling was changed, and instead of Christ's Apostles his Prophets became primary actors in the scheme.

The Ceiling, with its central theme of man's fall and the prophecy of his redemption, may be a summary, from the view of Christian hindsight, of the moral situation of the pre-Christian world. The bonze-colored nudes [figs. 33–53], for whom we have no counterpart in the first designs, afford the clearest hint of what the whole constellation of nude forms may mean. They are the antitheses of the Prophets they adjoin: unillumined captives of ancient ignorance. Dark, and darkly imprisoned, they may represent the barbarian peoples of a pre-Christian time, inaccessible to the prophecy of Christ's coming; they have no sense of the history in which they are imbedded. The Ignudi suggest another place in the scale of awareness, between the absolute illumination of the Seers and the dark ignorance of the figures in the spandrels: they would be the creatures of the pagan, classical, pre-Christian world, who are half-conscious of the meaning of the history they attend and the prophecy they oversee. The bronze-colored nudes are almost animal in nature, moving in soulless contortions like those of caged beasts; oppositely, the attitudes and expressions of the Seers are precise and purposeful, dictated by an ultimate explicitness of state of spirit and of mind. Between the two, the Ignudi are possessed by moods and express themselves in posturings that are neither wholly rational and inspired nor merely physical and animal; they are beings in whom the mind and soul have not yet assumed, as in Christian habit of belief, a separable identity from the flesh. As for the caryatid putti: if we continue to assume that things basically mean, in the Ceiling, what they evidently say, it may be that they stand in fact for *Innocenti*, representing a state of man that precedes Knowl-

edge; and they may allude as well, as Innocents, to the children whom Herod sacrificed, as later he would be the instrument of the sacrifice of Christ which the Ceiling entirely foretells.

The role we discern in the Ignudi would explain the conjunction in them of paganized beauty and Christianized disquiet of personality, and would justify the presence of these figures, so much more precisely recollective than the Sibyls of the Ancient classic world, in the Christian context. The history of pre-Christian man becomes, by their presence and that of the bronze-colored nudes, enriched by a symbolic and anonymous population of all of antiquity. The nudes are not participants or spectators but concurrent presences in the Christian history, blind to its meaning or half-knowing of it; and at the same time its meaning resonates through and is differentiated in them. The conception—not only in the nudes but in the Seers—of a division of humanity into strata that are different in their proportion of spiritual and physical content, and in their articulation of a distinguishable and rational soul within the body, is the profoundest demonstration (and the first one intellectually formulated in terms of visible ideas) of the nature of man as classicism within Christianity conceived it.

The sources of this thinking are of course generally Neo-Platonic, but there is no definition we know in Neo-Platonic writing of a proposition quite like this. In the figures of the Ceiling it is demonstrated that the human physical being untouched by Grace is animal in nature and behavior; it is in proportion as the creature has knowledge—here fore-knowledge—of Christ that the soul is a distinguishable identity and no longer confounded with the tissues of the body. In beings like the Seers who know Christ, or in Adam who is made by God directly, the soul is inspired, and distinguishable from the mortal flesh; but that flesh is infused by the soul, directed by it, and expressive of its force and splendor. It is this last conception that the classical style within Christianity intends as its ideal. In the Ceiling this conception is exactly articulated for the first time, in the context of a history, and in the guise of a process that history reveals.

The general design and the subject matter settled, Michelangelo began the labor of execution of the Ceiling in January 1509 at latest, and in a campaign of work that lasted likely through September of that year painted the frescoes of the first three bays, the last in the order of the succession of the Bible narrative. His first effort was apparently *The Flood* [fig. 19], the large panel of the second bay. Confronted with a large space to be painted and with a narrative episode that required the presence of many figures, Michelangelo inevitably recalled his own precedent in the *Cascina* cartoon. Here, however, the actors seem to be moved more genuinely than in the *Cascina*

by the drama of their situation. In their expressions of countenance and sometimes in gesture Michelangelo has evoked, in powerful imaginative reconstruction, their sensation of primitive tragedy. The attitudes of body are, generally, less expressive: not so arbitrary nor nearly so athletic as in the *Battle* piece, these postures still carry something of its sense of inventions made first for form's sake and only secondly in consequence of the actors' state of mind. It is as if the development of expressive powers demonstrated in the unfinished *St. Matthew* had not been; in this less accustomed role of painter Michelangelo is diverted by the painter's problems—not only of the many-figured narrative but of technique as well—from the concentration of purpose sculpture had permitted him.

More than in *The Battle of Cascina*, Michelangelo tries in *The Flood* to attain a structure of pictorial kind. There is more effort here to bind the single figures, still emphatically sculptural, into unities of groups but these are still related to each other conjunctively more than cohesively; each group remains a plastic episode in the design. The distribution of the groups into a depth of space intends to be pictorial, but his sculptor's sense is here—as in his design of the whole Ceiling—for solids rather than for voids. The space, a summary notation of environment, has neither a framework of traditional perspective nor of arbitrary geometric shape; it has no structure to support and unify the solids set within it. *The Flood* is inspired with pictorial intention but it remains in a limbo between a painter's and a sculptor's aesthetic.

*The Sacrifice of Noah* [fig. 21] was probably the second fresco to be designed and executed. In it, the less extensive narrative allowed a change in scale from *The Flood*, which must surely have accorded instantly with Michelangelo's disposition to work with monumental, and with solid, forms; the subject also permitted the reduction, to the same end, of the first fresco's extent of space. Nevertheless, Michelangelo's ambition in the *Sacrifice* is still pictorial: he is visibly concerned to "compose" the figures both in respect to their arrangement on the surface and in the limited space. He disposes them (unlike *The Flood* or the *Cascina*) in a sequence of carefully connected postures; these, linking one form to the next, make an oval unity of design around the altar in the center. In this binding of forms in a whole, clear, movemented geometry the *Sacrifice* develops, beyond its antecedents, a solution of classicizing kind to a pictorial problem. At the same time Michelangelo's ineradicable tendency to work sculpturally gives the composition, with its bulk of figures and restricted space, an effect of structure which tends toward that of classical relief. The formal problem of the *Sacrifice*, more than in *The Flood*, is the dom-

inating one; the subject was not such as to inspire a compelling inter-
pretation of the content.

In the third scene to be painted in this set, *The Drunkenness of
Noah* [fig. 18], Michelangelo seems to have overcome effectively the
unclarities of purpose that had accompanied his first sculptor's attempts
to work as a painter on large scale. The solution of his problem was
already implied in the *Sacrifice*, in the tendency in it to fill the picture
surface with large plastic forms in a reduced space, and thereby sug-
gest an effect as of relief. In the *Drunkenness* Michelangelo is more
confident in technique of painting, but he is no longer concerned
with the making of a peculiarly pictorial structure. The fresco is com-
posed quite frankly according to a classical sculptural aesthetic: it
reduces the pictorial expression of space to a near-minimum, enlarges
the scale of the figures within the frame, and distributes them along
a narrow plane close to its forward limit. The figures are connected
still more fluently, and with more energy than in the *Sacrifice*, but
their arrangement is now not at all in space but in a lateral sequence.
In the most forthright way the conception makes an analogue to that
of a classical relief.

Now that Michelangelo has evolved, by this means, a solution in
the language of his own aesthetic for the painter's problem and, simul-
taneously, gained facility in the painter's fresco technique, he is free
to express himself with less impediment; he resumes, in the *Drunken-
ness*, his momentarily deviated development. The figures in this fresco
are the first on the Ceiling to stand again at the level of expressive
power that Michelangelo had sketched out in the *St. Matthew*. Here
also, perhaps as the fruition of still more of an experience of ancient
art, the figures begin to assume a more developed classical appearance
than in the first two frescoes. In their forms and movements they
display, for the first time so clearly in Michelangelo's art, the won-
drous consonance that he is able to establish between power and grace.

It was with this quota of experience behind him that Michelangelo
began the first Ignudi and the first Seers of the Ceiling. In them there
was not, even at the beginning, a conflict of pictorial and sculptural
purpose: they were initially conceived in the sense of sculpture, as
compact solids on a base of architecture. Probably the first one painted
of the Seers, the *Delfica* [fig. 59], retains (like the first narrative panel)
Florentine reminiscences: of the gesture of the Madonna of the Doni
tondo and the type, already sibylline, of the Madonna of the sculpture
tondo in the Bargello. As in both those compositions the *Delfica* makes
a rounded and compact unity of form, of which the breadth is greater
and the articulation of the contrapposto fuller and clearer than in these
antecedents. Her counterpoise between movement and static mass is

contained within an implied sphere, and adjusted in a perfect balance upon both vertical and longitudinal axes: her structure is a consummation of the formal logic of the Florentine period. She is the end of a prior stage of research, which Michelangelo will now use as a threshold for the evolution of a harmony of massive forms continuously more energized and internally diverse.

The counterpart of *Delfica*, on the opposite side of the same bay, is *Joel* [fig. 61], the Prophet of the vine on the fruit of which Noah has become drunk. He is of greater bulk, appropriately masculine, than the *Delfica* but not less constrained within a unitary plastic form. However, he is informed by an energy of spirit higher than hers: this contrast between male power and the lesser spiritual vigor of the Sibyls continues through the Ceiling. There is a profound force in the attention with which Joel reads and his body answers to it, shifting in the narrow space and turning slightly in diagonal torsion out of an attitude of rest. His movement implies a potential of energy far greater than is actually expressed, and this energy is at once intensified against and absolutely controlled by a discipline of counterpoise and by the whole containing shape. In the *Joel*, more than in his probable immediate predecessor *Zachary* [fig. 60]—and differently than in the *Delfica*—we are made aware that Michelangelo describes a dimension of humanity higher and more confident than he had conceived before. Joel has the intensity of the *St. Matthew*, but not Matthew's irrationality: this personality is as clear and forceful in mind as he is powerful in feeling. His dimension of spiritual being is matched by the scale of his form, and by his controlled energy of physical response; we have the whole impression of a creature magnified far above the normal stature, of body and of spirit, of humanity.

Isaiah, who denounces the sacrifice that he attends, was the last of the Seers to be executed in this set, surely following after his sibylline counterpart, the *Erithrea* [fig. 62]. In *Isaiah* Michelangelo has not only described a higher humanity, but given a more complex interpretation of it. Isaiah [fig. 64] has the same bodily dimension as Joel and implies the same potential energy of feeling, but Michelangelo now wants to differentiate, more exactly than in the *Joel*, the resources of personality of this kind of ideal being. Isaiah shows a spiritual power not assertively expressed but in the process as of its unfolding: he is in a crepuscular state between melancholy meditation and the beginning of inspiration. To express this more complex situation Michelangelo displays a subtlety of articulation greater than in any previous image of the Ceiling; this subtlety is reflected even in a higher expertness of expressive drawing with the brush. Isaiah's body is made to echo, comment on and reinforce in its every part the state of mind that is

revealed upon his face: the whole of his person communicates at once more precisely and more variously, and yet with a profounder power, the sensation of his slow-awakening might.

The Ignudi are even less bound than the Seers to illustrate a specific literary content and among them the development of expressive form is yet more free. From the evidence of the first set of Ignudi, around *The Drunkenness of Noah* [fig. 12], it would seem that Michelangelo initially entertained a notion of their role that related them not only to the prophetic thrones which they surmount but to the central scene as well: the restraint of attitude of these first Ignudi and their veiled melancholy of glance suggests a function like that of a chorus, of commentary on the scene that they adjoin. A first pair of Nudes, above the *Joel*, are placed in quiet, literally corresponding poses in plane against the wall [figs. 36–37]; the matching pair above the *Delfica* move only gently forward in their space. In the second set of Ignudi, around the *Sacrifice* [figs. 33–34], their liberty of action and expression has already expanded to a point which the first, choral idea of their role cannot contain. Each pair of these Ignudi echoes the posture of his pair of predecessors on the same side of the earlier bay, but with a far greater energy. Their attitudes, though still carefully coresponsive, are more vigorous and more complex, particularly in their play of form in space. Their moods are much more individually assertive and more varied among themselves. What they express is not much less distinctly articulated than in the *Isaiah* [fig. 64] or the *Erithrea* [fig. 62] of the same bay but obviously belongs to a different order of emotion and idea. It begins here to be clear how the feelings of the Ignudi are those of a lower category of humanity than that of the illumined Seers: they express melancholy or fear or joy that is tinged with the irrational; and their actions, for all their energy, are finally bound, slave-like, by the physical duty which they must perform of holding up the bronze medallions. It is, however, in these enslaved Ignudi of the third bay, executed before he went on to the *Isaiah* and *Erithrea* below, that Michelangelo seems first to have fully realized a new liberty of his own: that conceded by the painter's art which let him make, in the time of one true sculptured image, a dozen figures freer and more various than he had made so far in stone [figs. 38–41].

What we have described so far, together with such—relatively—less important elements as the bronze-colored nudes and the medallions illustrating subjects from the Book of Kings, completed the painting of the actual curved surface of the eastern portion of the vault. Only then did Michelangelo proceed to the painting of the prophetic Old Testament scenes in the pendentives, *David and Goliath* and *Judith*

*and Holofernes,* and to the depictions of the Ancestors of Christ in the severies [spandrels] and lunettes. While the pendentives are closely related in style to the work that immediately proceeded them, the Ancestors in the severies, and yet more in the lunettes, make a somewhat different effect, summary and quick in execution, reduced in places to blunt shorthand. This difference applies not just to this early portion of the ceiling but through its later course as the painting of the severies and lunettes followed, more or less in sequence, on the painting of the bays above them. The economy of execution seems to have been justified mainly by the lesser visibility of the lunettes, but this objective factor must have been reinforced by the lesser interest of their theme and its accessory importance to the whole. Michelangelo seems to have regarded the Ancestors as more nearly actual human types and personalities than the other actors on the ceiling, less susceptible of ideal interpretation than the Seers or the Ignudi. Few of the Ancestors are conceived in a noble or heroic vein: in general, it is their common humanity that is stressed, even to the accenting in some of them of a Semitic cast of features and, in others, of a caricatural ugliness of face. Their expression and action tend to be ordinary—sometimes meditative, but more often merely domestic, even verging upon genre. The interpretation of specific persons almost surely depends initially upon literary authority, but this is only a point of departure for Michelangelo's description of beings as unexceptional as it is possible for one of his habit of mind to conceive. Unlike the Seers, the Ancestors do not see toward the Christian future. They wait, mostly passively, as if they were less actors than human accidents in the fulfillment of a destiny they do not know. Their status in the scale of prophetic knowledge is less than that of the idealized Ignudi but higher than that of the dark imprisoned beings just above them; as doctrine prescribes, the Ancestors are in limbo.

The general consistency among the three eastern bays, their lunettes and pendentives, make them seem a group, internally cohesive and in a measure distinguishable from the painting on the ceiling that followed. It is not clear, given our very insufficient information about the scaffolding from which Michelangelo worked, whether the next bays were done from the original extent of scaffolding or from some further construction. In any case, in the central bays, Michelangelo seems first to have painted the panel with *The Creation of Eve* [fig. 24]. He brought to this story the new dimension of power and the subtlety of articulation he had invented for the *Isaiah* of the third bay, applying it now to the service of the narrative. More than the last previous narration, *The Drunkenness of Noah, The Creation of Eve* is at the same time more painterly in technique and structurally even less pictorial:

here there is an absolute organization of the picture in a mode of classical relief. The figures are expanded to the largest scale within the frame that the subject will permit, massively modelled, and set in lateral sequence on the foremost plane, they wholly prevail over any sense of space. The space, in turn, has been reduced to a notation still more summary than in the *Drunkenness*.

Like that composition this one recalls, more precisely, Michelangelo's early study of Jacopo della Quercia; and this reference recalls how Michelangelo's first formation of a classical style found authority not only in the idealism of antiquity but in that of a still partly medieval, not yet realistic, Quattrocento art. The essentials of actors and accessories to which Michelangelo has confined his narrative are not different than in Jacopo's version of the scene; the force of Michelangelo's interpretation is, however, vastly greater. From Michelangelo's precisely expressive manipulation of his persons—impossible to Jacopo in this degree in his historical situation—the same idea acquires an altogether different virtue of communication: the spectator experiences Michelangelo's meanings almost emphatically. Not only the crumpled posture of the Adam but the whole tissue of his body is infused with the expression of his sleep. The face of Eve communicates a dawning sentience, a still dazed, half-animal recognition which in this moment belongs to a lesser spiritual status than the sleeping Adam—and which is less also than that of the Ignudi. Her body demonstrates explicitly how she is in part lifted by the magic power of God's gesture and in part already stumblingly supports herself. Not so far had Michelangelo's art expressed ideas of a human situation that were at the same time so essential—so elemental—and so profound as these.

The Ignudi who accompany *The Creation of Eve* are of identical anatomical character with the figures in the panel, and as articulate of emotional states [figs. 43–46]. In posture these Ignudi are freer and more elaborate than the Ignudi near the *Sacrifice;* they are less bound by their nominal function as supporters, and less literal in their counterpoise of pairs. They assume, now, a more attention-demanding role not only for their freer and more various powers of expression but by their now quite noticeable larger size. There had been, not only in the Ignudi, a progressive magnification of the scale of figures from one bay to the next in order of their painting, at the beginning mainly for aesthetic reasons; but there is more now, clearly, than a formal motive to impel this process. This magnifying of the human form was an inevitable response to the growth in dimension of Michelangelo's ideas of its content. The figures do not merely grow in size, they grow in grandeur; their expansion results from the accretion in them of force and depth of meaning.

The most apparent change in figure scale occurs in the panel of *Temptation and Expulsion* [fig. 22]: it is in this scene that Michelangelo's actors in the narrative assume in splendor of physique, in power of movement, and in resonance of feeling, the character of the heroic. Not only the scale but the very conception of the body is changed to fit this higher role. Its forms of musculature become more complex and cursively energetic, and the shape of body becomes less heavy toward its extremities: the anatomy is grander but more lithe; its center of gravity has been raised (Wölfflin). These changes in the bodily structure make its power more finely and flexibly articulate; the figures are more resilient in action and in their expressions of response. And because their ideal regularity of proportion is now more touched with the quality of grace they seem yet more beautiful than before.

The figures of this panel act in a setting almost as drastically summary as that in *The Creation of Eve*. The environment in the part of the scene that describes *The Expulsion* is almost desolate, as abstract as that in the Masacciesque model to which it refers. However, the relation of figures to their background is not so purely relief-like as in *The Creation of Eve*. The openness behind and around the figures, though it is so sparsely defined, contains a painter's effect of spatial and atmospheric ambience; but this pictorial ambience is exploited to affirm, to a new degree, the force of plastic existence of the figures. Michelangelo sets them a little deeper in the space and rounds them, with a painterly chiaroscuro, into more wholly tactile substances. These figures look less like figures in relief than those of *The Creation of Eve*, or of *The Drunkenness of Noah*, and they assume, as much as the frankly sculpturesque Ignudi and the Seers, the character of presences in full round.

In this panel Michelangelo has come to the definitive solution of the problem the narrative panels of the Ceiling had posed, of conflict between the painter's and the sculptor's language. From the subordination, in *The Flood*, of sculptural figures to an intended pictorial scheme of composition and of space Michelangelo had proceeded to an evident compromise, the simulation in paint of sculptural relief. Finally, as he came increasingly to understand painterly values—but not necessarily the values of pictorial structure—and to control painterly techniques, he evolved the solution of *The Temptation and Expulsion*, in which sculpturally wholly plastic form, set within a summary pictorial ambience, is described with the fullest powers of a painter's hand.

*The Creation of Adam* [figs. 26–29] affirms this solution still more explicitly. Against an openness of sky and a strip of primordial earth are placed two great plastic masses, on one side the Adam and on the

other God, enclosed with his angels in a cloud-like cloak. The composition is a simple formal and contentual equilibrium of these two masses, more direct even than the bipartite balance between *The Temptation and Expulsion* scenes. Almost altogether abandoned here is the close-joined sequence of forms, resembling that of the classical picture-designer, that appears in the compositions of the earlier panels in relief-like style. This composition is rather one of part and counterpart of sculpturally distinct units, such as had already been devised for the pairs of the Ignudi. This simple order is exactly proper to Michelangelo's conception of the content of the theme: the confrontation in a high bare world of the first man and his Maker.

For the moment of this fresco God and Michelangelo enjoy a confusion of role: God acts the classical sculptor. He has just shaped the first image of a man, giving him such beauty of physical being as should belong to the ideal ancestor from whom we imperfectly descend. He hovers above his creature, in the act of endowing it with its content of life and soul. The vital spark flows from the outstretched hand of God into the matter He has shaped, and in response this matter begins to live: to move physically and to feel. The body of Adam shows precisely how and to what degree it is, at this moment, infused with vitality: each part of the anatomy articulates how much it contains of energy and how much is still inert flesh. The Adam illustrates the essence of the classical idea of interpenetration of the physical and spiritual being, but he also illustrates the nonclassical origin of this recreative synthesis: the flesh and spirit are conceived of as initially separate elements and it is the spirit, divine in source, which controls and moves the flesh. At the same time the splendor of the flesh and its worth of beauty are as much the work of God as its inner radiance of soul: the beauty of divine creation is in the archetypal substance of the first man as well as in his spirit. What Michelangelo thought God meant by the Idea of man and what, thus, humanity was meant to be was this Adam before the deformation of experience—by God's will and grace a hero, the mortal counterpart of God.

Not only the idea, but the forms also, of *The Creation of Adam* are sufficiently more grand than in the preceding scenes to justify an interval in time between them, occasioned by a brief absence of Michelangelo in Bologna, from which he had returned before February 1511: the *Creation* accords in scale with the last three central scenes. The other members of the decoration of these bays are, however, on a grander scale still; there is a marked acceleration in them of the process, until now relatively gradual, of expansion of external and internal dimension of the figures. The Ignudi, and still more the Seers, in the last bays grow remarkably in size, and still more remarkably in power

of content; and in the last scenes of Genesis, even without further change in scale, there is also an expansion of the power of content. They contain a profundity and urgent motivation in idea that is suddenly beyond the level even of *The Creation of Adam*. As Michelangelo mounts backward in the history of Genesis to this phase where God creates omnipotent and alone, his own thought seems to enter into a vaster and more abstract realm and to be informed with the conception of the Creator's primordial and awful power.

On internal grounds of style it may be that the large panel of *The Creation of the Sun and Moon* [fig. 31] was executed earliest in this last set. God is depicted here as creating with a terrible dynamic energy; He himself moves in the heavens like a celestial body. On the right of the panel, with a gesture of explosive force, He wills into being the spheres of sun and moon; on the left He hurtles like a meteor toward the new-formed earth. In the smaller panel which precedes this one, most often called *The Separation of the Earth and Waters* [figs. 15, 30], the temper of God's movement is altogether contrasting: in slow-gliding majesty He smooths into peace the forms and forces He has created. In both frescoes the shapes assumed by God in his three aspects are compact plastic units suspended, as in *The Creation of Adam* also, in an abstract space. In the *Separation*, however, God's image takes on a yet more concentrated shape which suggests, more than before, the merging of the human form of God with that of a celestial sphere. This whole form is extremely simplified, generalized without and within to a degree not so far shown in the Ceiling.

As Michelangelo dwells on the first episodes of Genesis his conception of God's nature and actions becomes higher and more remote: apart from incident, narration, and materiality. The *Separation* is concerned with God's presence and being, and hardly with the description of an action; it is for that reason that the fresco is not precisely nameable: the exceptional generalization in it of form and content is that of Michelangelo's idea. But the last panel of the Ceiling [figs. 16, 32], the first act of Genesis, is conceived by Michelangelo in an image still more remote, and at the same time intellectually and spiritually yet more profound. The beginning of creation is reduced to an essence which reaches as if above and through the first bald sentence of the Bible to a vision of a hardly apprehensible God, seemingly newly self-formed from the surrounding chaos. He turns in chaos—and again a cosmic simile suggests itself, unknown to Michelangelo, of a solar body in its process of formation—seeking to shape the dark reaches where there is as yet no form and no direction. The idea of this image, so exalted and so nearly abstract, is given us in a corresponding language, so general as to border on abstraction.

The Ignudi of the last two sets also seem, by comparison with their predecessors, to have been generated in a higher and more powerful range of Michelangelo's invention—applied still, however, to the thematic idea they are supposed to illustrate. Their various emotions are much more intense, but are of no less irrational, nature than before. The Ignudi still convey the sense of personality involved with and enslaved by bodily existence. Their bodies, proceeding from the conception of a physical splendor arrived at for the Adam, elaborate that conception and try, even, to surpass it. Around the *Separation* [figs. 47–50], the Ignudi—not less physically remarkable than the Adam—move as he is not permitted to in his role. One of them, possessed by an incoherent fear, is wound into a posture at once uncomfortably strained and almost calligraphically ornamental. Another, satyr-like in countenance, moves on his seat as if seized by the impulse of a dance. A third is inspired with a furious energy which makes him turn quickly and violently, pulling toward him the swag of the medallion to which he is bound. His partner is as if locked into a pose of contrasting immobility, but not of rest; he is in an extreme torsion of contrapposto. In his rhythmic eloquence of posture and in the beauty of his head he exceeds the Adam as an ideal physical image of humanity.

The Ignudi of the last bay [figs. 51–55] are more profound in mood: melancholic, and bound in upon themselves. Nearest to the highest image of God, it seems as if their power of spirit has become more penetrating and more possessive, but still not liberated from their enslaved and now yet more massive bodily forms. These creatures, more but not yet wholly knowing, yearn and struggle still only half-sentiently within, and incipiently against, their flesh. Only one Nude here, as powerful as Hercules and beautiful as an Antinoös, sits in almost sullen meditation [fig. 51] as if he alone, a *summum* of the beauty of antiquity, were reluctant to see his epoch vanish and the half-comprehended prophecy fulfilled.

Not only he but all these last Ignudi have bodies still more powerful than the Adam's, or both more powerful and fine: in these figures Michelangelo finally has won his long private war with the *Laocoön*, and surpassed the envied model of the *Torso Belvedere*. But we are struck, in the Antinoös-like creature in particular, as nowhere earlier so strongly in the Ceiling, with the sense that this figure is no longer a possible or credible being. The archetypal perfection of this physical beauty and, as well, the gigantic muscularity of the Nude opposite him share, in a way, the extreme ideality of the image of God above their heads: the proportion in them of ideal invention and of plausible description is decisively weighted toward the former. This shift of emphasis, by which the image is removed yet further than before from

natural appearance and toward an idea invented in the artist's mind, marks a change from what we may regard as a median of classical ideality attained in the preceding set of pictures of the Ceiling, as in *The Creation of Adam:* the images of the last bay already point away from the sphere of thinking that is in the *Adam* and toward that of the Medici Tombs.

More marked even than this change in the Ignudi is the contrast of the last group of Seers with their predecessors; in them new energies and depths of thought are released in awesome crescendo and finale. For all their massiveness and force the Prophets and Sibyls of the middle bay belong to a perceptibly lesser order than these last five Seers. The difference, as always in the Ceiling, is not only of scale but of dimension of personality. The ancient crone Cumea [fig. 68], almost clumsy in her heavy-muscled compact shape, contrasts with the grave, suave, slow-unfolding power of the grander Persica [fig. 69]. The mood and movement of Ezekiel [fig. 66] are almost blunt by comparison with that of Daniel [fig. 70], whose state of spiritual possession electrifies the swift and subtle action of his form. As in the Ignudi of the same bay, in the *Daniel* a higher energy and more complex emotion are articulated in a freer action of the body, here vastly more monumental than the nude forms just above.

The last three Seers are developed, in some ways, even beyond the level of the *Daniel* and *Persica.* They are touched with the character of a still higher ideality that appears in the other figures of their last bay and they each express this ideality in a seemingly deliberately differentiated way. The *Libica* [fig. 74] most of all resembles, in kind of ideal meaning, one of the aspects of the Ignudi who, in time of painting, just precede her: among the Seers she is the one who most intends an archetypal beauty of physical presence and of formal attitude. Her form, still more evidently than in the last Ignudi, has been invented for its ornamental value: it refines the conception of the last Nudes toward a poised quick elegance which becomes, in Michelangelo's necessary interpenetration of content and form, the coloration of her personality. She may be regarded as a development in a special sense of one of the ideas, that of formal beauty, which elsewhere in the Ceiling—except only in the Antinoös-like Ignudo of the same bay—had appeared only as one among the complex of elements that composed the synthetic whole of a mature classical image. It is as if, in the process of development of Michelangelo's thinking toward a higher ideality, this concept of formal beauty had assumed a degree of clear identity, as a separable idea, within the whole ideality of classical style. In the concern in the *Libica* for formal beauty as a specifiable primary ambition, and in her complex ornamental elegance, she takes on the role of art-historical as well as of religious prophetess, of the style of

Mannerism. However, the intention in her of formal beauty is not, as in later Mannerism, a divorce of this element from a classical context but only a stress of this value within it. The thinking in the *Libica* remains a development—a special stress of one of its ideals—within classical style.

A similar development toward an ideal archetype of one aspect of the whole classical conception of the figure determines the character, very different, of Jonah. Here again the idea follows on the thinking of the last Ignudi—not from their beauty of form but from its power and diversity of expressive action. In the *Jonah* [fig. 75] this conception is enlarged by a tremendous increase, possible in him as a Prophet, of spiritual content. Where the Ignudi and most of the preceding Seers have emotion that is self-generated and self-contained, Jonah is inspired instead by an actual outward vision of his God. Symbol of Resurrection and ancestor of Peter, Jonah projects a bridge between the epochs of Genesis and Grace, looking up at the history that is past and gesturing passionately toward the world that is to come.

More terribly inspired and possessed than any other figure on the Ceiling, Jonah moves with a vehemence that strains the limits of a classical constraint. His energy of action, like his implication of content, expands beyond the bounds of his allotted place. As the *Libica* appears to prophesy a Mannerism, the *Jonah*, an ecstatic spirit in a dynamically active actuality of form, seems to prophesy a baroque. Again, however, though his image explores a new reach of the classical ideal, it remains within it: the impulse of the figure is compensated externally by its accessories and internally by its absolute adherence to the principle of contrapposto, of equilibrium of energy and mass upon the body's core. Further, the emotion of the *Jonah* is not only passionate but clear and pure, exalted even beyond the emotions of the other Prophets; what moves him is an idea higher than that which had inspired his companion Seers.

Jeremiah [fig. 71], Prophet of Lamentations, is a demonstration of a third archetype. In massive presence he is of a race as grandiose as Jonah's, but he is his antithesis in expression. The power of feeling in this Prophet, as great as the expansive passion of the *Jonah*, is oppositely turned in on itself: Jeremiah's great, compact, gathered form expresses the dimension of his thought and its concentration. Every other Seer had been given some pretext of action or of illustrative incident, but Jeremiah has no "motive" beyond that of his thought. This slow-breathing, meditating monolith embodies, more than any allegory, the concept of thought itself, in that dimension of it Michelangelo himself had now attained: Jeremiah is the image of Michelangelo's Idea.

In ways that are different in their form and in intent of content,

these last three prophetic figures express aspects of the conception that dictates the image of God in the final bay. In that central image the idea is expressed in terms of generalization so high as to verge toward abstraction, and in the Seers the ideas are more substantially defined as well as specifically differentiated from each other. Yet like the God, all three Seers are not any longer idealized representations but, instead, representations of ideas; and Michelangelo's whole evolution in the Ceiling may be summarized in this inversion of a phrase. He has moved, in the process of this inversion, toward an ideality so high that it now stands at the limits of a classical expression.

In the pendentives that flank Jonah, except for the western Ancestor lunettes the last works done before the final unveiling of the Ceiling in October 1512, Michelangelo in fact finally trespassed beyond the limits permitted by a classical concept of style. What had occurred between the first and last bays of the Ceiling was all of it encompassable in a definition of classicism, but what has happened between the first pendentives and these last two shows not only a development but a cleavage between styles. The sculptor's mentality—more rather than less affirmative since the early portions of the Ceiling—is in part responsible for the character of the late pendentives. No longer concerned, as he had been in the *David and Goliath* [fig. 83] and in the *Judith and Holofernes* [fig. 82], to make a pictorial unity of narrative, Michelangelo, in the late pendentives, thinks entirely in terms of figure-mass; in both *The Hanging of Haman* [fig. 84] and *The Brazen Serpent* [fig. 85] the ambience is not only summary and secondary, but drastically arbitrary. In the *Haman* four narrative episodes coexist with not even minimum logic of spatial relation; in *The Brazen Serpent* there is hardly any space but only a turmoil of great plastic forms. In the *Haman* the arbitrariness of Michelangelo's thinking of the narrative is such that it is told not in a discernible sequence but with a juxta-position of concepts like that in the word order of a Latin sentence. The beginning of the tragic climax of the story, which in normal order would be most separate, inversely intersect in the most prominent central place, and initial cause and final consequence culminate in the figure, more anguished and desperate than *Laocoön*, of the crucified Haman.

In its violation of the rationale of space, in its blunt yet restless distribution of units of design, in its abstraction of narrative order and dark violence of mood this pendentive—despite its classicism of single forms—is no longer structurally or expressively classical. Michelangelo's urgency of spiritual sensation and his abstracting tendency of thought have carried him here beyond the limits of a classical discipline. Neither harmony nor unity, and little of classical constraint, temper the dis-

membered vehemence of this fresco.

*The Brazen Serpent* is more unified in order but not according to any classical system of design. Its form responds immediately to a terrible, and also pessimistic, vision of the subject, expressed in the serpentine twistings of the figures of the damned. Figures, as mighty in dimension as the Prophets, are inspired by terror and moved by agony; again Michelangelo returns to and exceeds the theme of the *Laocoön*. Not only the tormented action of anatomies but their eccentric foreshortenings deprive even the single figures of a character of classicism, which in some measure had persisted in the *Haman*. And where, as toward the background, there is no room for the whole body to express its anguish, single ghostly countenances, like the population of a nightmare, assume this function. By comparison with this melee of the damned the small group of the saved on the left are conventional and unconvincing presences.

Even more than the *Haman, The Brazen Serpent* depends on an interpretation of its subject in a willed unclassical sense. In violence of emotion, and in abstraction and illogic of form, it is yet further from recognizable principles of classical style. In both pendentives, moved perhaps in part by the dramatic potential of their subjects, but more by a climactic and irresistible surge of his own expressive intensity, Michelangelo's force and ideality acquire, for the moment only, an apocalyptic nature. In this momentary breach of classical disciplines the pendentives assume, prematurely, the character of postclassical phenomena of style, Mannerizing in the *Haman*, and in *The Brazen Serpent* simultaneously Mannerizing and proto-Baroque. Michelangelo had accomplished, in the Sistine Ceiling, what may be the highest and swiftest flight of spirit ever undertaken by an artist, and what may be the longest in the range of style it explores. In four-odd years of labor Michelangelo accomplished an evolution that embraced, in summary and essential terms, the possibilities of the classical style from a relatively elementary to an apparently final stage, and tested its impossibilities.

# SVEN SANDSTRÖM
## The Sistine Chapel Ceiling— [ 1963 ] *

The following is excerpted from a brilliant, often original book on the study of reality and illusion in Renaissance mural painting by a

* Sven Sandström, "The Sistine Chapel Ceiling," from *Levels of Unreality: Studies in Structure and Construction in Italian Mural Painting During the Renaissance* (Stockholm, Almquist and Wiksell, 1963, also published in *Acta Universitatis Upsaliensis*, ed. Nils Gosta Sanblad).

modern Swedish historian of art, Sven Sandström. He had earlier written in 1955 a volume on the "imaginary world" of the French painter Redon. In this selection on the Sistine ceiling he works out in a logically conceived development an idea proposed as early as 1921 by the noted German art-historian, Erwin Panofsky, under whose influence Sandström came directly in Stockholm where Panofsky gave late in his life a memorable lecture-series on the topic of Renaissance and Renascences. Sandström's thesis is that the spatial construction in Michelangelo's design for the ceiling retains an objective "reality" preserving the integrity of the actual surface while at the same time it suggests by illusion spaces for a hierarchy of types of figures (and therefore also symbols of aspects of being). It is the fullest treatment so far available of the over-all formal structure of the ceiling's complex composition.

"SINCE THERE HAVE BEEN interpreters, almost everything has been said about this work except the main idea which unites the whole and makes it appear an animated organism," writes Charles de Tolnay in his book on the Sistine Chapel ceiling. * * * Most of the conceivable comparisons and derivations of its elements have already been put forward. Yet it seems that while the artistic significance of the work has caused attention to be concentrated upon the importance of the elements * * * and their composition * * * the mural structure as such, and the ensemble as a functioning whole, have not received the same amount of attention.

We do not know when Michelangelo made his first sketch of the plan of the work. Even though he may have had an opportunity to reflect on the pope's desire that he should execute the paintings, it is unlikely that he began on the sketches until this desire was translated into an obligation in May 1508, or—most probably—in the summer, presumably in June, when he changed his plans for the work and enlarged the scope of his programme.

Of his first sketch, Michelangelo wrote—as late as 1523, admittedly —that it showed twelve apostles, and a (central) area filled with decorations as custom required. This description agrees with the well-known drawing in the British Museum [fig. 114a], in which the pendentive is provided with a false plastic throne with a seated figure and with a richly decorated upper part, while the rest of the vault was evidently designed to be filled up with smaller painted areas enclosed by decorative frames. Vasari writes of the choir vault in S. Maria del Popolo with the same emphasis on the enthroned figures [see fig. 136]; he makes no mention of other details. The distinction between large figure-painting and decorative filling is an important one.

The date of the painting of the choir vault in S. Maria del Popolo

cannot be determined with certainty, though some evidence points to the period September 1508 to May 1509. The fact that Michelangelo's drawing bears such essential affinities with the choir vault, despite the fact that there is not a single detail in this latter that needs to be accounted for by reference to the sketches or finished works of Michelangelo, makes it extremely probable that Pintoricchio had at least completed his sketches at the time when Michelangelo was starting work on his own.

Even if Michelangelo derived from Pintoricchio's vault the distinction between the false plastic thrones with their figures, the actual forms adumbrated in the vault panel itself show kinship not with those of Pintoricchio, but rather with those of Perugino in the Collegio del Cambio. All the evidence points to the assumption that it was Michelangelo's intention that the frames with their different shapes should appear to be laid upon the wall of the vault without forming an architectonic structure, that they should decorate the vault wall just as the medallions had done on Perugino's wall [see text fig. 5]. The fact that the circular medallion form already occurs in this first sketch leads one to surmise that, like Perugino, Michelangelo intended to make polychromatic pictures alternate with false reliefs of the medallion or cameo type.

Even if the sketch did convey a distinction between the false plastic decoration of the pendentives and the "flat", surface decoration of the rest of the vault, there is none the less an unresolved self-contradiction here: the upper parts of the thrones reach higher up than the limits of the painted areas; parts that must be assumed to constitute a direct vertical continuation of the wall reach beyond the boundary of that which must be assumed to be the horizontal or at least nearly horizontal ceiling. In the next sketch that has come down to us—the drawing in Detroit [fig. 115]—the contrast has been so radically attenuated that the artist must have been searching for a solution to exactly this problem [see text fig. 6]. Besides the important cornice which is painted round the vault, and which was already there in the first sketch, Michelangelo has now inserted an attic-type middle section that corresponds to the majority of the upper parts of the thrones—here formed as an oval medallion, flanked by winged genii in standing positions. At the same time, two false ribs have been introduced as a continuation of the verticals of the thrones, and these form transverse communications across the vault. Finally, the number of painted areas on the vault has been reduced, so that a band of alternately large octagonal and small rectangular panels forms a long chain traversing the vault surface from one short side to the other.

The changes are assuredly connected with the fact that the plan

was expanded, with the pope's sanction. It reveals not only the desire to enrich the whole with bigger pictorial units, but also an awareness of the logical requirements consequent upon the introduction of a false plastic element as a dominant ingredient. This is a point of essential importance, because certain writers—Thode among others—have pointed out what they regard as inconsistencies in the structure of the completed work. * * *

The second sketch showed a tendency in the direction of a firm false architecture and larger painted areas in the vault panel, while the decorative elements were simplified, ornamental forms already hinted at in the first sketch were reduced. The genii crowning the thrones—which had first formed a part of the plastic structure of the thrones—were emancipated and the human figure was allowed to stand out freely against the vault. The cartouche frames that still occur in the second version vanish in the completed work, where purely ornamental forms are reduced to a minimum and are replaced by figurative forms—it is noteworthy that the spandrels joining the window lunettes are united to the cornice with the help of unstylised bucrania. The path has thus led from the dualism between figurative depiction and decorative adornment—where the painted area has a formal function as a decorative object—to the dualism between the painted area on the one hand and a false plastic system, including false architecture, on the other. * * *

The principle of the closed wall, upon which the Sistine Chapel is based, gives opportunities for a false modelling of the wall both outwards into the room and inwards, back into the wall structure. The question is whether, while planning his work, Michelangelo made use of any actual wall-penetration effects—as would seem to be indicated by the presence of the large octagonals in the later sketch. In the final scheme of the work, imaginary wall-openings cannot be presumed to occur—as will be demonstrated later.

The presence of a continuous tier of pictures on the vault surface constituted a special axis lengthwise along the room and disturbed the complete dominance enjoyed by the transverse axis in the first sketch. But the direction of this latter axis is on the other hand even more strongly stressed by the false architecture. The number of decorative areas in the vault was reduced and their forms simplified, but at the same time the total number of pictorial types was increased. Altogether ten different types of picture occur in the completed work: of these three are descriptive pictures with space-formations of their own, two are groups in the proper sense of the word, and the remainder are single figures, with or without subsidiary figures or pendants.

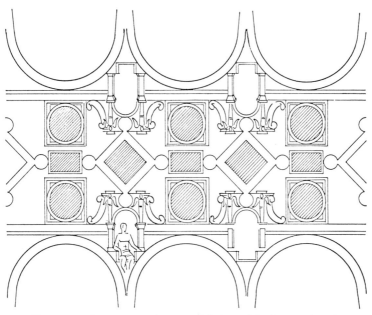

*Text fig. 5. Reconstruction of Michelangelo's first project for
the ceiling (after Sandström).*

*Text fig. 6. Reconstruction of Michelangelo's second project for
the ceiling (after Sandström).*

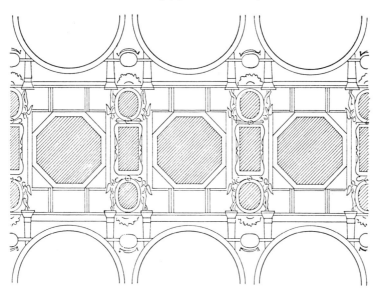

It is scarcely possible to find anything like this in earlier mural painting. The proliferation of different pictorial tiers had culminated in vault painting, but the homogeneity of vault painting is here disrupted. It was usual for the false architecture of wall painting to be combined with homogeneity in the picture. But there was a group of monuments which might have pointed the way to a rich and complex structure of the ensemble in which a set of different pictorial themes can be correlated and interwoven. This is once more the Roman triumphal arch. * * * The Arch of Constantine [fig. 137], which with its many tiers of pictures is again the most likely point of departure, was easily accessible and visible to all. Various scholars have already seen a connection between many details of the Sistine Chapel and elements of the Arch of Constantine, and we should remember the fact that the whole enterprise was initiated immediately after the triumphal return of Julius II from Bologna to Rome.

It has often been asserted too that features from the tomb of Julius II, which Michelangelo had begun, had an influence upon the architectonic structure and upon the insertion of plastic figures in the ensemble. We have already drawn attention to the connection between the plastic art of tombs and that of the triumphal arches, but it is not very likely that Michelangelo based his conception of the structure of the Sistine ceiling upon the tomb and upon nothing else—there are far too many points of direct and immediate agreement with the Constantine arch for this to be the case.

For observing the Sistine ceiling along the transverse axes, the best starting-point is from the wall seats along the sides of the chapel. According to Johannes Wilde the paintings are oriented in the direction of such a viewpoint—though this is not enough to ensure full illusionism in the false architecture. From here, in a continuous succession, one can regard the thrones as a homogeneous construction, with the crowning ignudi, the vault arches and between them the painted areas of the central axis—while obviously the thrones on the opposite side lose their pictorial meaning [see text fig. 7]. It is hardly necessary to interpret this structure as a direct paraphrase of a triumphal arch, even though there is some meaning in such an interpretation, stressing as it does the importance of the whole as a monument to the della Rovere family. The elements in the pictures which may have been influenced by the Arch of Constantine are grouped according to quite different principles.

The thrones, with the throne-pillars flanking them, remind one of the columns on the Arch of Constantine: the figure-reliefs on its plinth bear considerable likeness to the small human figures that support the projections of the cornice in Michelangelo. For example, the figures

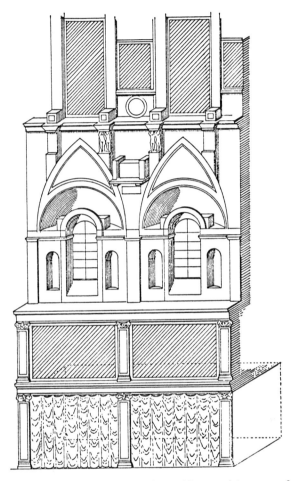

Text fig. 7. Over-all view of the architectural framework
for the whole Chapel (after Sandström).

on the front side, of the thrones, standing in pairs, with their soft
curvature, are as it were barricaded in the frame of the relief area.

The ignudi [figs. 33–55] crowning the throne pillars occupy a
position corresponding to that of the barbarian princes standing in
front of the attic of the triumphal arch; and the painted area of the
vault panel, which in the central axis reaches down among the ignudi,

corresponds to the aurelian reliefs on this attic.

Finally, the medallions among the ignudi [figs. 56–58] recall the pictorial medallions set in pairs around the Arch of Constantine, as already noted—the reminiscence is moreover not only one of form but also of pictorial language. The dark, bronze-coloured nude figures which rest in the spandrels between the webs of the windows and the thrones and in the cornice have likewise been compared with the river gods just above the side portals of the Constantine arch, and the small *"spiritelli"* beneath the thrones have their direct counterparts in the small personifications of the seasons under the victoriae of the middle portal.

Only two tiers of pictures on the façades of the Arch of Constantine have no direct counterparts in the ceiling of the Sistine Chapel: the victoriae—their sweeping and impetuous movement may recall the ignudi, it is true, but there is otherwise no resemblance—and the band of Constantinian reliefs under the medallions and immediately above the vault of the side portals. It is enough here to refer to the continuous suites of pictures on the walls of the Sistine chapel, where the stories of Christ and of Moses are depicted with an equal epic breadth.

For most of the pictorial elements, there are other derivations that are more important for the individual forms; here we are limited to a consideration of the structure. It was in his search for a way of differentiating more richly between the tiers of the pictures and for an unambiguous logical relation between the pictures and the structure of the false architecture that Michelangelo found fundamental inspiration in the Arch of Constantine. In this arch he found a structure of pictures, assembled like bricks to form a consistent whole. * * *

The link between the walls and the vault of the chapel is deserving of special study. The continuous wall in which the thrones are integrated is regularly broken by the spandrels of the windows.

This is all the more remarkable in view of the fact that lunettes and spandrels stand by virtue of their form in a continuous relationship to the walls, and to a certain extent constitute a tier of their own, together with the uppermost part of the walls. A reexamination of the false modelling of the walls supplies the evidence for this [see text figs. 8–9]. The drapery imitations at the bottom are indicated as concealing a wall of unknown position, and they provide an uncertain delimitation of the room. As we have insisted here the tier of the large paintings above them must be primarily interpreted as wall surface, covered with paint. Above the robust, real cornice which crowns the pictorial tier there are false niches with figures of popes, arranged in

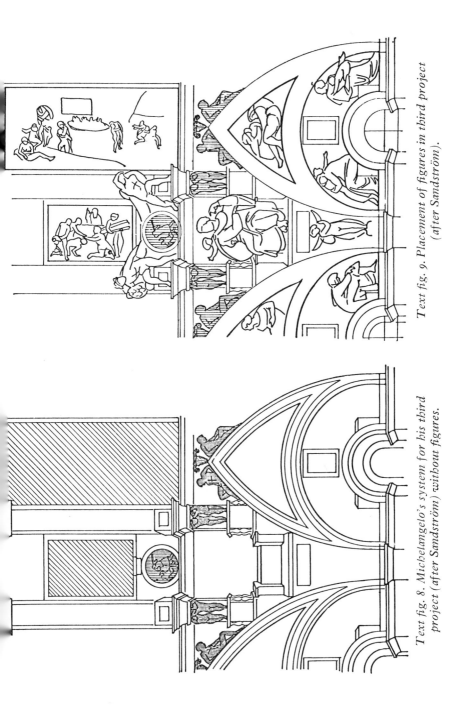

Text fig. 9. Placement of figures in third project (after Sandström).

Text fig. 8. Michelangelo's system for his third project (after Sandström) without figures.

pairs around the high windows, where the real wall-modelling also makes itself felt in the pilasters. Only an unemphasised frieze and a narrow, flat plinth separate the lunettes with the ancestors of Christ from the gallery of popes [fig. 96].

The formal distinction is such that one is under no temptation to regard the popes and the ancestors of Christ as partaking of the same reality; the difference in their format is itself enough to dismiss such an interpretation. When, however, the artist has established this basic distinction, he can afford to set up links between them. This is done, for example, by the placing of the forefathers of Christ in niches too, and here they are subject to the same type of illumination as is ascribed to the chapel room itself. This last detail, which does not appear to have been observed before, proves the decisive importance of the system of false architecture, which ensures that each and every type of picture is related directly to the chapel room and is also defined according to the type of illumination, which distinguishes picture surfaces from false plastic forms.

Thus the forefathers of Christ are situated in the lunettes, in a structure of niches that is assumed to be a part of the architecture of the wall. In the spandrels above, however, these representatives of human kind repose in undefined spaces of unknown depth and character, perhaps in pictorial spaces of their own, perhaps in deep niches; but the illumination that plays upon their bodies comes from the chapel room here too, and quickly grows paler when it passes inwards to the interior, as would be the case if there were no other source of light. In this way these figures also belong to the sphere of the false architecture.

The moulding around these painted areas creates a definitive boundary between the tier of the walls and that of the vault. And yet there is a successive modification in the character of the pictures such as to presage a transition. This transition between wall and vault is expressed by the fact that the half-reclining bronze figures in the spandrels above—those which have been compared with the river-gods on the Constantine arch—occupy shallow flat niches similar to those in the suite of lunettes depicting the forefathers of Christ. Their status has often been described as uncertain; but if they are seen in relation to the modelling of the vault of which Michelangelo created an illusion, their status becomes unambiguous: the feeble light that penetrates into the niches, past the projecting thrones and the moulding, is insufficient to give them a plastic clarity comparable with that which characterises the enthroned prophets and the sibyls or ignudi. By the spaces that these figures occupy it is also stressed that the spandrels with their mouldings are to be understood as sticking up

in front of the wall of the vault, not laid directly upon the vault. The vault's architectonic anchorage in the walls is thereby situated at the height of the crowns of the lunette arches and the socles of the prophets' thrones; but the mediating link which can be seen is a non-architectonic support, or rather a symbolic support, namely the "*spiritelli*" with name-tablets underneath the thrones, which stress the supporting function of the pendentives but at the same time mask these pendentives. If their places had been taken up by architectural links in false plastic modelling, the regular vertical division of the throne tier would have seemed to be an odd anomaly—whereas now there is a logical possibility of interpreting the whole tier as a homogenious, vertically-rising wall structure, a direct sequel to the painted walls. But the false architecture is not illusionistic; it is content with signifying a logical *modus vivendi*.

As one's viewpoint is moved from bay to bay, one is nowhere offered a view of the false architecture that is oblique enough for one to determine what profile it is intended to have. It seems possible, however, to identify the wall surface with the backs of the thrones —which thus become a sort of zero point in the construction—and to regard the vault ribs as existing on the same level. This provides the clearest starting-point for a study of the relations which the remaining forms bear to the wall.

It is striking that only prophets and sibyls are at the same time represented in such a way that they are presumed to exist entirely inside the chapel room and are surrounded by an air space of their own. The small genius-figures behind them show that there is a space which, although it has the character of a niche because of the thrones, is nevertheless clearly illuminated. The small caryatid figures standing in pairs on the thrones are interpreted as high relief, while the cornices above them and the bases under them are interpreted as the most forward-lying level of the false architecture.

The ignudi on their cubic socles are bound to the wall surface in quite a different way from the prophets and sibyls, although they have a freely plastic character. Whereas the throne figures are directed outwards into the room, they are oriented towards the sides, and through the oak-leaf garlands of the della Rovere family they are bound to the wall by the round bronze-coloured medallions, which are attached to the wall surface like seals.

If one also takes a transverse view of the continuous series of pictures in the middle section, depicting the story of the Creation and the story of Noah, which as pictures must be seen from a viewpoint along the long axis, it appears with especial clarity that these pictures must be interpreted as painted surfaces, not as some sort of openings

in the vault or visions through the vault. The absence of the traditional framework is of no importance here, since the sketch showed clearly that Michelangelo started out with decoratively framed painted areas and then successively simplified them in proportion as the idea of the false architecture grew upon him. But first and foremost in a ceiling, pictures seen from top to bottom cannot create an illusion, and indeed only one of them is really seen *dal di sotto in su*—the first picture in the creation suite, which is also the last in order of time.

When seen along the direction of the transverse axis, then, the mural structure is on the whole devoid of ambiguities and assigns an exact location to all types of picture. Only the middle areas and the four big corner areas fall as pictures outside this context and cannot be read together with the other elements in this way. It is only when we see the chapel ceiling along the long axis, from the entrance side, that these pictorial areas assume a dominant position as descriptive pictures. Even then the middle areas still remain pictures painted on a wall, but they acquire new opportunities of gradually absorbing the observer's attention and luring him out of the fiction of a plastic vault peopled by living beings, into the fiction of the biblical narrative itself.

But at the moment that this happens, the implications of the structures in the transverse axis change too: what according to the former point of view was a richly differentiated spectrum of human figures directly or indirectly represented, now conserves its effect only in the form of false modellings in and on the surface of the wall, elements in an incredibly rich framework.

Thus the planes of reality in the whole can be interpreted in two different ways, depending on which main aspect or point of view we choose. It is thanks to Michelangelo's extraordinarily skilful management of the weights and counterweights of the whole structure that in this explosive seething mass of shapes and figures the observer can experience its individual details undisturbed.

In *Die klassische Kunst*, Wölfflin pointed out that not all the figures on the vault have the same degree of reality, the same nearness to the pulsating life of humanity. Panofsky carried this view further in 1921, in a radically thorough analysis:

> . . . The more foursquare and unadorned the architectonic structure becomes, the richer and more lively becomes the figurative decoration, which for Michelangelo could consist only of human beings—of human beings with different measurements and different degrees of reality, who are evolved in exact contrast to the rigid "quadratura" system, and attain the greatest and most animated volume.

In painted architecture, he continues, human figures can be inserted in two ways. Either one can imagine that as apparently living persons they populate the spaces available, or else they can be depicted as illusory works of art, which themselves make up a part of the architecture. But the scale on which Michelangelo operates is even richer; in the pictures of the ceiling panel he presents human beings as apparent pictorial representations, in the infant caryatids are human beings as apparent stone sculptures, in the prophets and sibyls he shows human beings as apparently living personages—and between these categories, Panofsky writes, we have the recumbent bronze-coloured nudes, which we do not know whether we are to interpret as living human beings or sculptures. * * * Indeed, even the ignudi seem less immediately alive than the prophets and the sibyls.

Only at one point is an amendment to this analysis necessary: the recumbent bronze-coloured nudes share in the same homogeneous space relationships as the other figures; they cannot be understood as paintings but must instead be seen as sculpture—or possibly human figures—in the room, that is common to them.

The scale which has been set up here—the anthropomorphic scale —has, as has been pointed out, its complement in the objective scale— a fact to which Panofsky alludes, certainly, but without taking fullest advantage of it.

The interpretation of the middle area's painting as decorations on the wall surface increases our faith in the real plasticity of the surrounding elements of the architecture. The bronze medallions have a reliability as objects which, as far as the perfectly preserved and fully-painted examples are concerned, might well have a *trompe-l'oeil* effect. Through them, the surroundings become more credible as plastic structures—and this applies therefore to the ignudi too, which need to be supported in principle, since they seem to be sitting fastened to their sloping plinths. As objects, the infant caryatids give material concreteness to the thrones of the prophets and the sibyls, and thereby raise the credibility of these figures. Finally, the false reliefs become—to repeat a metaphor used just now—the seal which secures the whole host of plastic elements to the vault wall; and that which on Panofsky's scale should have been the bearer of the lowest degree of reality acquires instead the highest degree of objective reality. When prophets, sibyls, ignudi, all those splendid figures that rivet our attention and cause that strong artistic radiation that meets the observer who looks at the Sistine ceiling from side to side, are transformed into plastic ornaments, when the vigorous movements and sculptural bodies of the ignudi are changed into frame ornaments around the paintings on the central axis, then only the medallions and the "infant" caryatids retain their concreteness as objects; they do

not change their figure and their function when the observer turns his attention from the sculptural Sistine ceiling to the pictorial one.

With Michelangelo the mural system was given a life and an artistic significance which it had probably never achieved before. Pioneering geniuses in the art of decoration, like Mantegna and Pintoricchio, laid the foundations, devised the grammar so to speak; but only with Michelangelo was the mural system itself transmuted into a living language.

The Sistine ceiling cannot be considered an illusionistic achievement in the ordinary sense of the term; its frescoes are built on solider foundations than the astonishment of the observer—astonishment that is momentary and quickly past—who finds that the vault is suddenly lifted above his head to form an extra space, filled with gigantic figures on thrones and socles. The basic premise underlying the whole of his architectonic system, and thereby also the arrangement of the vault as a whole, is the concession which the observer grants, not a defeat that he suffers. Not until we have clambered over the thorny barrier which lunettes and spandrels raise for an illusionistic interpretation can we perceive the structure as a perfectly logical and consistently achieved unit.

A rich programme of pictures is interwoven in this unit, but it is a programme whose import is hardly altered or made richer by the fact that we can distinguish its structural foundation. The forefathers of Christ remain as a circle of representatives of earthly existence, separate from the splendour of the biblical figures and the great drama of the biblical narrative; prophets and sibyls remain sculptural figures of great power, announcing the coming of Christ; ignudi remain the fair youths who surround pictures from the Book of Kings and who with their garlands of oak-leaves bear witness to the greatness of the della Rovere family; the central pictures and the corner areas remain depictions from the Bible. Nowhere in the structure itself do we find ambiguities or insinuations such as to reveal hidden connections between the motifs or give them new connotations. Just as the plastic language in this masterpiece is simple, powerful and free of all ambiguity, so also the solid structure of colours and contours which makes this whole work cohere in its innermost core is simple and devoid of subtlety or sophistication.

Only in one place, the boundary between the pictorial tiers is pierced by a contact of such visionary intensity that it transcends the static laws of the structure: this is the part that was painted last of all, immediately above the altar, where the prophet Jonah turns his eyes upards with a great sweep, and abandons that state of meditation, anguish or self-scrutiny which unites the rest of the prophets

and sibyls, in order to let his gaze fall upon Him whose countenance is said to be unendurable to mortal men.

The ignudi surrounding the picture of the creation are unaware of the cosmic storm of human forms seething above them; they stand watch over one picture only. This picture, however—by contrast with the others—is seen *di sotto in su;* it is the only one that can possibly be understood as an opening in the vault.

When the pictures of the fresco became objects, it became the rule that no deity, whether Christian or pagan, may emerge as personally present in the space of the false architecture. Instead, the picture becomes the mirror in which the human being can gaze on the god with impunity—whether the god is depicted on tapestry, on medallions, false reliefs or painted areas, or as a picture on the sky of the apsidal vault.

But while the observer standing on the chapel floor must interpret also this picture as a picture on the vault, he is also privileged with the help of Jonah to experience a more intimate view; not only a reflection but an actual glimpse of the Creator Himself, as He soars past a rift in the shell of the wall—more like a formation of mighty rhythms in turbulent movement, more like a part of the cosmos in inchoate form, than a human figure [see fig. 7].

Jonah accomplishes a link between two disparate spheres. The two structures of the ceiling (one pseudo-sculptural and connected with the transversal axis at the chapel; one both really and as a fiction to be accepted as pictorial and connected with the longitudinal axis), the activity of the one of which constantly demands the passivity of the other, now make contact at last—a contact that ignites a spark and gives life. This happens on that spot of the vault where the whole work was brought to its conclusion, above the high altar and above the enormous wall fresco which was finally to burst asunder that paradoxical closed unity which Michelangelo succeeded in creating within his work, and between it and the older frescoes of the walls.

# CHARLES DE TOLNAY
## from *The Sistine Ceiling*—[ 1945 ]*

Charles de Tolnay, the leading contemporary authority on Michelangelo's art, is director of the Casa Buonarroti in Florence. His view of the meaning of the imagery of the Sistine ceiling as a whole is

* Charles de Tolnay, *The Sistine Ceiling*, vol. II of *Michelangelo,* 5 vols. (Princeton, Princeton University Press, 1945, 1969). Reprinted by permission of the author and publisher.

strongly slanted toward the mystical aspects of Florentine Neoplaton-
ism—upon which Michelangelo must have been brought up while he
was hardly more than a boy in the household of Lorenzo de' Medici
(1490–1492) in Florence. Tolnay's thesis was already sketched out in
article form some years previous to its full publication in 1945. The
following excerpt has been selected from the latter.

Among other things, Tolnay's writings develop several concepts of
Neoplatonism in Michelangelo's Sistine cycle. One is the concept of
*ascensio*, and the author gives this explanation: "The spectator ad-
vancing from the main entrance towards the altar experiences from
history a gradual ascension; freed from his bodily prison he leaves his
early existence and attains a state of absolute freedom in infinity."
The notion of spiritual ascension from the earth and body is a key
theme beginning with "The Sphere of the Shadow of Death: Span-
drels and Lunettes," the concluding pages of which are offered here.
The reader is directed to the complete text to follow Tolnay's careful
treatment of the iconography of the spandrels and lunettes. In the
selection given here, the author develops the conception of *ritorno*
or the return of God of the soul imprisoned in the body.

The student should read Tolnay's commentary on what he calls the
thematic foundation of the ceiling (*The Sistine Ceiling*, pp. 20–24 ff.).
Here, Tolnay wrestles with some of the more troublesome art-his-
torical problems that the ceiling presents. What material facts—
*e.g.*, the existing *quattrocento* frescoes and the *quattrocento* vault—did
Michelangelo have before him in beginning his own frescoes? Why
are there some iconographic inconsistencies in the cycle? In what
succession should the series of histories be contemplated?

*The Sphere of the Shadow of Death: Spandrels and Lunettes*

                    *       *       *

IN THE FIRST three paintings (history of Noah) the fields are crowded
with many relatively small figures; in the next three (history of
Adam and Eve) the compositions, made up of a few large figures
arranged in the first plane, repeat in their relationship the general
tension of the curved ceiling; in the last three paintings the move-
ments of the figures of God the Father are independent of the surface
of the ceiling and the architectural framework and attain the effect
of a view into the infinite. In considering them a reality, the spectator
becomes a "dupe" of these frescoes, as did probably Michelangelo him-
self during their execution. In identifying himself with the grandiose
flight of the highest being he feels himself freed from all shackles of
terrestrial life, carried away in temporal and spatial distances into a
sphere of absolute freedom, until he sinks into the primordial womb
of existence.

To sum up, this series of frescoes reveals * * * the return to God
of the human soul imprisoned in the body—i.e. the idea of the *Deifi-
catio* or *Ritorno*, widspread in the Neo-Platonic philosophy of the

Renaissance.

The liberation of the human soul from this slavery of the flesh is achieved only by a return to God. *"Erunt igitur tum demum felicissimi animi nostri, cum ab omni corporea contagione libri, solum deum intuebuntur . . . "* (Landino, *Disputationes Camaldulenses*, Lib. II). However, the return to God is nothing but a return to the source and first essence of the soul itself; for, according to Neo-Platonism, God is but the idea of man, and is no longer the transcendent being He was considered to be in the Middle Ages. Pico della Mirandola states in his *Heptaplus* (Introduction to the 7th book, *Opera*, 1572–1573, pp. 45 ff.): *"Felicitatem ego sic definio, reditum uniuscuiusq [ue] rei ad suum principium . . . quod autem omnia appetunt, id ipsum est, quod omnium est principium . . . Idem igitur finis omnium quod omnium principium Deus unus omnipotens & benedictus optimum omnium quae aut esse aut cogitari possunt."*

As a matter of fact, in the last five frescoes of the ceiling above the presbyterium, one can see that for Michelangelo the ascension is but the progressive deification of man, that is, the realization of his highest innate faculties. In this, he departs from the conception of the Middle Ages concerning the mystical ascension of the soul (*Scala del Paradiso*), which consisted of a total annihilation of the human personality in God.

This idea of *deificatio* is, however, intimately bound to the idea of *emanatio*. As a matter of fact, the series comprising the last five histories is connected along a serpentine movement which directs the eye of the spectator, once having arrived to the last fresco, from the purest form of the divinity back to its form most materially expressed and most human in *The Creation of Eve*. The same reverse movement can be seen in the seers: contrary to the Prophets and Sibyls in the first part of the ceiling above the room of the laymen, who are all facing in the direction of the altar, those over the presbyterium accompany the double movement of the histories. Those at the right all face the altar; those at the left face in the opposite direction. Together they form a "garland" leading the eye back and forth at the same time.

Besides Michelangelo's own philosophic convictions, the idea of superimposing this deeper signification of the *ascensio* on the biblical scenes was also suggested by external requirements, one of which was the desire to offer a visual and spiritual unity to the spectator entering at the side opposite to the chronological sequence. In early Christian art cyclical compositions began at the altar proceeding toward the entrance without regard to the inner requirement of the spectators and conforming only to liturgical prescriptions. We have already seen

how Michelangelo was bound to this tradition in his cycle and was obliged to make the historical sequence of his series conform to that of the Quattrocento masters below. But as an artist of the Renaissance, he might not have been satisfied by this kind of representation, and he must have tried to present at the same time the whole cycle as a unity likely to be experienced by the spectator. He attained this by the insertion of a new content the sequence of which develops from the entrance to the altar. The spirit of the past century seems far off. In the cycle below that earlier spirit gave a succession of isolated paintings, without compositional connection between them, and for the comprehension of which the spectator is forced each time to delve into a new world.

Another factor which may have inspired Michelangelo to insert the meaning of the Platonic ascension of the soul into his cycle of Genesis is the fact, previously stated, that the Sistine Chapel was dedicated to the Assumption. Now, the Christian Assumption was already fused, in the minds of the Neo-Platonic *deificatio*. Proofs for this can be found in *L'Altercazione* (Chap. III) of Lorenzo de' Medici, in the above quoted *Disputationes Camaldulenses* of Landino, in the *Theologia Platonica* (Bk. III) and the *Commentary of Phaedrus* by Ficino, in the *Commento di Pico sopra una canzone de Amore composta da Benivieni*, (in the *Opera*, p. 207) of Pico, and in the *Cortegiano* (Bk. IV, Chap. 62) of Castiglione. According to the esthetic principles of the Cinquecento it was necessary to establish an inner correspondence between the purpose of the room to be decorated and its pictorial decoration (*convenienza*, Armenini). It was fitting, therefore, for Michelangelo to paint in the chapel consecrated to the Assumption, frescoes which depicted the progressive elevation of the soul. Inversely, some of the later representations of the Assumption borrowed freely for their figure of the Virgin certain poses which are derived without doubt from Michelangelo's figure of God the Father. Thus one finds in the Assumption of Annibale Carracci at Dresden the Virgin in the same pose as that of God separating the sky from the water, and in the Virgin of the Assumption of Rubens in the Cathedral of Antwerp the pose of God creating the sun and moon.

On the other hand, the Platonic interpretation of the Genesis had been well known for a long time. The most celebrated example of this during the Renaissance is the *Heptaplus* of Pico della Mirandola. It is true that these interpretations did not serve Michelangelo directly, but it is significant that he interpreted the Creation with a like approach.

By means of this hidden meaning Michelangelo was able to reconcile his new conception with an ancient tradition that saw heaven in the ceiling of a church. This idea was known from the time of the

ancient Egyptians. During the Middle Ages the church ceiling, as a matter of fact, was even called "heaven" (*el cielo*); and before Michelangelo had undertaken his decoration of the ceiling of the Sistine Chapel it had, as stated previously, its ancient decoration of blue sky studded with golden stars. Michelangelo has transformed this medieval Christian heaven into a ὑπερουρανιος τόπος, a heaven peopled with figures who by their perfection resemble the inhabitants of Olympus. It is the abode of the divine, flooded like Olympus with a "white glow" and, like it, in sharp contrast to the shadowy material world of mortals (in the spandrels and lunettes).

The Olympus of the ancients was basically the image of the accumulated hopes of the race, the vision of a life not yet lived. Likewise, the *deificatio* represented by Michelangelo was not only the remembrance of the original sources but also the eternal dream of a predestined future: the image of a perfect godlike existence.

Having discussed the historical and the symbolic significance of the Sistine ceiling, a word remains to be said on the subjective meaning which the artist inserted therein. The image of the God of this series was the archetype of a creative being. God (in *The Creation of Adam and Eve*) is the perfect maker Whose "*disegno interno*" is immediately realized in His work without the obstacles of matter, space and time, as in the terrestrial creation. In the paintings following, Michelangelo added to this perfect creator the qualities of omnipotence, omnipresence and omniscience, to conceive finally this highest being similar to the primitive impulse of the spirit striving to arrive through chaos to clarity.

The representations which he made of the creative work of the absolute being as attaining more and more to perfection were, in his conception, the exaltation par excellence of the free, sovereign and spontaneous creative act to which his promethean soul aspired. After the unsurmountable obstacles which compelled him to abandon the project of the Tomb of Julius II, his greatest artistic dream, he found compensation for his highest aspirations and his ideal of unlimited sovereign creation in the imagination and the expression of the work of the Absolute Being. It is as characteristic for this period of his life that the highest ideal lies in unlimited creative power as it will be characteristic for his next great work—the Medici Chapel—that his highest ideal will consist in the passive contemplation of the life cycle of existence. Thus on the ceiling of the Sistine Chapel Michelangelo left, probably unconsciously, an "ideal portrait" of his genius, the profound mark of his highest desires in the years of his maturity.

The Sistine ceiling, made at a time when the classical style was flourishing, has a style of its own. At first sight it appears as an anach-

ronism. The intimate structure of this work is indeed rather me-
dieval: by the dynamism of the architectonic forms (instead of the
rational tectonism), it has a relationship with the Gothic architectural
forms. It is Gothic in the idea of the series of isolated figures
(Prophets and Sibyls), Gothic in the differing scale of proportions
of the figures in the same work, and Gothic in the relationship be-
tween the figures and the architecture—a relationship in which the
architecture does not form the surroundings of the figures but is the
frame which determines their places. The medieval inspiration also
manifests itself in the first six histories of the ceiling which are in-
spired by Quercia and Masaccio. But this Gothic structure is concealed
within forms having an ancient aspect, in which are found the gravity
and the fullness of the Roman triumphal arches and of a whole world
of ancient statues.

By means of this dynamic exaltation of classical forms Michelan-
gelo could arrive at his supreme aim: to create a new second world—
a transcendent reality.

## DON CAMERON ALLEN
from *The Legend of Noah*—[1949]*

> The following excerpts are from a well-known book-length study by
> Professor Allen, who since 1945 has been Sir William Osler Professor
> at Johns Hopkins University. Selections from the introductory part
> of the book, which are included here, should give a fair idea of the
> author's approach and intentions. These amount to an outstanding
> historical tracing of the entire Noah legend as it was treated in
> literature and art up through the Baroque. Only those portions of
> direct interest to the student dealing with the imagery of the Sistine
> ceiling are retained for reprinting here, and the numerous reference
> notes omitted in order to give more space to the originality of the
> text. The illustrations may be found in his book; Bible text: pp. 126–
> 130.

* * * THERE IS NO TRULY authoritative way of writing a poem or
painting a picture or composing a violin concerto, although in each
case authority may have a small place. In fact, the history of most
artistic procedures is the chronicle of revolt. A tradition exists, but it
exists because it is violated. The manifestoes of artistic movements
were thus paradoxical in that they invariably propose one authority
for another. But the human mind is so made that authority is breached

* Don Cameron Allen, *The Legend of Noah: Renaissance Rationalism in
Art, Science and Letters* (Urbana, Ill., University of Illinois Press, 1949),
pp. 1–3, 138–173. Reprinted by permission of the publisher.

by authority; yet it is the persuasion of dissent, not the dissent itself, that counts.

In the following essay, I wish to study some aspects of this process by examining what happened to the literary and artistic treatments of the story of Noah as rationalism demonstrated its lack of truth. During the Middle Ages and the early Renaissance, the Biblical account of the Flood was regarded as an essential historical fact, and we shall see that this conviction was mirrored in the artistic treatments of the tale. * * * The story of Noah is not so sublime as that of Christ; nonetheless, it is a salient even in the Christian legend. In the allegorical accounts of the Middle Ages, Noah was always treated as one of the great precursors of the Saviour. Endless comparisons were made between the waters of the Flood and those of baptism, between the wood of the Ark and the wood of the Cross, and between the door in the Ark and the wound in Christ's side. So the story of Noah had as definite a sanctity as the story of Adam, Samson, David, and any other of the great adumbrators of the doctrine of grace; consequently, it is quite important to see what happened to the artistic portrayals of it as it decomposed under the glare of rationalism into a simple myth. * * *

The two centers of fact in the Renaissance are the sacred and the national history, and few men of this age doubted the historicity of Brutus and Francus any more than they doubted that of Noah or Samson. As rationalism grew in power, however, both centers of fact came under surveillance; and before the year 1700, doubts were registered about the actuality of events in each division. For this reason I have followed the alterations in the attitude towards the Noah story; but I think that I should have had equally good fortune had I investigated some other event in sacred or secular history, for in many other cases rationalism did its work and a great truth was converted into a simple myth. In each instance we should have seen that the artistic imagination, released from the bonds of tradition and authority, spread its wings and soared.

<div align="center">*      *      *</div>

To the Christian artists of the first five centuries, Noah was a symbol. He appears many times, but he is usually the joyful emblem of the risen Christ. We see him, for example, in a second-century fresco in the catacomb of Priscilla; he stands in what appears to be an open box and stretches his hand towards the dove. In other paintings, the box of Noah has an open lid or hinges or a lock. We know that the commentators have always insisted that the Ark was not a ship but rather the *box* or *chest* of the Greek and Hebrew texts. These early

paintings may be governed by these comments, but there is more in them than that. Noah is the premonstration of the second Adam's victory and so the Ark must look like a gravechest, like a sarcophagus, the funeral box in which the body of Christ was laid. * * *

The directions of early painting and sculpture are * * * widened by the masters who illuminated several early manuscripts. The Vienna Genesis, a fifth-century manuscript, has four illustrations of the life of Noah. In one of these, the Ark (a sort of catafalque of three cubes that diminish from the top) rides in the Flood; in another, the animals depart from a door in the lower cube while the birds leave from the small upper cube; in a third miniature, Noah and his sons look toward a stylized rainbow and "hand of God." The last illustration shows Noah drunk and Ham beckoning his brothers, who approach with a cloak while Canaan watches. This is a broad unfolding of the Noah legend, and it forced other artists to consider the full scope of the Genesis account.

An important second corpus of illustrations is contained in the now ruined Cotton Genesis, which goes back to the fifth or sixth century. * * * On one of the fragmentary pages we can still see a picture in which Noah leans from the window of a square Ark. * * * On another leaf is a miniature of the episodes in the story of Noah's drunkenness. The importance of these miniatures is that they were used by the artists who did the mosaics of St. Mark's in Venice. A third collection of Noah illustrations is found in the seventh-century Ashburnham Pentateuch, which contains a "Flood" and an "Exit." The Ashburnham Ark, like the catacomb Arks, is a square [1] chest with a raised cover. All the events of the Flood are recorded in the same miniature; hence, we see a row of Noahs appearing in a row of windows to send forth a raven and a series of doves. Standing under the lifted lid of the Ark is Noah and his family, who appear again in the open door. In this way, a number of episodes from the Noah story are incorporated in the same leaf, and, quite obviously, the themes are increased. The Ark itself is of early Christian design; it has even the chair-like legs that occur in one early Noah-in-the-box.

Unlike their predecessors, the artists of the tenth century are more interested in the story of Noah than in the symbolism of Noah. Symbolism is of course still present, but it is the human aspect of the story that comes to the fore. * * * The Byzantine Ark with a keel and even a mast is catching on, and in a tripartite ivory plaque carved as early as the seventh century, we can see the Ark as a definite ship, with birds roosting on the yardarms. In the tenth century, however, a

---

1. Actually the "chest" is shaped elliptically in the guise of a frequently found Roman sarcophagus type [Ed.].

new type of Ark appears that was shortly to be standardized by the commentary of Hugo of St. Victor * * * a three-decked Ark with a pitched roof which has a large window above a series of smaller windows.

The tenth-century Pseudo-Caedmon manuscript contains miniatures that seem to combine this new type of Ark with the Byzantine ship-ark. In one miniature, God, an elderly man, instructs Noah; in another, Noah works on the keel of a boat. In the third miniature, we see the finished Ark, a magnificent structure of three floors with a handsome roof, a sort of cathedral, really, with towers and balconies. * * * The fine structure is the product of the new symbolism. The Ark now represents the Christian Church afloat in the sea of the world under the guidance of sanctified men who are directed by God. During the Renaissance, this type of Ark vied for popular favor with the scientifically constructed Ark and the Byzantine-St. Victor Ark. * * *

The most fabulous series of Noah designs of the twelfth century are the mosaics in the greater nave of Monreale Cathedral. * * * Seven episodes of the Noah legend are illustrated by the Monreale masters. In the first, we see Noah getting instructions from God Who is represented by a "divine hand." Then we see Noah directing five workers, three of whom are sawing at timbers and the other two working with axes. The superstructure of the Ark * * * rests on a hull and has two windows. When we look at the Ark in the third mosaic, it has changed, for now it has three windows from which peer six people. * * * When the Ark is completed it has a pitched roof, and we see the animals being helped up one gangplank by Noah and up another by one of his sons. In the fourth mosaic, we see the Ark tossing in the Flood. The Noachides look from two of the windows while Noah receives the dove at a third window. The raven is at his regular routine on a floating corpse. The fifth mosaic is like the third, save the animals are now leaving the Ark; and the sixth mosaic shows the sacrifice and the rainbow. The left side of the last mosaic shows Noah making wine near a vine of grapes; on the right he is stretched out in drunken slumber.

Of similar Byzantine style but wider in scope are the great thirteenth-century mosaics at St. Mark's in Venice. In this series, fifteen episodes from the career of Noah were selected and executed with the greatest care. The first episode, like that of Monreale, shows God (represented by a hand in an arc) instructing Noah. Then we see the Ark being built. Noah lectures a workman—probably a foreman—while ten carpenters labor at the construction. Noah is next shown putting the birds and animals into the Ark; they enter in the Biblical pairs and sevens for the first time in the history of art. After

this, we see the family of Noah entering the Ark and the Ark riding on the waters. The Ark is surprisingly enough not a ship, but a great rectangular construction with one window and one door. * * * The St. Mark's mosaics then go on to tell the story of the sending forth of the raven and the dove, and to describe the exit from the Ark and the "Sacrifice." Finally, there is a group devoted to the end of Noah's life. He squeezes the grapes and drinks; he is naked and observed by Ham; Ham summons the brothers; Sem and Japhet cover Noah; and Noah curses Ham. At last, we see the burial of Noah. * * *

The groupings and the postures of these early designs are responsible for many of the patterns of the Renaissance, for tradition always remains the directing sub-current. But it is in the fifteenth century (that age of the great masters and of that new discovery, the wood-block book) that the story of Noah spreads far and wide in the realm of art. When the tale gains popularity as a subject for illustrators, it becomes increasingly varied. The variations are on an old theme, but they are, nonetheless, variations in the direction of the rationalists. * * *

One of the earliest [Italian Renaissance] paintings dealing with the Noah story is a three-scene fresco by Pietro di Puccio d'Orvieto in the Campo Santa at Pisa. The frescos, which show *The Building of the Ark, The Exit from the Ark,* and *Noah's Sacrifice* were painted in the latter part of the fourteenth century. The Ark is a very tall structure with a flat base. Neither its width nor length is very great; it reminds one at once of the Beatus Arks. It is also highly suggestive of the Arks painted later by Michelangelo and Raphael. Slightly later than these frescos are the early fifteenth century paintings by the painter Paolo Uccello, in the Chiostro Verde of Santa Maria Novella at Florence. The first fresco shows Noah at prayer while three men build the Ark. The second painting is quite confused. To the left, one sees the lower portion of an Ark of tremendous length with sides that slope like those of the Origen Ark.[2] This Ark is on a sort of raft. One sinner stands on the raft in the foreground and clings to the side of the Ark while a second sinner in the middle ground tries to break in. In the immediate left foreground, a man on horse strikes with a sword at a nude man with a club. In the center is a man who appears to be treading a vat of grapes, a seated woman, and an elderly man with his hand lifted in conversation or surprise. To the right is the lower side of another Ark, with Noah leaning from the window. The design is very baffling, but it seems to represent various episodes from

2. Elsewhere in the text defined as a pyramidal structure—so called because it was first proposed as a shape for the Ark by the controversial Early Christian Biblical editor Origen (185?–254?) [Ed.].

the story of Noah: the fighting antediluvian giants, the Flood, the sending forth of the dove, Noah leaving the Ark, the making of wine. A third fresco, which is now ruined was inspired by *The Drunkenness of Noah.*

The Origen truncated pyramid Ark that seems to have attracted Paolo Uccello is the same Ark that was used by Ghiberti for the Noah panel in the Baptistery at Florence. But not all Arks painted during the early fifteenth century are of this nature. In the Old Testament frescos of the Cappella dell'Annunziata at Cori, one sees a Noah crouched in a chest with a raised lid; the design is simply a fifteenth century recrudescence of the [Early Christian] Noah. The nature of some other Arks is difficult to ascertain, because their artists have been interested more in the human beings or the animals than in the Ark. The fine relief of *The Exit from the Ark* by Jacopo della Quercia in St. Petronio at Bologna gives us no notion of its shape. The same is true of the Noah fresco by Filippino Lippi in Santa Maria Novella where the Ark that forms half of the background may be either the Origen or St. Victor type. A curious variant, however, of the Origen Ark is seen in a painting of *The Harrowing of Hell* by a member of the school of Hieronymus Bosch. In this canvas, Noah kneels and holds his ark symbol which is the Origen Ark on the Byzantine keel.

\* \* \*

But the great Flood picture of the Renaissance was Michelangelo's fresco in the Sistine Chapel [fig. 19]. In this picture we have an entirely new theory. For the first time in the history of artistic representations the Ark is truly of secondary interest. \* \* \* One notices that it has none of the qualities of a ship; but we hardly observe the Ark, because it is the doomed antediluvians who trap our attention. This is the first painting of the Flood to place such an extraordinary emphasis on the sinners. There is a slight indication of this in the fresco of Paolo Uccello \* \* \* but no painter before Michelangelo had dared to push the Ark to the rear of the scene and make the intense sufferings of the doomed the essential artistic focus. This is a humanization of the story which is in keeping with the rational abandonment of the Genesis text. If there was a Flood, one might say, the fearful death of the unfavored is for a rationalist a greater and more important fact than that a patriarch and his children were saved.

\* \* \*

In the beginning, we recall that the Ark and the family of Noah are placed at the front of the picture. A little later, the Ark is moved back so that a few corpses may be shown, but the Ark is still the central object. With Michelangelo, the Ark moves to the horizon and the dying mortals become the focal point of the painting. In time, the

Ark disappears over the horizon. Now it is difficult to explain Michelangelo's innovation. It was probably the result of his sympathy for mankind or, better still, of his joy in delineating the contorted features of men. There is no doubt, too, that the authority of the Sistine Ceiling is responsible for the similar attempts of sixteenth and seventeenth century artists who follow the groupings of the great master. Nevertheless, it seems to me that behind it all there is a disregard of the inspired story that is the equivalent of the position assumed by the rationalists. The story of the Ark is a legend, a myth, but the story of human suffering is always true, always the same.

Further suggestions of this same trend are found in the illustrations of Noah's wine-making and attendant disgrace. The episode is divided into the planting of the vines, the treading of the grapes, Noah's drinking, the discovery by Ham, the covering of the naked Noah by Sem and Japhet, and, on very rare occasions, the cursing of Canaan. * * * The great artists go back to the more ancient masters. In Paolo Uccello's ruined fresco, one sees the three sons but not the inebriated father.[3] The relief of Jacopo della Quercia at Bologna shows the two sons covering Noah while Ham looks on through an arbor. In neither of these representations are the sons hiding their faces as they do in the earlier frescos and mosaics. In Ghiberti's relief, the older pattern is revived. Noah lies drunk in a shed near casks of wine; Sem and Japhet turn their backs to him and face Ham. In the great frescos at the Campo Santo in Pisa by Benozzo Gozzoli, the whole story is told after the manner of Monreale or St. Mark's. To the left of the first fresco, we see Noah's vineyard. The grapes, which are gathered from a splendid trellis by charming young women, are trodden in a vat by a workman who is much like the vintner of the Uccello fresco. Noah, surrounded by his grandchildren, stands before this scene. In a small middle plane, Noah holds a goblet and converses with some of his relatives. This episode transfers us to the right side of the fresco where we see Noah drunk in the doorway of his house. One of his sons covers him while Ham shouts his derision. The women stand about, and one of them peeps from an upper window. The second fresco deals with the cursing of Canaan, an event in the life of Noah that also appears in the mosaics at St. Mark's. * * *

This is the straight course of a tradition which leads us once more to the Sistine Ceiling. Here again we see the nude Noah sprawled drunkenly by his wine vats, mocked by one son and covered by the others [fig. 18]. All the symbolic objects are there: the wine pitcher at the patriarch's elbow, the roof of the shed at the top of the fresco,

3. The figure of Noah is indeed missing, but it is missing because it was evidently in the section at the bottom of the fresco which has perished [Ed.].

and to the left an aged man, the sober Noah delving in the soil. But the scene is not comic nor religious, for it contains matter for the brooding sympathies of mankind. The old Titan is down and his sons stand before him shocked into laughter or into shame. It is the eternal symbol of youth averting its eyes from the weaknesses of age. There is only one painting of the episode that in any way compares with this and it is Bernardino Luini's great work in the Real Pinacoteca di Brera at Milan. The Noah is more obviously drunk, and the sons are more clearly villains and heroes than they are in Michelangelo's fresco. But the Ark in the background also tells the story; it is there for the observer's information. Without it the subject of the picture would not be immediately clear.

It seems to me there is a kind of parallel between the artistic and literary treatments of the life of Noah. In art we find first a symbolic use of the figure followed by a realistic attempt to illustrate the whole Genesis story. As time passes, the artistic traditions cross and grow, but they are peculiarly complicated by the exegetical art that should be more carefully studied than it has been. Then, as the rationalistic period approaches, there is an inclination to swing away from the story as a matter of sacred inspiration and to see it as a particularly human or imaginative event. So in time the Deluge, which was once the story of the salvation of mankind by one God-fearing man, comes to be a symbol of human suffering and the eternal woes of men before the power of an angry Creator. We begin with Moses and we end with Kafka.

# GLOSSARY OF ART-HISTORICAL TERMS

A fresco: *see* FRESCO.

A secco (It.; L. *siccus*, dry): a technique of mural painting in which the PIGMENTS are applied when the plaster is hard and dry; as opposed to *a fresco* (*see* FRESCO).

*Azurite:* blue PIGMENT derived from the mineral azurite, containing hydrous carbonate of copper.

*Barrel vault:* a continuous rounded vault; sometimes intersected by transverse ribs.

*Bay:* compartments of an interior, each delineated from the other by divisions marked in the side walls (columns or shafts).

Bucranium (pl. *bucrania*): in architecture, the ornamental motive of an ox-skull.

*Cartoon:* the final full-scale drawing for a large painting, whether on panel or plaster.

*Cartouche:* in architecture, an ornamental scroll or tablet.

*Corbel:* in architecture, a projection from the wall which supports a beam or other horizontal member.

*Cornice:* a horizontal architectural molding projecting from a wall or at the top of an architectural order which finishes or crowns it.

*Finial:* in architecture, an ornamental termination of a spire or pinnacle.

*Fresco (a fresco;* It. fresh, cool): a technique of mural painting in which the PIGMENTS are applied while the plaster is still moist and cool; as opposed to A SECCO.

*Frieze:* a painted or sculptured band running horizontally usually at or near the top of a wall.

*Ignudo* (pl. *Ignudi*): in the Sistine Chapel ceiling, one of a number of seated nude male figures who are represented as supporting festoons of oak leaves or MEDALLIONS.

Intonaco: in the classic FRESCO-technique, the uppermost fine-grained layer of plaster into which the PIGMENTS are brushed.

*Lunette:* in the Sistine Chapel ceiling, one of the rounded compositions immediately over the windows.

*Medallion:* one of the circular discs painted with a design in imitation of bronze-gilt supported by IGNUDI in the Sistine Chapel ceiling.

*Pendentive:* arbitrarily used here as a term to differentiate the large corner ceiling SPANDRELS at the east and west walls of the Sistine Chapel.

*Pigment:* any coloring matter; in Renaissance painting, pigments were derived from mineral and vegetable sources ground to appropriate fineness.

*Pilaster:* a rectangular column inserted into, or built against, a wall.

*Plinth:* a projecting band at the base of a wall.

*Pozzolana(o):* light, pumice-like, ground stone sometimes mixed with plaster as a base for mural painting in Rome and Naples.

*Presbyterium (presbytery):* the sanctuary of a church, housing the main altar.

*Prophet:* in the Old Testament, one of a number of successive religious leaders who interpreted God's will and the scheme of providence.

*Putto* (pl. *putti*): an infant or childish figure.

*Quadratura:* a system of determining proportions in figure design by blocking drawing paper into squares.

*Secco: See* A SECCO.

*Sibyl:* in classical mythology, one of several women of varying ages, some being priestesses associated with the cult of Apollo, who were inspired to foretell the future.

*Socle:* a horizontal molding at the base of a wall or pedestal.

*Spandrel:* in the Sistine Chapel ceiling, one of the concave triangular portions over the windows.

*Splay:* in architecture, a sloped surface usually associated with doors and windows.

*Stanza* (pl. *Stanze*): in the Vatican, one of a series of connecting rooms which were painted in the sixteenth century by Raphael and his school.

*String-course:* a narrow horizontal molding slightly projecting from a wall.

*Tempera (distemper):* a medium with an egg base used for painting.

*Terminal figures:* a shaft terminating in a human figure.

*Tier:* a row or one of a series of ranks.

*Tondo* (It. round): a circular or near-circular field for painting.

*Travertine:* porous stone found in the environs of Rome used from Antiquity to the present in Roman building.

*Ultramarine* ("beyond the sea"): fine blue PIGMENT derived from lapis lazuli imported into Italy. Alternate to AZURITE.

*Victoria* (pl. *victoriae*): in ancient architecture, female winged-figures, usually found on triumphal arches, that symbolized victory.

# BIBLIOGRAPHY

THE EMPHASIS IN THIS bibliography is on accessibility. Usually, the edition cited is the most recent, preference being given to easily obtainable paperbacks. Moreover, an effort has been made to limit citation to works written in English or to translations into English, though this has not always been possible particularly for some early works, articles in learned journals, and certain important recent studies.

A highly selective bibliography on the Sistine ceiling and related material, such as this one, can only hint at the vast literature on Michelangelo. For more complete coverage the interested student is referred to several bibliographies: E. Steinmann and R. Wittkower, *Michelangelo Bibliographie, 1510–1926* (Leipzig, 1927); H. W. Schmidt's appendix to *Michelangelo in Spiegel seiner Zeit* (Leipzig, 1930); P. Cherubelli's "Supplemento alla bibliografia Michelangeolesca 1931–1942" in *Centario del Giudizio* (Rome 1942); P. Barocchi's bibliography to her edition of Vasari's *Lives* cited below; and P. Meller's list, to 1964, at the end of *The Complete Works of Michelangelo*, edited by Mario Salmi, also cited below.

It is hoped that this Bibliography will not only supply a basic short list for art-historical consideration of Michelangelo and the Sistine ceiling but also a preliminary guide to the general historical and artistic milieu within which Michelangelo moved. There are five subject categories; titles are arranged within each of these divisions by date of most available edition.

### Sources

Gaye, G., *Carteggio inèdito d'artisti dei secoli XIV, XV, XVI*, Florence (1839–1840).

Milanesi, G., ed., *Le Lettere di Michelangelo Buonarroti edite ed inedite*, Florence (1875).

Frey, K., ed., *Condivi, A., Vasari, G., Le vite di Michelangelo*, Berlin (1887).

Frey, K., ed., *Sammlung Ausgewahlter Briefe an Michelagniolo Buonarroti*, Berlin (1899).

de Vere, G., tr., Vasari, G., *Lives of the Most Eminent Painters*, IX, London (1915).

Barocchi, P., ed., *Giorgio Vasari, La Vita de Michelangelo della redazione del 1550 e del 1568*, 5 vols., Milan-Naples (1962).

Girardi, E. N., ed., *Michelangelo Buonarroti, Rime* (Series *Scrittori d'Italia*), Bari (1960).

Frey, K., ed., *Die Dichtungen des Michelagniolo Buonarroti*, Berlin (1964; original ed., 1897).

Gilbert, C., (with Linscott), eds., *Complete Poems and Selected Letters of Michelangelo*, New York (1963).

Ramsden, E., ed., *The Letters of Michelangelo*, Stanford (1963).

Poggi, G., Barocchi, P., and Ristori, R., eds., *Il carteggio di Michelangelo*, I, Florence (1965).

## Historical Background

Burckhardt, J., *The Civilization of the Renaissance in Italy*, (*Die Kultur der Renaissance in Italien;* first ed. 1860), transl. S. Middlemore, New York (1961). Mentor Paperback.

Pastor, L., *The History of the Popes*, ed. F. I. Antrobus, VI, London (1898).

Klaczko, Julian, *Rome and the Renaissance: The Pontificate of Julius II*, transl. J. Dennie, New York (1903).

Rodocanachi, E., *Histoire de Rome: le pontificat de Jules II, 1503–1513*, Paris (1928).

Robb, N. A., *Neoplatonism of the Italian Renaissance*, London (1935).

Aubenas, R., "The Papacy and the Catholic Church," *The Renaissance, New Cambridge Modern History*, I, ed. G. R. Potter, Cambridge (1957), pp. 76–94.

Cantimori, D., "Italy and the Papacy," *The Reformation, New Cambridge Modern History*, II, ed. G. R. Elton, Cambridge (1958), pp. 251–274.

Pater, W., *The Renaissance*, New York (1959). Mentor Paperback.

Jacob, E. G., ed., *Italian Renaissance Studies*, London (1960).

Gilmore, M. P., *The World of Humanism*, 1453–1517, New York (1962). Harper Paperback.

Jedin, H., *A History of the Council of Trent*, I, Edinburgh (1963).

Randall, J., Cassirer, E., Kristeller, P., eds., *The Renaissance Philosophy of Man*, Chicago (1963). Phoenix Paperback.

*Artistic Background*

Symonds, J. A., *Renaissance in Italy: The Fine Arts*, London (1879).
Spingarn, J. E., *A History of Literary Criticism in the Renaissance*,
New York (1925; first ed., 1899).
Lee, R. W., *Ut Pictura Poesis: The Humanistic Theory of Painting*,
New York (1967; first published in *The Art Bulletin*, XXII,
1940, pp. 197–269). Norton Paperback.
Blunt, A., *Artistic Theory in Italy, 1450–1600*, Oxford (1962; first
published Oxford, 1940). Oxford Paperback.
Wölfflin, H., *Classic Art: An Introduction to the Italian Rensissance*,
trans. Peter and Linda Murray from the 8th German ed.,
London (1952; first ed., 1899).
Borsook, E., *The Mural Painters of Tuscany from Cimabue to An-
drea del Sarto*, London (1960).
Freedberg, S. J., *Painting of the High Renaissance in Rome and
Florence*, 2 vols., Cambridge (1961).
Sandström, S., *Levels of Unreality: Studies in Structure and Con-
struction in Italian Mural Painting during the Renaissance*,
Uppsala (1963).
Schulz, J., Review of Freedberg (see above) in *The Art Bulletin*, XLV
(1963), pp. 159–163.
Panofsky, E., *Tomb Sculpture*, London (1964).
Procacci, U., ed., *The Great Age of Fresco: Giotto to Pontormo*
Metropolitan Museum of Art Exhibition Catalogue, New
York (1968).

*Michelangelo: General*

Thode, H., *Michelangelo und das Ende der Renaissance*, 4 vols.,
Berlin (1902–1912).
Thode, H., *Michelangelo, Kritische Untersuchungen über seine
Werke*, 3 vols., Berlin (1908).
Justi, C., *Michelangelo, Beiträge zur Erklärung der Werke und des
Menschen*, 2nd ed., Berlin (1922).
Tolnay, C. de, *Michelangelo*, 5 vols., Princeton (1943–1960).
Clements, J., *Michelangelo's Theory of Art*, New York (1961).
Panofsky, E., *Studies in Iconology*, New York (1962). Harper Paper-
back.
Arthos, J., *Dante, Michelangelo, and Milton*, New York (1963).
Tolnay, C. de, *The Art and Thought of Michelangelo*, New York
(1964).

Goldscheider, L., *Michelangelo: Paintings, Sculpture, Architecture,* Phaidon (1964).

Hartt, F., *Michelangelo,* New York (1964).

Salmi, M., ed., *The Complete Work of Michelangelo,* New York (1965).

Weinberger, M., *Michelangelo, the Sculptor,* 2 vols., New York (1967).

*Sistine Chapel Ceiling*

Wölfflin, H., "Die Sixtinische Decke Michelangelos," *Repertorium für Kunstwissenschaft,* XIII (1890), pp. 264–272.

Steinmann, E., *Die Sixtinische Kapelle,* 3 vols., Munich (1901–1906).

Wurm, A., "Zu den Lünetten und Stichkappen der Sixtina," *Repertorium für Kunstwissenschaft,* XXXI (1908), pp. 305–313.

Foratti, A., "Gli Ignudi della Volta Sistina," *L'Arte,* XXI (1918), pp. 109 ff.

Panofsky, E., *Die Sixtinische Decke,* Leipzig (1921).

Berenson, B., *The Drawings of the Florentine Painters,* Chicago (1938; enlarged ed.), I, pp. 197–200; II, pp. 165–211.

Gombrich, E., "A Classical Quotation in Michelangelo's 'Sacrifice of Noah,'" *Journal of the Warburg Institute,* I (1937–1938), p. 69.

Wind, E., "The Crucifixion of Haman," *The Journal of the Warburg Institute,* I (1937–1938), pp. 245–248.

Wind, E., "Sante Pagnini and Michelangelo: A Study of the Succession of Savonarola," *Gazette des Beaux-Arts,* 6th series, XXVI (1944), pp. 211–246.

Tolnay, C. de, *The Sistine Chapel,* Princeton (1945; re-edition announced for near future, as of 1969).

Hartt, F., "*Lignum Vitae in Medio Paradisi:* The Stanza d'Eliodoro and the Sistine Ceiling," *Art Bulletin,* XXXII (1950), pp. 115 ff., 181 ff.

Wind, E., "The Ark of Noah: A Study in the Symbolism of Michelangelo," *Measure,* I (1950), pp. 411–421.

Wind, E., "Typology in the Sistine Chapel: A Critical Statement," *Art Bulletin,* XXXIII (1951), pp. 41–47.

Wilde, J., "The Decoration of the Sistine Chapel," *Proceedings of the British Academy,* XLIV (1958), pp. 61–81.

John, R., *Dante und Michelangelo: Das Paradiso Terrestre und die Sixtinische Decke,* Krefeld (1959).

Wind, E., "Maccabean Histories in the Sistine Ceiling," *Italian Renaissance Studies,* ed. E. F. Jacob, London (1960), pp. 312 ff.

Ettlinger, L. D., *The Sistine Chapel before Michelangelo: Religious Imagery and Papal Primacy*, Oxford (1965).

Camesasca, E. (Introduction by S. Quasimodo), *L'Opera completa di Michelangelo pittore*, Milan (1966), pp. 88–102.

Sinding-Larsen, S., "A Re-reading of the Sistine Ceiling," Institutum Romanum Norwegiae, *Acta ad Archeologiam et Artium Historiam Pertinentia*, IV (1969), pp. 143–157.

Hartt, F., *The Drawings of Michelangelo*, New York (1971). Contains new summary of earlier article (above).

Salvini, R., Camesasca, E., and Ragghianti, C. L., *The Sistine Ceiling*, New York (1971; originally appeared in Italian, 1965). Contains sumptuous illustrations.

CHARLES SEYMOUR, JR., an internationally known authority on Medieval and Renaissance art, was Professor of the History of Art and Curator of Renaissance Art at Yale University. His publications include a number of books: *Notre-Dame of Noyon in the Twelfth Century; Masterpieces of Sculpture in the National Gallery of Art; Tradition and Experiment in Modern Sculpture; Italian Sculpture 1400–1500* (in the Pelican History of Art Series); *Michelangelo's 'David': A Search for Identity; The Early Italian Paintings in the Yale University Art Gallery: A Catalog;* and *The Sculpture of Verrocchio.* Professor Seymour attended King's College at Cambridge University, Yale University, and the University of Paris, where he studied under Henri Focillon, Marcel Aubert, and Paul Vitry. His B.A. and Ph.D. degrees were from Yale. For eight years he was Curator of Sculpture and Assistant Chief Curator at the National Gallery of Art in Washington. He has been a Sterling Fellow, a Guggenheim Fellow, and Visiting Mellon Professor at the University of Pittsburgh.